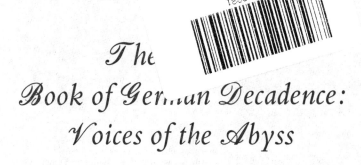

The
Book of German Decadence: Voices of the Abyss

Edited by Ray Furness
and
translated by Ray Furness & Mike Mitchell

Dedalus/Hippocrene

Dedalus would like to express its gratitude to The Austrian Ministry of Culture & Education in Vienna for its assistance in producing the translation of the texts written by Austrian authors.

Published in the UK by Dedalus Ltd, Langford Lodge, St Judith's Lane, Sawtry, Cambs, PE17 5XE

UK ISBN 1 873982 21 6

Published in the US by Hippocrene Books Inc, 171, Madison Avenue, New York, NY 10016

US ISBN 0 7818 0294 6

Distributed in Australia & New Zealand by Peribo Pty Ltd, 26, Tepko Road, Terrey Hill, N.S.W. 2084

Distributed in Canada by Marginal Distribution, Unit 103, 277, George Street North, Peterborough, Ontario, KJ9 3G9

First published by Dedalus in 1994

Printed in Finland by Wsoy
Typeset by Datix International Limited, Bungay, Suffolk

Ray Furness would like to express his gratitude to the German Academic Exchange Service for its support.

Contents

The passages indicated by an asterisk were translated by Mike Mitchell, the others were translated by the editor (except for the Thomas Mann). I am grateful to Reed Book Services for permission to include Thomas Mann's *Blood of the Wälsungs* and to Langen-Müller Verlag for permission to translate Paul Leppin's *Blaugast*. Every attempt was made to seek permission to include a translation of a section of Kurt Martens's *Novel from the Age of Decadence* (published by F. Fontane and Co., Berlin-West 1898).

I have grouped the translations into two sections, the first consisting of writers from Austro-Hungary, the second from Imperial Germany.

THE EDITOR

Ray Furness is Professor of German at the University of St Andrews. He has published a large number of books and articles on Expressionism, Wagner, Romanticism, Nietsche and fin de siècle German Literature.

His translations include the poetry of George Trakl, a study of Mozart and Posterity and *Die Alraune* by Hans Ewers (to be published by Dedalus in 1996).

THE TRANSLATOR

Mike Mitchell is a lecturer in German at Stirling University. His publications include a book on Peter Hacks, the East German playwright, and numerous studies on aspects of modern Austrian Literature; he is the co-author of *Harrap's German Grammar* and the editor of *The Dedalus Book of Austrian Fantasy: the Meyrink Years 1890–1930*.

Mike Mitchell's translations include *The Architect of Ruins* by Herbert Rosendorfer, and Gustav Meyrink's novels *The Angel of the West Window, The Green Face, Walpurgisnacht, The White Dominican* and *The Golem*.

'There is an energy which springs from sickness and debility: it has a more powerful effect than the real, but, sadly, expires in an even greater infirmity.'

[Novalis]

If an educated middle-class German of a century ago had sought clarification of the term *décadence* (a term which he may have come across in periodicals and newspapers) he might well have taken down the appropriate volume of his Brockhaus encyclopaedia of 1896 and found the following: '*Décadence* (French: pronounced "Dekadangss") – decay, decline, deterioration. Recently the term has been applied in France to an artistic movement which is a reaction against Naturalism; it is a symptom of today's nervous, senile, fragmented society which is impervious to anything which is healthy and natural, and which seeks to whip up its blasé, jaded attitudes through extravagant stimuli. The practitioners of this school of writing are called decadents.' Had he sought elsewhere for further information he would have discovered that the most decisive formulation of decadence had been given by Baudelaire in his essay on Edgar Allan Poe of 1867: the French poet has accepted the term – hitherto purely pejorative – and welcomed it with approval. Those critics who had rejected Poe for being morbid and bizarre had failed to realise, Baudelaire had explained, that Poe's works had aimed at being 'unnatural', for the natural and the normal had lost their charms (if, indeed, they had ever possessed any). Gautier had, in the following year, admirably summed up Baudelaire's position – the refined, the ultra sophisticated, the *recherché*, the subtle, the neurotic, the knowledge of being somehow explorers, or manifestations, of a terminal cultural sickness: these qualities Gautier had extolled in Baudelaire, as Baudelaire had extolled them in Poe. And that which had been adumbrated in Paris in the 1860s had become the literary watchword of the 1880s, especially in Verlaine, who had overtly proclaimed his love for the word 'décadence', going so far as to announce that he was 'L'Empire

9

à la fin de la décadence'. Our German, if he had browsed further in his Brockhaus, would finally have found references to Stéphane Mallarmé and Jean Moréas (the term 'déliquescents' was also used to define modern French writers, also, confusingly, 'symbolistes'), and references to 'artifice' and, indeed 'idiocy', abounded. The impression our reader might have gained was that 'décadence' was a symptom of French degeneration, typical of a nation defeated in war, a country nervously strained and somehow predestined to morbid derangement.

But let us move to a more sophisticated level and see what the German-speaking literary critics have to tell us. Hermann Bahr, the Austrian *littérateur* and essayist, visited Munich in 1888 and moved from there to Paris: with acute sensitivity and remarkable openness to the literary scene in that city Bahr saw that the Naturalist watchwords and slogans had had their day and that something new was in the air. Naturalism, that short-lived attempt to reproduce the surface texture of reality as faithfully as possible was now superseded by the cultivation of inner visions and the search for the *outré* and the artificial. Bahr's collection of essays, *Studien zur Kritik der Moderne* (1894), contains a section on 'Die Décadence' which succinctly and with considerable insight formulates the preoccupations of the new generation of writers: they wished, Bahr explains, to flee from the trivial superficialities of Naturalism, wishing instead to 'modeler notre univers intérieur'. They despised the taste of the mob and sought the bizarre and the extraordinary. They demanded artifice and were characterised by a febrile mysticism. They wished to express the inexpressible and to grasp the impalpable; they sought dark, sultry images. They entertained above all the insatiable desire to portray the monstrous and the boundless – it was no coincidence that they were Wagnerians. They detested the banal, the banausic and the quotidian; they sought with assiduity the exceptional and the outlandish. With unfailing acumen Bahr saw the importance of Wagner for the new mentality – Wagner as purveyor of

10

unheard-of delights and sensations, the hierophant and magus for impoverished souls who sought that fearful ravishing of which Baudelaire had spoken some thirty years earlier. And decadence did not simply mean sterile decline, for the literary scene in Paris brought forth fascinating blooms which sprang as asphodels from fetid waters.

Bahr established himself in the Café Griensteidl in Vienna and acted as intermediary between Paris and Vienna in terms of ideas and manifestoes: his novel *Die gute Schule* (*The School of Love*), published in 1890 when Bahr was twenty-seven portrays the Parisian *vie de bohême* in a lurid and sensational manner, particularly the contorted relationship between the hero and Fifi (Bahr's father rejected it out of hand). But a man who achieved a greater notoriety (and a much wider readership) for his writings on decadence was Max Nordau, whose *Entartung* (*Degeneration*) appeared in two volumes in Berlin 1892/3. Nordau had moved to Paris in 1880 and keenly observed the latest literary and medical developments in France: he had studied with Charcot at the Salpêtrière at the same time as Freud. It seemed to Nordau that he was surrounded by symptoms of general decline, seeing in the decadents, symbolists and mystics unmistakable symptoms of degeneracy. 'We stand now', he wrote ' in the midst of a severe mental epidemic, a sort of black death of degeneration and hysteria'. Nordau's pseudo-scientific, journalistic survey of the contemporary literary scene, interspersed with peevish broadsides against the chief exponents of modernism, was widely read: there are references to him in works as divergent as Bram Stoker's *Dracula* and Andrey Bely's *The Dramatic Symphony*. Although Nordau had first-hand experience of Paris (he commented on Verlaine's asymmetrical skull and 'Mongolian physiognomy', symptoms, apparently, of degeneration, as were Mallarmé's long, 'faun-like' ears) he also singled out Swinburne and the Pre-Raphaelites for scathing attack: imbecility, mysticism and incomprehensibility seemed to be rampant. Of interest here is Nordau's furious attack on Richard Wagner. 'Richard Wagner is in himself

11

alone charged with a greater abundance of degeneration than all the degenerates put together with whom we have hitherto become acquainted . . .' For Nordau the German composer was the paradigm of decadence, an artist both degenerate and harmful whose grandiose visions were but histrionic gestures poised above incandescent decay and which sprang from 'a pathological over-excitement of the genitals'. Seeing a link between decadence and Romanticism, this guardian of cultural standards and public morals could not refrain from condemning Wagner's art as a lurid and dying manifestations of that earlier efflorescence, with the composer himself representing 'the last fungoid growth on the dunghill of Romanticism'. But a much greater intellect had already launched his dazzling attack on the Master of Bayreuth, on the ageing and perfumed voluptuary of *Parsifal* above all, and *his* polemic lifts the discussion of decadence to a considerably higher level.

Friedrich Nietzsche, shortly before his mental collapse, felt compelled once again to come to terms with his erstwhile mentor and idol, that man who, for good or ill, had had the most profound effect upon his stricken life. In *Der Fall Wagner* (1888) Nietzsche sought to single out those cultural manifestations of his age which he considered to be diseased – and Wagner is their paradigm. 'Wagner's art is sick. The problems that he deals with on the stage – they are without exception the problems of hysteria. The convulsive nature of his emotions, his overheated sensibility, his taste which demands ever stronger stimuli, his instability, which he raises to the status of a principle, and last but not least his choice of heroes and heroines, if you look at them as physiological specimens (a gallery of degenerates!) – all of this provides a case-history that leaves no doubt: *Wagner est une névrose.*' He continues: 'Yes, if you look at it closely, Wagner doesn't seem to be interested in any other problems than those that interest the little Parisian décadents today. Just a few steps away from the hospital!' Unaware of the existence of the *Revue Wagnérienne* and knowing of the 'little Parisian décadents' only by

hearsay, Nietzsche nevertheless sensed the peculiar affinity which existed between the German musician and the new literary tendency in France; the expression 'névrose', a possible borrowing from Paul Bourget, is an appropriate one. The thinker who suffered most under Wagner, who felt intense relief at the latter's death in 1883 but who was drawn time and time again to re-define his own intellectual position vis à vis the Master (and Thomas Mann goes as far as to claim that Nietzsche's polemic against Wagner was the most important aspect of his entire work) – this man knew that Wagner's grandiloquence and imperiousness concealed fascinating uncertainties, vagaries, even perversions; it was the French capital which, interestingly enough, received his dubious and prodigious offering most readily.

The 'last fungoid growth on the dunghill of Romanticism'? A 'neurosis'? Thomas Mann, like Nietzsche, never failed to be enthralled by Wagner and the composer's presence may be found in the earlier stories, the great essays, the later novels, in countless letters and diary entries; it is also Thomas Mann who openly insisted that he, Mann, was a 'chronicler and analyst of decadence, a lover of the pathological and of death, an aesthete with a tendency towards the abyss . . .' That sickly connoisseurship of sensation which Nietzsche had detected in Wagner, as well as the brutality of many of his effects, provided Mann with many an insight into the nature of decadence. The proximity of love and death in *Tristan und Isolde* (prefiguring Freud's writing on Eros and Thanotos by decades), the glorification of incest in *Die Walküre*, the heady fusion of sexuality and religion in *Parsifal* (the holy grail and gaping wound, the omnipresence of blood, the spear and chalice, flower maidens, castration and incense) – appropriate indeed that Wagner should be High Priest of an age characterised by a guilt-ridden eroticism, a morbid inflation of the ego and the cultivation of recondite worlds. Did we ever, Thomas Mann was later to muse, truly 'overcome' decadence? – or did we simply play with the idea that it was to be superseded? As a young writer he was able to

observe closely the bohemian atmosphere of Munich, that city where Stefan George reigned as hierophant and *Grand Maître* in matters relating to poetry (his *Algabal* poems, dedicated to King Ludwig the Second, continued the 'Heliogabalic' cult of beauty, cruelty and degeneracy which was adumbrated by Gautier in the famous preface to *Mademoiselle de Maupin* and referred to by des Esseintes in *A rebours*, that bible of French *décadence*). Munich was the city of Richard Wagner and that king who worshipped him and escaped finally into death by drowning: Nordeau would make mocking references to the 'madman' who, appropriately, 'marched at the head of the Wagnerites'. There will be much of Wagner in Thomas Mann's *Der Tod in Venedig* (*Death in Venice*), also of George and the cult of male beauty: Aschenbach moves from Munich to that city where Wagner had composed much of *Tristan* and where he was to die. Other Thomas Mann stories with a Munich setting include *Beim Propheten* (*At the Prophet's*) where the narrator describes a visit to an attic to listen to the overheated perorations of a manic visionary, and *Gladius Dei*, a delightful portrayal of Munich as a city of art which an overwrought and censorious student condemns for its frivolity and wickedness.

What, then, is 'decadent' about Mann's early writing? An aestheticism which renders its practitioners incapable of warm, human feeling, a heightened sensitivity, a paralysing glimpse into the heart of things, the cultivation of a blasé and ultra refined lassitude – and above all an exposure to Wagner, with frequently fatal consequences. The short story *Tristan* portrays a sanatorium where Gabriele Klöterjahn and her unlovely suitor swoon in an illicit enjoyment of the 'Liebestod'; the novel *Buddenbrooks* describes the nervous exhaustion and collapse of Hanno who surrenders to that same opera (the naturalistic descriptions of typhoid fever do not blind the reader to the inference that it was the Wagner delirium which drew a willing victim to his dissolution). But the finest example of decadence in Thomas Mann is the story *Wälsungenblut* (*The Blood of the Wälsungs*)

14

of 1906. In Thomas Mann's own words it is 'the story of two pampered creatures, Jewish twins from an over-refined Berlin-West milieu who take the primeval incestuous relationship of Wagner's Wälsungen-twins as a model for their own sense of luxurious and mocking aloofness.' Spoilt and cosseted, Siegmund Aarenhold leads a life of sterile boredom: his days pass in emptiness and narcissistic self-reflection. With his twin sister Sieglinde he has an equal partner in elegant and arrogant refinement, and her fiancé, the hapless von Beckerath, is their equal neither in sartorial nor in intellectual matters. It is he who is the blundering Hunding-figure, and it is inevitable that the twins, without him, should be driven to the opera to see *Die Walküre*. Haughty and blasé in their box they watch the performance and cannot refrain, amidst the consumption of Maraschino cherries, from ironic and condescending remarks on both singers and orchestra. Enthusiasm of any kind is alien to their sense of snobbish superiority, but Siegmund particularly feels the powerful surging momentum of Wagner's work, and the passionate turmoil of the music excites him, causing doubts and an unsettling perturbation. As Wagner's twins had defied Hunding and passed through ecstasy and tribulation, so Siegmund Aarenhold, nervously agitated despite his cool exterior, sinks with his sister on to the rug in stammering confusion: the Wagner parallels are obvious. But whereas Wagner created out of passionate inspiration it is Siegmund Aarenhold's tragedy that what was probably his first spontaneous act should be one of narcissism and perversion, born of defiance and vindictiveness (the cuckolding of the 'goy' von Beckerath). It is only Wagner who can stimulate powerful responses in Siegmund, responses which, however, result in an act of crude desecration.

Thomas Mann was closely associated with writers like Kurt Martens and Arthur Holitscher (the latter providing a model for the degenerate aesthete Detlev Spinell in *Tristan*). Martens made his reputation in 1898 with the novel *Roman aus der Décadence* (*A Novel from the Age of Decadence*), a title which Thomas Mann had wanted as a subtitle for his own

novel *Buddenbrooks*. The novel is set in Leipzig in the years 1896–7 and attempts to capture the fin-de-siècle atmosphere prevalent amongst the intellectuals of that city. The hero, Just, is characterised by an enervating lassitude: his erotic entanglements with Alice, the wealthy daughter of an industrialist, drift into paralysis (he fills his room with wilting foliage and hopes, in vain, for stimulation). His attempts to transform a beggar girl into an Amaryllis, a Salome (Wilde and Gustav Moreau are cited), or a great criminal (des Esseintes had prepared the way) get nowhere. Just has read the obligatory Scandinavian literature (Jonas Lie), and Martens's autobiography also tells of the influence of Arne Garborg (*Tired Souls*). The decadent climax of the novel is the so-called 'Festival of Death': Just's friend Erich von Lüttwitz, having inherited a fortune, decorates his villa in the latest art nouveau style and invites his colleagues to an orgy, the culmination of which is to be his death. Both von Lüttwitz's escapades and Just's exhaustion seem symptoms of some deep malaise; it is no coincidence that the latter – as a good decadent should – seeks refuge in the Catholic Church.

Holitscher's *Der vergiftete Brunnen* (*The Poisoned Well*) (1900) tells of another villa, owned by one Désirée Wilmoth (née Wulp) where dubious and extravagant fantasies are enacted. Désirée, widow of the wealthy Scot McAllinster whom she had met in Monte Carlo, forms a liaison with the young genius Wilmoth (Melmoth?) who dies in mysterious circumstances. After extensive travels she settles in Munich where a host of *literati* dance attendance: the young poet Sebastian Sasse, from Transylvania, falls under her spell. Désirée is a femme fatale with copper-coloured hair, a deathly pallor and blood-red lips, not far removed from that vision of a sphinx-like creature described by Holitscher thus: 'She was naked to the hips, sitting rigid and upright in a black armchair in the middle of the room. Her hair was red and, parted in the middle, fell over her shoulders and across the back of the chair ... Her eyes were of pale turquoise and of a deceptive gleam, her lips

were cut of dark-violet amethysts. Her nipples, erectile, were of large rubies; a diamond sparkled in her navel.' Désirée's dancing is reminiscent of that of Loïe Fuller: images of fire abound. The presence of Wagner is paramount in the bacchanal that Désirée performs to seduce the hapless poet; the Venusberg music from *Tannhäuser* is meant to overwhelm him, as are lascivious eurhythmics. The performance takes place in an enormous conservatory, choked with rank vegetation. Sasse escapes and flees to Belgium, to a town which is obviously Bruges, where he writes his novel (Bruges, together with Venice, being the decadent town par excellence, indebted above all to Rodenbach's *Bruges la morte* with its descriptions of swans, brackish water and dark courtyards). He returns, healed, to Munich: he has drunk of the 'poisoned well' of life, and survives. Holitscher's story *Von der Wollust und dem Tode* (*Of Lust and Death*) (Munich, 1902) does not end on such a conciliatory note, however, in its portrayal of a grotesque 'Liebestod'. The hero can only find sexual release in death, silently cutting his wrists and sinking dead upon his beloved during a rendez-vous.

Munich had been the city in which Désirée Wilmoth's villa stood, as had Aschenbach's residence and the attic of the prophet who, in Thomas Mann's story, had exulted in visions of blood and violence where millennia of human domesticity were to be expunged in a new apocalypse. If decadence also revels in perverse cruelty then Hanns Heinz Ewers may also be included. Ewers was also associated with Munich; he had appeared in cabaret there where his grotesquely satirical humour had been exploited to the full. His first literary success were the two selections of bizarre stories *Das Grauen* (*Horror*) (1907) and *Die Bessessenen* (*The Possessed*) (1908); the novel *Der Zauberlehrling oder die Teufelsjäger* (*The Sorcerer's Apprentice or the Devil's Huntsmen*) (1909) shocked by its horrifyingly orgiastic scene in which a pregnant girl is crucified and her unborn child transfixed by a pitchfork. The second novel *Alraune. Die Geschichte eines lebenden Wesens* (*Mandrake. The Story of a Living*

Creature) (1911) was immensely popular (a girl is born from the seed of an ejaculating victim of an executioner which is implanted in a prostitute named Alma Raune – the pun is untranslatable – in a nearby hospital): it reached sales of over a quarter of a million in ten years and was filmed twice, the 1928 version being provided by Henrik Galeen (who also wrote the film script for Murnau's vampire masterpiece *Nosferatu*). *Vampire* appeared in 1920; *Nachtmahr* (Nightmare), another collection of horror stories, followed in 1922. Ewers considered himself to be the herald of a new fantastic satanist movement that looked back to Poe and de Sade: the stories contain portrayals of stock-in-trade horror (spider women) and various forms of commercial nastiness. *Der Fundvogel* (1928) is a sensational account of an enforced sex change. Ewers was ready and eager to serve the Nazi cause; in 1932 he published an account of the escapades of the *Freikorps* and then, probably on Hitler's recommendation, the biography of the pimp and martyr Horst Wessel, *Ein deutsches Schicksal* (*A German Destiny*) (1934). His earlier writing, not surprisingly, was found to be incompatible with the promulgation of rude Nordic health and Ewers was pronounced degenerate ('entartet'). But fascism is fed by some very questionable nourishment; the links between sadomasochism and fascism are natural ones and the eroticization of that movement of which Susan Sontag has written (*Fascinating Fascism*, 1974) shows that Ewers, for all his degeneracy, may not have been such a unusual precursor after all.

Sadism . . . masochism – any account of what decadence was, must needs deal with these terms. The writers of French decadence, as Mario Praz has told us, were well aware of the 'divine Marquis', and cruelty and perversion abound in Huysmans, Octave Mirbeau, Jean Lorrain and others. Our concern here is with Leopold Sacher-Masoch whose relationship with decadence is oblique but whose name, thanks primarily to Richard von Krafft-Ebing, is redolent of an eccentric and perverse sexuality. This Ruthenian writer published his best known novel *Venus im Pelz*

(*Venus in Furs*) in 1869, some fifteen years, that is, before *A rebours* : it was meant to be part of a cycle known as *Das Vermächtnis Kains* (*The Legacy of Cain*). The brutality of de Sade is rarely found in Sacher-Masoch, who prefers the fetish, the artificial and the blurring of the human and the image, the statuesque and the atmospheric: the shrill confrontation of light and darkness in de Sade's castles gives way to hotels, sanatoria and heavy curtains where Venus-Wanda holds sway. Sacher-Masoch was fêted by the literary establishment when he visited Paris in 1886 and certain of his stories (including *Femmes slaves*) were published in 1889 and 1890 in *La revue des deux mondes*. Rachilde's *Monsieur Vénus*, a novel which, on its appearance in Brussels in 1884, was greeted by a fine of two thousand francs and a two year prison sentence, owes much to Sacher-Masoch (the heroine, Raoule, delights in humiliating Jacques, her ostensible lover: after his death she transforms him into a wax doll in which his hair, nails, eyelashes and teeth have been implanted). Sacher-Masoch is in the curious situation of having his work virtually ignored whilst his name became universally known and vulgarised. There is no reference in German decadent literature to his work; a later echo, however, is found in Franz Kafka, particularly in his masterpiece *Die Verwandlung* (*The Metamorphosis*), with its picture of a lady in fur, the name 'Gregor' and numerous punishment fantasies. Kafka's fearful machine (*In der Strafkolonie* (*The Penal Colony*)) may also have its precursor im Sacher-Masoch's *Jungbrunnen* (*The Fountain of Youth*), whose heroine uses an 'iron virgin' to torture her lovers. The tension between debility, power and desire was one which Kafka well understood.

In 1874 Sacher-Masoch published a somewhat titillating account of the depravities and perversions of Viennese aristocratic ladies in *Die Messalinen Wiens*. It was in Vienna that Hermann Bahr, as we know, analysed the new direction in the arts: his novel *Die gute Schule* exulted in portrayals of accidie and excess. Bahr emphasised the role played by 'nerves' in French decadent literature (Paul Bour-

get); 'neurasthenia' seemed to be a common disorder, a modern epidemic. It was Hofmannsthal who formulated the Wildean statement 'To be modern means to like antique furniture – and youthful neuroses'. A cult of the 'soul' is adumbrated, also the cult of the artist-figure whose nerves are so finely tuned that he can pick up private sensations and transmute them into art. Aestheticism, the conscious refinement of the senses (and also of the personality itself) is very much in evidence. But whether this necessarily can be equated with decadence is another matter; impressionism would seem to be a more appropriate label for this narcissistic introspection, these exquisite rêveries. A writer like Felix Dörmann strove to love 'all things abnormal and sick', but the pose is unconvincing.

What, then, was specifically decadent about the Vienna of this time? Certain aspects of the painting of Klimt (*Judith*), Bahr's sensational novel, Mahler's morbidity and fascination with death and transience (despite the desperate attempts at life-affirmation), the obsession with sexuality in its stranger forms and an awareness of sterile refinements. Was it a city of neuroses? It was a world analysed by Sigmund Freud and observed with detachment by Freud's *Doppelgänger* Arthur Schnitzler whose work frequently reflects a world of repression, sexual tension and guilt. But Schnitzler's self-deprecating irony and gentle scepticism preclude any attempt to label him as 'decadent'. (The famous *Traumnovelle* certainly dabbles with the accoutrements of decadence – black silk, naked nuns, crucifixion – but the dreams and visions are not simply there to give a *frisson*; they represent the working out of a married couple's repressed feelings of guilt.) There is no preoccupation with degeneration in Schnitzler, albeit mental illness is frequently encountered in his writing; there is a humour which is sadly lacking in the purveyors of the *outré* and the abnormal. Schnitzler recorded the poses of the coffee-house *literati* with wry amusement: he did not castigate them as did the satirist Karl Kraus. Worthy of mention is the Salzburg writer Georg Trakl who lived sporadically in

Vienna and Innsbruck before enlisting in 1914 and dying by his own hand in a psychiatric hospital in Cracow later that year. Trakl was much indebted to the French in his early poetry, and the prose narrative *Verlassenheit* (*Desolation*) with its portrayal of the Count who silently awaits his own dissolution brings Roderick Usher forcibly to mind, Poe filtered, as it were, through Mallarmé. Usher's passive assent to his own decline and his bizarre relationship with his sister fascinated many of the artists of fin de siècle France (Debussy had made sketches for an opera on their story): the minute yet ubiquitous fungus that covers the whole of the house in *Usher* and the evil water of the adjacent lake are also found in Trakl's obsession with putrefaction. The overwrought, over-ripe passages in Trakl, the poisoned plants, sultry Catholicism and, above all, the theme of incest – the decadent sin par excellence, sweet and accursed – put Trakl very much within the decadent camp, as does the sadomasochism of *Blaubart*. But Trakl did not remain a Felix Dörmann; the prurience of decadence and the effulgence of symbolism are transcended in the last utterances, which point to a mystical Expressionism.

Trakl briefly visited Berlin in 1913, visiting that sister to whom he was bound by an incestuous relationship and whose miscarriage (or abortion) finds an oblique reference in his poetry; he made few contacts in the city, one exception being the Expressionist poetess Else Lasker-Schüler. She would later become closely associated with Expressionism, marrying Georg Lewin in 1901 and renaming him Herwarth Walden, but she was also aware of fin de siècle preoccupations and delighted in neo-romantic exoticism: Peter Hille, arch-Bohemian and vagabond, called her 'the dark swan of Israel, a Sappho whose world has disintegrated.' Hille collapsed on a Berlin railway station and died in a nearby hospital in 1904. The 'novellette' *Herodias* is a genuflection towards the Salome topos which had always haunted the decadent imagination, from Gustave Moreau to Oscar Wilde – and Oskar Panizza who depicted her as the Devil's consort and the mother of all-

conquering syphilis. The *femme fatale* Herodias – the name given to Salome by the Fathers of the Church who confused her with her mother – dances and triumphs, but there is no joy in this voluptuous evil, and she longs for some transcendent blessing from this prophet whom she has had beheaded. Trakl's early sketches *Barrabas* and *Maria Magdalena* share the predilection for oriental barbarism (Hille had also attempted a *Cleopatra* and a *Semiramis*): cruelty and exotic religiosity are very much part of the decadent stock in trade. Another poet associated with Berlin is Georg Heym, drowned in a skating accident in the Wannsee in January 1912. Heym is acknowledged to be one of the most talented among the early Expressionist poets but is represented here by *Die Sektion* (*The Autopsy*), a remarkable piece of poetic prose which finds beauty in viscera and faeces and a mystical rapture in the laceration and surgical dismemberment of flesh. Heym, a great admirer of Baudelaire (that poet who, as was mentioned, had accepted and embraced the epithet 'decadent') may have been drawn by his reading of the French poet to Edgar Allan Poe, particularly *The Colloquy of Monos and Una* and its memorable lines 'I appreciated the direful change now in operation upon the flesh, and, as the dreamer is sometimes aware of the bodily presence of the one who leans over him, so, sweet Una, I still duly felt that you slept by my side': the dead man's mind is still filled with the dream of love. It has been claimed that *The Autopsy* somehow parodies the morbid aesthetic cult of death at the turn of the century; Heym's tour de force is more probably an extension of diary entries (June 1908) where Heym identified himself with the first dead person he ever saw, imagining that he himself were dead, his head still filled with what he called his 'year of love" for Hedi Weißenfels with whom he associated red poppies. Heym's horrified fascination with death reverberated throughout his whole work, and *The Autopsy* is a brilliant evocation of the repugnant and the poetic.

It is obviously erroneous to think of Berlin simply as the

city of Naturalism and, later, Expressionism: writers like Hille and Scheerbart (an eccentric precursor of Dadaism who died an alcoholic in 1915) exemplify quite different attitudes. And in the work of Stanislaus Przybyszewski we find what is probably the most extreme form of writing in which decadent themes, plus a lurid satanism, excel even the practitioners of Paris. In the 1890s there stood at the corner of Unter den Linden and the Wilhelmstrasse a wine-bar advertised by a sign depicting a Bessarabian wine skin: August Strindberg renamed it 'Zum schwarzen Ferkel' ("The Black Pig") and it became a meeting place mainly for the Scandinavian artists of that city. Into this milieu came the German-speaking Pole Stanislaus Przybyszewski, arch-bohemian and self-styled satanist, together with the fascinating Dagny Juel, painted by Munch, married by Przybyszewski and later murdered in a hotel room in Tiflis. Przybyszewski had intended studying architecture but abandoned this and turned to psychology and medicine before devoting himself entirely to literature, settling in Friedrichshagen and mixing freely with the writers and artists who had settled in that suburb. The impression that Przybyszewski made was one of a febrile and demonic bohemian, obsessed with a tormented and lubricious sexuality. *Zur Psychologie des Individuums* concludes with a paean of praise to ecstasy, the rapture of sex and the acceptance of pain; in *De Profundis* the emphasis is upon the psychopath and on those whom society rejects as sick; *Totenmesse* (*Requiem Mass*) uses a stream-of-consciousness technique to convey the chaos of deranged speculation of some neurotic protagonist, a requiem for a dead woman which degenerates into self-indulgent laceration. In later life Przybyszewski, in a moment of exaltation, felt a perverse pride in that Peter Altenberg had claimed that he, Przybyszewski, was a murderer because Otto Weininger had committed suicide after reading *Totenmesse*; he would also announce that it had been his playing of Chopin which had inspired Richard Dehmel's cycle *Verwandlungen der Venus* (*The Metamorphoses of Venus*). Sexuality in its more aberrant

forms begins to predominate in Przybyszewski's writing. *Androgyne* is a short narrative in exalted prose which delights in the rhapsodic evocation of bizarre sexuality fused with mystical longing. It is a typically elaborate concoction, very reminiscent of Huysmans in the portrayal of a secret chamber encrusted with fantastic jewels where strange rites are enacted. Przybyszewski's lurid hyperbole, his mephistophelean appearance and cult of the abnormal were avidly rehearsed to project an unwholesome and diseased image; the emphasis on the rank, choking growths of his inner world, and the foul miasmas which rose from the depths of his psyche make this writer one of the most remarkable within the decadent canon.

We come finally to Prague, the famous Bohemian city which is always associated with Franz Kafka. But Kafka stood aloof from the eccentricities of young writers such as Paul Leppin, wishing (despite the echoes of Sacher-Masoch) to write an elegant and pellucid German without excrescences and convolutions. Prague is also the city of the Golem and the old Jewish cemetery, of dark corners, alleyways and courtyards shot through with legend and fantasy. Gustav Meyrink is its narrator and Alfred Kubin its illustrator, the former's novels and short stories being inextricably associated with supernatural horror. Meyrink certainly aimed for a *frisson* in his readers and a story such as *Die Pflanzen des Dr Cinderella* (*The Plants of Dr Cinderella*) (see the *Dedalus/Ariadne Book of Austrian Fantasy*) is particularly effective in its portrayal of the synthesis of human and vegetable (the pulsating plants, the bowls of whitish fatty substance where toadstools were growing). But the writing of Paul Leppin is closest to what may be called decadence: *Severins Gang in die Finsternis* (*Severin's Journey into Darkness*) (1914) is a portrayal of listlessness, artifice, a prurient dallying with thought of murder and destruction and a final collapse into impotence and resignation. Leppin gives us the full range of decadent types – the neurotic Severin, the nihilistic Nathan Meyer, the aesthete Doktor Konrad, the hedonist Nikolaus and Lazarus Kain, addicted to pornog-

24

raphy. *Blaugast* (published 1948) is a portrayal of degeneration not dissimilar to Heinrich Mann's *Professor Unrat* (known to English readers as *The Blue Angel*): the hero slithers to the lowest depths of society and finally ends up exposing himself in a park; he also earns money in bars by imitating animal noises and delighting the drunks of both sexes by masturbating. Leppin is very much of his time in his descriptions of boredom, futility and *accidie* which are only relieved by thoughts of violence and lurid sensationalism. Max Brod, friend of Kafka and close observer of the literary scene in Prague in the early years of this century had contributed (in his *Schloss Nornepygge* (1908)) to the portrayal of aestheticism and violence (the hero's involvement in anarchy, the orgies in the castle and the ball in the open-cast mine where the resentment of the proletariat is meant to heighten the pleasure of the participants). The cult of violence in decadence, when linked to the antics of the Futurists, would produce an atmosphere of instability both fascinating and disturbing.

To be decadent, then, meant to draw sweet, morbid sensations from the contemplation of dissolution, to prefer the artificial and the unnatural, to tend towards a sterile aestheticism, to flirt with cruelty in an attempt to rouse a flicker of interest, to dabble in febrile mysticism or in immorality with deliberately satanic overtones. There is much of the *poète maudit* about its practitioners, much of the young man's defiance and extravagance, an exhibitionism which prefers the poisoned tinctures to more wholesome fare. But a drop of poison, we are told, can improve the health of an organism, just as an exotic spicing can improve the taste of the blandest offering: Munich and Vienna, Berlin and Prague provided much that was unsettling. And the livid phosphorescence of decadence can still be enjoyed in these later, more rebarbative times.

Sacher-Masoch: *Venus in Furs*

In the middle of the night there was a knock at my window. I got up, opened it and started back – it was Venus in Furs, just as she had first appeared before me.

'Your stories have excited me, I've been tossing and turning and can't get to sleep' she said. 'Come and keep me company.'

'Wait a moment.'

When I entered her room I saw Wanda crouching before the hearth; a small fire was burning.

'Autumn is coming' she announced, 'the nights are already quite cool. I don't wish to displease you but I can't take off these furs until the room is warm enough.'

'Displease me! You minx! You know perfectly well –' I put my arms around her and kissed her.

'Of course I know it – but how did you get this obsession with fur?'

'I was born with it,' I replied. 'I've had it since childhood. As a matter of fact, fur has an unsettling effect on all overwrought individuals, and this is caused by universal, natural laws. It's a physical effect, at least it's strangely tingling, and nobody can quite resist it. Science has recently discovered a certain affinity between heat and electricity – at least they have a similar effect upon the human organism. The earth's torrid zones produce people who are more passionate, and a warm atmosphere produces excitement. It is the same with electricity. That's why we get the bewitchingly beneficial influence that cats make upon excitable, intellectual individuals, and that's what makes these long-tailed darlings of the animal world, these graceful iridescent electric batteries, the favourites of people such as Mahomet, Cardinal Richelieu, Crebillon, Rousseau and Wieland.'

'So,' Wanda cried, 'a woman in furs is nothing more than a large cat, a charged electric battery?'

'Of course,' I replied, 'and this is how I explain the symbolic power that fur has gained as an attribute of power and beauty. Kings looked to fur for this in earlier times; a ruling aristocracy insisted on fur in their sartorial requirements, as did great painters when they portrayed the queens of beauty. For the divine form of his Fornarina Raphael could find no more precious frame than dark fur, as could Titian when he painted the rosy flesh of his mistress.'

'I am most grateful for this learned erotic disquisition,' Wanda said, 'but you haven't told me everything. You associate fur with something quite distinctive.'

'Certainly,' I cried. 'I keep telling you that I find a strange excitement in pain, that nothing can whip up my passions more than tyranny and cruelty, especially the perfidy of a beautiful woman. And I can only conceive of this woman, this strange ideal from the aesthetics of baseness, this soul of a Nero in the body of a Phryne, as being draped in furs.'

'I know,' Wanda interceded 'it gives a woman something imperious, impressive.'

'It isn't only that,' I continued. 'You know that I am a *supersensory* being, that for me everything is rooted in the imagination and draws it nourishment from this source. I was a precocious child and extremely excitable, and when I was about ten years old I came across a book on the legends of the martyrs. I can remember the mixture of horror and ecstasy with which I read how they rotted in prisons, were laid upon the grill, were transfixed with arrows, boiled in oil, thrown to wild animals, were crucified and suffered the most appalling agonies with a kind of joy. From that time onwards I regarded suffering and torment as a kind of pleasure, and it had to be a torment imposed by a beautiful woman, because for me everything poetic, everything demonic, is concentrated in woman. I made a cult of this.

In sensuality I saw something holy, indeed, *only* holiness; I saw something divine in woman and her beauty because

life's most important goal – reproduction – is her prime task. I saw in woman the personification of nature, of *Isis*, and man was her priest, her slave; she confronted him as cruel as nature which thrusts away that which has served her as soon as she no longer needs it – whilst for him mistreatment, even death *through her* is the most voluptuous bliss.

I envied King Gunter who was tied up by the powerful Brunhilde on their wedding night; I envied the poor minstrel who was sewn up into a wolf's skin by his moody mistress who then hunted him like a wild animal; I envied the Knight Ctirad whom the bold amazon Scharka captured through cunning in a forest near Prague: she dragged him to her castle at Divin and, after she had toyed with him for a while she bound him on the wheel and –'

'Monstrous!' Wanda cried. 'I could wish that you had fallen into the hands of such a wild woman, sewn into your wolf-skin, and, I tell you, you would soon forget your poetry beneath the teeth of her wild dogs, or on the wheel.'

'Do you think so? I don't.'

'I don't think you're being particularly clever.'

'Perhaps not. But listen: from that time onwards I used to read insatiably stories which portrayed the most dreadful cruelties, and I especially liked to look at pictures or prints where these were portrayed – all the bloodiest tyrants who ever sat on a throne, the inquisitors who tortured heretics by roasting or beheading, all those women who have gone down in history as voluptuous, beautiful and violent, like Libussa, Lucrezia Borgia, Anne of Hungary, Queen Margot, Isabeau, the Sultana Roxalane, the Russian tsarinas of the last century – and I saw them all in furs or robes lined with ermine.'

'And so this fur is beginning to inspire your extraordinary imagination,' Wanda cried, and began to drape herself coquettishly with her fur coat so that the darkly gleaming sable played charmingly about her arms and breasts. 'Now – how do you feel about this? Are you on the rack already?'

Her green piercing eyes were fixed on me with a strange, scornful ease; overwhelmed by passion I threw myself before her and flung my arms around her.

'Yes . . . you have aroused in me my favourite fantasies, longings which have lain dormant for years.'

'And what are these?' she asked, placing her hand upon my neck.

I was seized, beneath this little warm hand, beneath her gaze which questioned, beneath those half closed lids, with a sweet intoxication.

'*To be the slave of a woman, a beautiful woman, one whom I love and worship!*'

'And one who ill-treats you for it!' Wanda interrupted me, laughing.

'Yes, one who binds me and whips me, one who kicks me whilst belonging to another.'

'And one who, when you are insane with jealousy, will go to your happy rival and go so far as to present you to him and give you over to his crudeness, his brutality. Why not? Do you like my final picture?'

I looked at Wanda, terrified.

'It exceeds my wildest dreams!'

'Yes, we women are resourceful' she said. 'Be careful when you have found your ideal, as it can easily happen that she will treat you more cruelly than is good for you.'

'I fear that I have found my ideal already!' I cried, and pressed my glowing face into her lap.

'But you don't mean me, do you?' Wanda cried, throwing off her furs and dancing about the room. She was still laughing as I went downstairs, and when I was standing in the courtyard, deep in thought, I could hear that wilful, malicious laughter still.

* * * *

'Am I really to incorporate your ideal?' Wanda asked roguishly when we met in the park.

I could not answer at first. The most contrary of sensations raged within me. She had sat down upon a stone bench and was playing with a flower.

'Well . . . am I?'

I knelt and seized her hands.

'I beg you once more – be my wife, my faithful, honourable wife; if you cannot do this, then be my ideal, but completely without reservation, without mitigation.'

'You know that I will give you my hand after a year if you are the man I am looking for,' said Wanda, very seriously. 'But I think you would be more grateful to me if I were to realise your fantasies. So, which do you prefer?'

'I think that everything in my imagination lies in your nature.'

'You are wrong.'

'I think,' I continued 'that it gives you pleasure to have a man completely in your power, to torment him –.'

'No, no!' she cried, agitated. 'And yet . . .' She paused. 'I don't understand myself any more. I must make a confession to you. You have corrupted my imagination and heated my blood, I'm now starting to find pleasure in it all . . . The animation with which you've been speaking about Mme de Pompadour, about Catherine the Second and all the other frivolous, cruel, self-indulgent women has captivated me, overwhelmed me and makes me want to be like these women who were slavishly idolised throughout their lives and would perform miracles, even in the grave. And now you've made me a miniature despot, a Mme de Pompadour for domestic use.'

'Well,' I said, excited, 'if that's what you're capable of, then give in to it, let nature take its course, but don't be half-hearted about it: if you can't be a good, faithful wife, then be a devil!'

I was excitable, overwrought, and the nearness of this beautiful woman made me feverish. I don't remember what I was talking about, I only remember kissing her feet – and then I picked up one of them and placed it on my neck. But she swiftly and angrily drew it back, and rose to her feet. 'If you love me, Severin,' she said quickly, and her voice sounded sharp, peremptory – 'if you love me, then do not speak of such things again. Do you understand me? Never. Or I might –' She smiled and sat down again.

'I am absolutely serious,' I cried, almost hallucinating. 'I adore you so much that I would suffer everything at you hands for the sake of spending my whole life at your side.'

'Severin, I warn you once more.'

'Your warning is in vain. Do whatever you want with me, but don't push me away completely.'

'Severin,' Wanda replied. 'I am a frivolous young woman and it's dangerous for you to give yourself to me completely. You will finally become my plaything and who would protect you if I abuse your insane ideas?'

'Your nobility would.'

'Power makes us arrogant.'

'Be arrogant, then!' I cried, 'Kick me!'

Wanda folded her arms above my neck, gazed into my eyes and shook her head. 'I fear I may not be able to do it, but I'll try, for your sake, for I love you Severin more than I have ever loved a man before.'

* * * *

Today she suddenly took up her hat and scarf and bade me follow her to the market. She inspected a selection of whips, long whips on a short handle, used in dog training.

'These should do,' said the vendor.

'No, they're much too small,' said Wanda, casting a sideways glance in my direction. 'I need a big one.'

'Perhaps for a bulldog?'

'Yes,' she said, 'the sort they have in Russia for recalcitrant slaves.'

She looked at what was on offer and finally chose a whip which made me feel rather uncomfortable.

'Well, adieu Severin,' she said, 'I've got to make certain purchases where you may not accompany me.'

I took my leave and went for a walk; on the way back I saw Wands coming out of a furrier's shop. She called me to her.

'Consider this,' she said contentedly. 'I've never made a secret out of the fact that it was your deep, contemplative nature that captivated me so; it now appeals to me to see this earnest suitor completely in my power, writhing in

31

ecstasy at my feet, but how long will this last? A woman loves a man; she ill-treats her slave and finally kicks him away with her foot.'

'Well, kick me away with you foot when you have tired of me,' I responded. 'I want to be your slave.'

'I see that there are dangerous tendencies within me,' said Wanda after we had walked a few paces. 'You have awakened them, and it will not be to your advantage. You understand how to awaken hedonism and cruelty; you portray pride in such glowing colours ... What would you say if I embarked on this and if I started on you, like Dionys who roasted the inventor of the Iron Ox in his own creation to find out whether his roaring and his death-rattle really did sound like the lowing of an ox. Perhaps I'm a female Dionys?'

'Be it so!' I cried. 'Then my imaginings will have come true! I belong to you, for good or ill – you must chose. The destiny within my breast drives me onwards, demon-like, over-powering ...'

*　*　*　*

'My dear Severin,
 I do not wish to see you today, nor tomorrow, and only in the evening of the day after that – and then *as my slave*.
<div align="right">Your mistress,
Wanda.'</div>

'As my slave,' was underlined. I read the note again (it had come early in the morning), I had a donkey saddled and rode into the mountains in order to still my passion, my longing, in the splendours of the Carpathians.

Then I returned, hungry, tired, thirsty, and above all infatuated. I quickly got changed, and a few minutes later was knocking on her door.

'Enter!'

I went in. She was standing in the middle of the room, dressed in a white satin gown which flowed across her body like light, and a scarlet satin jacket with a rich trimming of ermine; in her powdered, snowy hair a small

diamond tiara was sparkling. Her arms were crossed upon her breast, her brows were knitted.

'Wanda!' I ran towards her, about to embrace her and kiss her, but she stepped backwards, and her glance measured me from head to foot.

'Slave!'

'Mistress!' I knelt and kissed the edge of her robe.

'That is correct.'

'How lovely you are!'

'Do I please you?' She walked up to the mirror and gazed at her reflection with haughty approval.

'I shall go mad!'

Her bottom lip twitched scornfully and she looked at me mockingly between half-closed eyes.

'Give me the whip.'

I looked about the room.

'No, remain kneeling.' She strode to the hearth, took the whip from the mantelpiece and let it whistle through the air, smiling at me. Then she slowly rolled back the sleeve of her fur jacket.

'Wondrous woman!' I cried.

'Silence, slave!' She suddenly glowered at me, wildly, and struck me with the whip: but in the next moment she had put her arm tenderly about my neck and bent down towards me, in pity. 'Did I hurt you?' she asked, half-ashamed, half-frightened.

'No!' I replied,' and even if you did, the pain that you give me is purest joy. Whip me if it gives you pleasure.'

'But it doesn't give me pleasure.'

And again that strange intoxication seized me.

'Whip me!' I begged. 'Whip me without mercy.'

Wanda cracked the whip and struck me a second time. 'Have you had enough?'

'No!'

'Are you serious? No?'

'Beat me, please, it gives me such pleasure.'

'Yes, because you know it isn't serious,' she replied, 'that I haven't the heart to hurt you. This whole crude game

offends me. If I were really a woman who beat her slaves, then you would be horrified!'

'No, Wanda,' I said, 'I love you more than I do myself, I am devoted to you, in life and death, you can do whatever you want with me, whatever your pride dictates.'

'Severin!'

'Kick me with your feet!' I cried and threw myself before her, my face close to the floor.

'I hate all these charades,' Wanda said impatiently.

'So, mistreat me in earnest.'

A sinister pause.

'Severin, I give you one last warning –'

'If you love me, be cruel to me,' I implored, lifting my eyes to her.

'If I love you?' she repeated. 'Very well!' She stepped back and gazed at me, smiling darkly. 'So be my slave, and know what it is to fall into the hands of a woman!' And at that moment she kicked me.

'How does that suit you, slave?' She swung the whip. 'Get up!'

I was about to rise. 'No,' she commanded. 'On to your knees!'

I obeyed, and she started whipping me.

The lashes fell, strong and swift, upon my back and my arms, each one cut, burning, into my flesh, but the pain ravished me and I felt an ecstasy that they had come from her, the one whom I adored and for whom I was ready to lose my life at any moment.

Now she stopped. 'I am beginning to find this agreeable,' she said, 'but it is enough for one day. I am seized by a devilish curiosity to see how far your strength will last, and by a cruel delight in seeing you tremble beneath my whip, hearing your cries, your groans, until you beg for mercy, and I whip you mercilessly until you lose your senses. You have awoken dangerous tendencies within me. Now get up.'

I seized her hand and tried to press my lips against it.

'What insolence!'

She kicked me away with her foot.

'Out of my sight, slave!'

[. . .]

It is evening. A pretty young maid orders me to appear before my Mistress. I climb up the wide marble steps, go through the vestibule – a large salon, decorated with sumptuous and lavish splendour – and knock at the door of the bedroom. I knock very gently, intimidated by the luxury that surrounds me, and she does not hear me, so I stand for a few minutes outside the door. It seemed as though I were standing before the bedchamber of the great Catherine, as though she would appear at any moment in a green fur négligée, a red medallion on her naked breasts and white, powdered ringlets.

I knocked again. Wanda opened the door impatiently.

'Why so late?' she asked.

'I was standing outside the door; you did not hear my knocking!' I replied timidly. She closed the door, took my arm, and led me to the red damask ottoman where she had been resting. The whole of the room was done out in red damask, the wallpaper, curtains and the four-poster bed, and on the ceiling was a splendid painting, Samson and Delilah.

Wanda received me in ravishing *déshabille* : the white satin robe floated lightly and picturesquely around her slim body, revealing her arms and breasts which nestled softly and casually in the dark fur of the large, green velvet jacket trimmed with sable. Her auburn hair, half loose, and held by strings of black pearls, fell down over her back to her hips.

'Venus in furs,' I whispered as she pulled me to her bosom and threatened to suffocate me with her kisses. Then I say no more, think no more as everything is drowning in a sea of inexpressible rapture . . .

Wanda finally pulled herself gently away and, leaning on one arm, looked at herself. I had sunk to her feet; she pulled me up and played with my hair.

'Do you still love me?' she asked, and her eyes were blurred in a sweet intoxication.

35

'How can you ask?' I cried.

'Do you remember your vow?' she continued, smiling sweetly. 'Now that everything is ready I ask you once again: do you really wish to be my slave?'

'Am I not your slave already?' I asked, astonished.

'You have not signed the documents yet.'

'Documents? What documents?'

'Ah! I see you're not interested in it,' she said. 'Let's forget it.'

'But Wanda,' I said, 'you know that there is no greater bliss for me than to serve you, to be your slave, and I would give everything to know that I was in your hands – even my life.'

'How handsome you are when you are excited, when you speak so passionately!' she murmured. 'I am in love with you more than ever before, and how can I be ruthless towards you, cruel and strict? I fear I won't be able to do it.'

'I am not worried about it,' I replied, smiling at her. 'Where are the documents then?'

'Here they are,' she said, pulling them half ashamedly from her bosom, and handing them to me.

'Now, in order that you should know that you're completely in my grasp I've also got a second document where you say that you've decided to take your own life. So I can kill you if I want to.'

'Give them here.'

As I was unfolding and reading the documents Wanda fetched a pen and some ink; she sat next to me, put her arm around my neck and looked over my shoulder. The first paper read as follows:

'Agreement between Frau Wanda von Dunajew and Herr Severin von Kusiemski. Today Herr Severin von Kusiemski ceases from this day forth to be the fiancé of Frau Wanda von Dunajew and renounces all rights and privileges; he swears on his oath and word of honour as a gentleman and a nobleman that he will henceforth be her *slave* for as long and until she gives him back his freedom.

As slave of Frau von Dunajew he has to bear the name of Gregor; he must carry out each of her wishes, obey every command and serve his mistress in abject servility; he must regard any token of her favour as a sign of extraordinary grace.

Frau von Dunajew is not only permitted to punish her slave as she thinks fit for the slightest inadvertence or oversight but she has the right to ill-treat him according to her moods, or as a diversion, just as she wishes; she may even kill him if she wishes. He is, in short, her property.

If Frau von Dunajew should free her slave by an act of manumission, so Herr Severin von Kusiemski must forget everything that he suffered as a slave and *never, under no circumstances, must he contemplate revenge or retribution.* On her part Frau von Dunajew promises, as his Mistress, to appear in furs as frequently as possible, particularly when she wishes to be cruel towards her slave.'

Today's date stood beneath the agreement. And the second document only contained a few words:

'Tired of life and of its disappointments I have voluntarily put an end to my worthless existence.'

I was seized with horror when I finished reading. There was still time, I could retract, but passion and its madness, the sight of the lovely woman, leaning at ease against my shoulder, carried me away.

'First of all you must copy this, Severin,' Wanda said, pointing to the second document. 'It must be written in your handwriting, but it doesn't matter about the agreement.'

I quickly copied the few lines in which I had signed my own death warrant and handed them over to Wanda. She read the paper and, smiling, placed it on the table.

'Now, have you got the courage to sign the agreement?' she asked, her head on one side and a faint smile on her lips.

I took the pen.

'Let me sign it first,' Wanda said. 'Your hand is trembling, are you frightened of so much happiness?'

She took the pen and the document. I gazed around,

distraught, and looked up at the paintings. It was then that I became aware of the unhistorical character of the painting on the ceiling, like other paintings of the Dutch and Italian schools, and this gave it a strange and, it seemed to me, weird aura. Delila was a voluptuous woman with flaming red hair; she was lying half undressed in a dark fur cloak on a red ottoman and was bending towards Samson with a smile on her lips. Samson had been flung down by the Philistines and was bound. The mocking coquetry of her smile was of a truly infernal cruelty; her eyes, half-closed, were gazing into Samson's whose last gaze hung on her with an almost demented love, and one of the enemy was already kneeling on his breast, about to plunge in the glowing iron.

'So,' cried Wanda, 'you're quite distracted, what's the matter? It'll be just as it was before, even after you've signed . . . Don't you know me yet, my sweet?'

I looked at the agreement. There was her name, in large, bold letters. I looked once more into her enchanting eyes, then seized the pen and quickly added my signature.

'You were trembling,' Wanda said quietly. 'Shall I guide the pen for you?'

She gently took my hand, and my name was on the second pierce of paper. Wanda looked once more at both documents, then locked them in the table which stood at the head of the ottoman.

'Now, give me your passport and your money.'

I took out my wallet and handed it to her: she looked in it, nodded and put it with the other papers whilst I knelt before her and let my head sink in sweet intoxication upon her breast.

She suddenly lashed out with her foot and kicked me from her; she jumped up and pulled the bell-rope, at which three young, slim negresses appeared, black as though carved from ebony, and wearing red satin. They approached, each one carrying a length of rope.

I suddenly realised what was happening, and tried to rise, but Wanda, rearing up and turning her cold, beautiful

38

face towards me, with darkening brows and scornful eyes, gestured imperiously to the three and before I knew what was happening they had thrown me to the ground and tied me up, my arms tied behind me like someone on his way to the executioner. I could scarcely move.

'Give me the whip, Haydée,' Wanda ordered with a sinister calm.

Kneeling, the negress handed it to her Mistress.

'And take off this heavy fur,' Wanda continued, 'it gets in the way.'

The negress obeyed.

'Give me the jacket.'

Haydée fetched the ermine trimmed jacket which was lying on the bed, and Wanda slipped into it with two incomparably charming movements.

'Tie him to that pillar.'

The negresses lifted me up, fixed a thick rope about my body and tied me, standing, to one of the massive pillars supporting the wide Italian bed. They then disappeared as though the earth had swallowed them.

Wanda quickly stepped up to me, her white satin robe flowing like a silver train, like moonlight, after her, and her hair gleaming like fire against the white fur of her jacket. She now stood before me, her left hand on her hip, her right holding the riding-crop, and she gave a short, sharp laugh.

'Now the game is over between us,' she said, and there was ice in her voice, 'now it is serious. You fool, I laugh at you, I despise you, you, who have become a plaything in a moment of blind infatuation, a plaything in the hands of an arrogant, capricious woman. You are no longer my lover, but my *slave*, given over to my arbitrary whims, and it's now a matter of life or death. You will get to know me now! And firstly you will in all seriousness get to know the whip, without ever having done anything, so that you will know what to expect the moment you are clumsy, disobedient or recalcitrant.'

With a wild gracefulness she rolled up the fur trimmed sleeve and whipped me across the back.

I shuddered: the whip cut like a knife into my flesh.

'Well, how did you like that?'

I remained silent.

'Just you wait, you will soon whimper like a dog beneath the lash!' she threatened, and began to whip.

The lashes fell thick and fast, with terrifying force, on to my back, my arms, my neck: I bit my teeth together in order not to cry aloud. And then she hit me in the face, the warm blood ran down me, but she only laughed and continued to wield the whip.

'Now I understand you' she was crying 'it is truly a great pleasure to have someone in your power like this, and especially the man who loves me – you still love me, don't you? Do you? I'll rip the flesh from you, I enjoy it more with every blow! So flinch, whine, whimper! You will find no mercy here!'

Finally she started to tire.

She threw the whip away, stretched herself out on the ottoman and rang the bell.

The negresses entered.

'Untie him.'

As they undid the rope I fell to the floor like a lump of wood. The black women laughed, showing their white teeth.

'Undo the bonds around his feet.'

This they did, and I was able to rise.

'Come to me, Gregor.'

I approached that beautiful woman who was never so seductive as that moment, in her cruelty and her scorn.

'One step closer,' Wanda ordered, 'kneel down and kiss my foot.'

She thrust her foot from under the white satin hem and I, like a transfigured fool, pressed my lips on it.

'You will not see me for a whole month, Gregor,' she said seriously. 'Then I shall become a stranger to you, and you will be able to adapt all the more easily to your new position. During this time you will work in the garden and await my orders. Now march, slave!'

[. . .]

Today she is going to a ball at the Greek embassy. Does she know that she will meet him there, this Greek noble-man, this Alexis Papadopolis?

She has certainly dressed as though she does. A heavy sea green dress of silk clings to her divine figure, leaving her arms and bust exposed: in her hair, done in one single gleaming knot, a white waterlily is gleaming, with green fronds linked with loose strands of hair falling upon her neck. There is no trace of excitement, nothing feverish or agitated, about her: she is calm, so calm that I feel my blood freeze and my heart grow cold beneath her gaze. Slowly, with majestic lassitude, she climbs the marble stairs, letting her precious wrap slip from her shoulder: with nonchalant ease she enters the ball-room, the silver mist of a hundred candles.

I stare at her, lost, for a moment, and then I pick up her furs which had sunk from my hands without my knowing it. It is still warm from her shoulders.

I kiss the spot, and tears fill my eyes.

There he is, her Greek.

In his black velvet coat, richly embroidered with dark sable, he is like a proud despot who plays with human lives and human souls. He is standing in the vestibule, gazing arrogantly around him, and he fixes me with a long, unsettling gaze.

Under this icy gaze I sense again that terrible, mortal fear, the suspicion that this man can captivate her, enchant her, subjugate her, and I feel a sense of shame vis-à-vis his wild virility, a sense of envy, of jealousy.

How pitiful to be the anxious, weakly intellectual! And the most shameful thing of all: I would like to hate him, but cannot. And how was it that he should pick on me – *me* – from amongst the crowd of servants?

He beckons me to him with an incomparably elegant movement of the head and, against my will, I obey him.

'Take off my fur,' he orders me, calmly.

My whole body trembles in fearful agitation, but I obey, humbly, like a slave.

* * * *

I wait all night in the vestibule, febrile and overwrought. Strange images haunt my imagination – I see them meet, I see the first, deep gaze – I see her drift through the room in his arms, lying on his breast intoxicated, with half-closed eyes – I see him in the sanctity of love, lying as a master on the ottoman, and she at his feet – I see myself kneeling before him, the tea-tray trembling in my hands – he seizes the whip . . . And now the servants are talking about him.

He is a man like a woman: he knows that he is beautiful and behaves accordingly. He changes his clothes, coquettishly, four or five times a day, like a courtesan.

In Paris he first appeared as a woman, and the men stormed him with love letters. An Italian singer – famed through his art, and also through his passion – succeeded in gaining entrance to his villa where he threw himself on his knees and threatened to kill himself if the Greek did not give 'herself' to him.

'I regret,' the latter said, smiling, 'that I cannot help you, so nothing remains but your death-sentence. I am, you see, a man . . .'

The ballroom has emptied, but she obviously has no intention of leaving yet.

Morning is already streaming through the shutters.

Finally I hear her rustling dress which flows like green billows behind her: she comes with him, in deep conversation.

I scarcely exist for her: she cannot even condescend to give me a command.

'Madame's wrap,' he orders me. Obviously he does not think of serving her himself.

He is standing with arms crossed next to her, as I settle the wrap around her shoulders. When I kneel to pull on her fur boots she supports herself lightly with her hand on his shoulder.

'What is the story of the lioness?' she asks.

The Greek explains. 'If the lion she has chosen, and with whom she lives, is attacked by another lion, well, she lies

42

down quietly and watches the fight. If her mate is defeated she doesn't help him but watches, indifferently, as he dies in his own blood beneath the victor's claws, and she follows the victor, the stronger one – that is woman's nature.

At this moment my lioness gave me a quick, strange glance.

I shuddered, I don't know why, and the red light of dawn bathed him, her and me in blood.

<center>* * * *</center>

She did not go to bed but simply slipped out of her ball gown and let down her hair: she told me to light the fire and sat at the hearth, staring into the flames.

'Do you have any further wishes, Mistress?' I asked, and almost choked at the last word.

Wanda shook her head.

I left the room, walked through the gallery and sat down on the steps which led down into the garden. A light northerly wind blew fresh moist air from the River Arno, the green hills stood in a rosy light and a golden vapour hovered over the town, over the cathedral's round cupola. A few stars still shimmered in the pale blue sky.

I tore open my coat and pressed my glowing forehead against the marble. Everything that had previously happened now seemed like a game – but now it was in deadly earnest. I sensed some sort of catastrophe: I saw her standing before me, I could seize her, but lacked the courage – my courage was broken. And if I am honest with myself, it wasn't the pain, the torment that could break over me, nor the ill-treatment that I could suffer, none of this frightened me.

I felt only one fear, the fear that I could lose the woman whom I loved fanatically; this fear is so powerful, so crushing that I suddenly began to sob like a child.

<center>* * * *</center>

She remained locked all day in her room, and only let the negress in to serve her. When the evening star was glowing in the azure aether I saw her walking in the garden; I

<center>43</center>

followed her carefully and saw her enter the temple of Venus. I crept after her and spied through a crack in the door.

She was standing before the noble image of the goddess, her hands folded as in prayer, and the holy light of the star of love cast its blue radiance over her.

* * * *

At night in bed the terror of losing her seized me with a violence that made me into a hero, a libertine. I lit the small red oil lamp that was hanging beneath a holy icon in the corridor and entered her bedroom, shielding the lamp with my hand.

The lioness had been hunted to exhaustion and was asleep in her pillows, on her back, with fists clenched; she was breathing heavily and seemed oppressed by some nightmare. I slowly raised my hand and let the full, red light fall on her wondrous countenance. But she did not wake.

I gently set the lamp on the floor and sank before Wanda's bed, resting my head upon her soft, glowing arm. She moved a little but also did not wake. I do not know how long I lay there, in the middle of the night, petrified in fearful torment. But then I was seized by a violent shuddering and wept: the tears flowed across her arm. She twitched a few times, then started up; she moved her hand across her eyes, and looked at me.

'Severin,' she cried, more in fear than in anger.

I found no answer.

'Severin,' she repeated quietly. 'What's the matter? Are you ill?'

Her voice sounded so full of sympathy, so good and tender that it seemed as though my heart were gripped with glowing pincers: I burst out in a loud sobbing.

'Severin!' she said again. 'You poor, unfortunate friend.' Her hand ran gently over my locks. 'I am sorry, very sorry for you, but I cannot help you; with all the will in the world I can find no cure for you.'

'Oh Wanda, must it be he?' I groaned in my pain.

'What, Severin? What are you talking about?'

'Do you no longer love me?' I continued. 'Have you no pity for me? Has that stranger, that handsome man torn you away from me?'

'I cannot deny,' she continued softly after a brief pause, 'that he has made an impression on me, he has done something to me that I cannot understand, which makes me suffer and tremble; he exerts an influence that I only found before in books or on the stage, and which I hitherto had only though existed in the imagination. Oh, he is a man like a lion, strong and handsome and proud, yet also gentle, not rough like the men of the North. I am sorry for you, believe me Severin, but I must possess him, or rather – what am I saying? I must give myself to him if he wishes.'

'Think of your honour, Wanda, which you have preserved so scrupulously,' I cried, 'if I in fact mean nothing to you.'

'I am thinking of it,' she replied. 'I shall be strong as long as I can. I want,' and here she buried her face, ashamed, in the pillows, 'to be his wife, if he wants me.'

'Wanda!' I screamed, overwhelmed once more by that deadly fear which robbed me of breath, of consciousness. 'You want to be his wife? You wish to belong to him for ever? Ah, do not reject me! He does not love you –'

'Who says so?' she cried, flaring up.

'He does not love you,' I continued hotly 'but I love you, I worship you, I am your slave, you can kick me, I shall carry you on me arms –'

'Who told you that he does not love me?' she interrupted, urgently.

'Be mine!' I implored, 'be mine! I cannot exist, cannot live without you. Have pity, Wanda, pity!'

She looked at me, and this time it was with that cold, heartless gaze, that malicious smile.

'You say he doesn't love me,' she said scornfully. 'Very well, let that be a comfort to you,' and she turned her back on me in contempt.

'My God, are you not a woman of flesh and blood, have

45

you no heart, as I do?' I cried, my heart convulsed in my breast.

'You know full well,' she replied spitefully, 'that I am a woman of stone. *Venus in Furs*, this is your ideal, kneel down and worship me!'

'Wanda!' I implored. 'Have pity!'

She started to laugh. I pressed my face into the cushions and let my tears flow freely, tears that assuaged my pain.

For a long time all was still, and then Wanda rose, slowly.

'You bore me.'

'Wanda!'

'I'm tired. Let me sleep.'

'Pity!' I begged. 'Have pity! Do not drive me away, there is no man who loves you as I do.'

'Leave me in peace,' and she turned her back on me.

I leapt to my feet and, seizing the dagger that was hanging by her bed, I placed it on my heart.

'I shall kill myself here before your very eyes,' I murmured darkly.

'Do as you please,' Wanda replied in complete indifference, 'but let me sleep.'

I stood there, petrified, for a moment, and then I began to laugh and cry aloud; I finally stuck the dagger in my belt and threw myself on my knees before her.

'Wanda, please listen to me, just for a few minutes.'

'I want to sleep, can't you understand?' she shouted angrily, leaping from the bed and kicking me from her. 'Have you forgotten that I am your Mistress?' And because I did not move from the spot she seized the whip and struck me. I got up, she struck me again, and this time in the face.

'Wretch! Slave!'

I suddenly pulled myself together and rushed from her bedroom, raising a clenched fist heavenwards. She flung the whip away and burst into a gay peal of laughter. I can well imagine how ludicrous this theatrical gesture made me look.

* * * *

I was determined to tear myself away from this cruel woman who had treated me so atrociously and who now was planning to betray me for all my slavish devotion; I packed my meagre possessions into a bag and wrote the following to her:

'Dear Madame,

I have loved you like a madman; I have devoted my life to you as no man has devoted his life to a woman before. You have abused my most sacred emotions and played an arrogant, frivolous game with me. As long, however, that you were only cruel and ruthless towards me I could still love you, but now you are on the point of becoming *common*. I am no longer the slave you can kick and beat. You yourself have set me free, and I am leaving a woman whom I can only hate and *despise*.

<div align="right">Severin Kusiemski.'</div>

I gave this note to the negress and fled as fast as I could. I reached the station, breathless: and then I felt a searing pain in my heart – I stop – I begin to weep. How shameful it is ... I wish to flee, yet cannot. I retraced my steps – my steps – to her, whom I detest and worship at the same time.

I pull myself together. I can't go back. I mustn't go back.

And how can I get away from Florence? I suddenly realise that I have no money, not a penny. Well, on foot then, and to be an honest beggar is better than to eat a courtesan's bread.

But I can't leave.

She has my word, my word of honour. I must go back to her. Perhaps she will let me go.

After a few, swift steps I stop again.

She has my word of honour, my oath, my pledge that I am her slave, as long as she wants me, as long as she refuses to liberate me. But I can kill myself.

I walk through the Cascine down to the Arno, down to the edge, where its yellow water monotonously washes a few scattered willows: I sit down and make my reckoning

with life. I let my whole existence pass before me and find it pathetic – a few single joys, a huge amount of indifferent, worthless material, and a rich harvest of pain, sorrow, dread, disappointment, hopelessness, bitterness, grief, mourning . . .

I thought of my mother whom I had dearly loved and whom I saw wilt and fade in a dreadful sickness; I thought of my brother who died in the prime of youth, deprived of joy and happiness, without having put his lips to the chalice of life; I thought of my dead nurse, the playfellows of my youth, my friends who strove and learned with me, and of all those covered by the cold, dead indifferent earth; I thought of my turtledove who often, cooing, bowed before me and not his mate – all dust, returned to dust.

I laughed aloud and slide into the water, but at the same time I cling on to a willow branch which hangs across the yellow waves, and I see the woman before me, the woman who made me so miserable. She is hovering above the surface of the water, transfigured by the sun, as though she were transparent, with fiery flames about her head and neck; she turns her face towards me, and smiles at me.

<p align="center">*　　*　　*　　*</p>

So back I come, dripping, sodden, trembling with shame and fever. The negress has already delivered my letter, so I am condemned, lost, given into the power of a heartless, scorned woman.

Let her kill me then, I can't bring myself to do it, and yet I no longer wish to live.

As I am walking round the house she is standing in the gallery, leaning over the railings, her face in the full light of the sun, her green eyes squinting.

'Are you still alive?' she asks, without moving. I stand silently, my head on my chest.

'Give me back my dagger,' she continued, 'it's no use to you. You haven't even the courage to take your own life.'

'I haven't got it any more,' I replied, trembling with fever.

She mustered me with a proud, scornful look.

'So you've lost it in the Arno?' She shrugged her shoulders. 'Very well. And why haven't you gone?'

I muttered something that neither she nor I could understand.

'Oh, so you have no money!' she cried, and threw me a purse with an unspeakably disdainful gesture. 'Take this!'

I didn't pick it up.

We stood silently for a long while.

'Don't you want to go?'

'I can't.'

<p align="center">* * * *</p>

Wanda drives through the Cascine without me, she goes to the theatre without me, she receives visitors, the negress serves her. Nobody asks after me. I wander aimlessly in the garden like an animal which has lost its master.

Lying in the bushes, I watch a pair of sparrows fighting over a seed of corn.

I hear the rustling of a woman's dress.

Wanda approaches in a dark silk dress, buttoned modestly to the throat; the Greek is with her. They are in animated conversation but I cannot understand a word. Now he stamps his foot and kicks up the gravel; he cracks his riding-crop in the air. Wanda flinches.

Is she frightened he might strike her?

Have they got this far?

<p align="center">* * * *</p>

He has left her, she calls after him, he does not hear, he does not wish to hear.

Wanda nods sadly and sits on the nearest stone bench; she sits for a long time, lost in thought. I look at her with a kind of malicious joy; I finally pull myself together and scornfully walk up to her. She starts, and her whole body trembles.

'I come to congratulate you,' I said, bowing. 'I see, Madam, that you have found your cavalier.'

'Yes, thank God!' she cries, 'no more new slaves, I have enough of these already. A woman needs a man, and worships him.'

'So you worship him, Wanda!' I screamed, 'this crude fellow.'

'I love him more than I have ever loved anyone before.'

'Wanda!' I clenched my fists, but tears were already coming to my eyes, and I was seized with the madness of passion, with a sweet madness. 'Good, so take him then, make him your husband, he can be your lord and master, but I shall remain your slave as long as I live.'

'You will be my slave, even then?' she asked. 'That *would* be somewhat *piquant*, but I'm afraid he won't allow it.'

'Him?'

'Yes, he's already jealous of you – *him*! Of *you*! she cried. 'He wanted me to get rid of you when I told him who you were.'

'You told him', I repeated, dazed.

'I told him everything,' she said 'our whole story and all your oddities, everything, and instead of laughing he grew very angry and stamped his foot.'

'And threatened to beat you?'

Wanda looked down, silently.

'Yes, yes,' I said with a scornful bitterness: 'You're frightened of him, Wanda!' I threw myself at her feet and embraced her knees. 'I want nothing from you, nothing, only to be near you, to be your slave, your dog!'

'Don't you realise how you bore me?' said Wanda apathetically.

I jumped up, boiling.

'You're no longer cruel, you're common!' I said, and each word was sharp and emphasised with bitterness.

'That sentiment is already in your letter,' Wanda replied, shrugging her shoulders coldly. 'An *homme d'esprit* never repeats himself.'

'What are you doing to me?' I cried. 'What do you call this treatment?'

'I could chastise you,' she said scornfully, 'but I prefer to give you reasons instead of whiplashes. You have no right to complain about my treatment: haven't I always acted

honourably toward you? Haven't I warned you, more than once? Didn't I love you deeply, passionately, and did I ever conceal the fact that it is dangerous to devote yourself to me, that it is dangerous to submit to me, and that I want to be mastered? But you wanted to be my toy, my slave. You felt the greatest pleasure in feeling the foot, the whip of a proud, cruel woman. What more do you want? Dangerous tendencies were lurking within me and you were the first to arouse them. If I now find pleasure in torturing you, in ill-treating you, well, it's your fault, you made me what I now am, and now you are cowardly enough, weak enough, pusillanimous enough to blame *me*.'

'Yes, it's my fault,' I said, 'but haven't I suffered enough for it? Let's finish this cruel game.'

'I want to as well,' she said with a strange, arch expression.

'Wanda!' I cried 'don't drive me to the edge, you can see how I'm becoming a man again.'

'It's only a passing fancy,' she replied, 'dry straw that crackles but is burned as soon as it flames up. You think you can intimidate me, but you're ridiculous. If you *were* the man I first took you for – serious, thoughtful, strict – I could have loved you faithfully and become your wife. A woman needs a man she can look up to; someone like you, who offers his neck for her to put her foot on, she can only use as a toy, something she can throw away when she's tired of it.'

'Try to throw me away then,' I cried scornfully, 'there are some toys that are dangerous.'

'Don't push me too far,' cried Wanda, her eyes sparkling and her cheeks flushed.

'If I can't have you,' I continued, my voice choking with rage, 'then nobody else will . . .'

'Where did you learn that quotation?' she said mockingly, and seized my lapels: she was pale with rage. 'Don't provoke me. I'm not cruel, but I don't know what I am capable of and whether or not I might overstep the mark.'

'What is there worse for me than making him your lover, your husband?' I cried vehemently.

'I can make you into *his* slave,' she replied quickly. 'Do I not have absolute power over you? Do I not have your agreement? But, naturally, it would only please you if I tied you up and said to him: 'Do what you want with him.'

'Are you mad!' I screamed.

'I am quite rational,' she said, calmly. 'I give you one last warning. Don't put up any resistance, not now, when I've gone so far, and can go still further. I feel hatred for you and would love to see him beat you to death; I can still control myself but . . .'

Scarcely able to control myself I grabbed her by the waist and forced her to the floor so that she was kneeling before me.

'Severin!' she screamed, her face twisted with rage and fear

'I'll kill you if you become his wife,' I threatened, and my voice was hoarse and hollow. 'You're mine, I won't let you go, I love you too much,' and I was embracing her, forcing her to me, and my right hand involuntarily groped for the dagger that was still sticking in my belt.

Wanda looked at me with a strange, calm, inexplicable expression.

'I like to see you like this,' she said steadily, 'now you are a man and at this moment I know that I still love you.'

'Wanda . . .' Tears started to my eyes in joy, I bent over her and covered her lovely face with kisses, and then she burst out into loud, mischievous laughter and cried: 'Have you enough of your ideal now? Are you pleased with me?'

'What?' I stammered, 'You're not serious?'

'I am completely serious,' she continued, 'I love you, only you and you, you silly little fool, didn't notice that it was all a joke, a game, and how difficult it was for me to beat you when I would have preferred to take you by the head and kiss you. But surely enough is enough? I played my cruel part much better than you expected, and now you'll be happy to have your good, nice little wife, who is also quite pretty, I think, back again. We will live quite sensibly now and . . .'

'You, you will be my wife!' I cried, transported in ecstasy.

'Yes, your wife, you dear, good man!' Wanda whispered, kissing my hands.

I drew her to my breast.

'So, you are no longer my slave Gregor, you are my dear Severin again, my husband.'

'And him? Don't you love him?' I asked, agitated.

'How could you think that I loved that crude fellow? But, then, you were quite confused, I was worried about you.'

'I nearly killed myself on account of you.'

'Really?' she cried. 'Oh, I'm still trembling at the thought of your being in the Arno.'

'But you saved me,' I said tenderly, 'you were hovering over the waters, smiling, and your smile drew me back into life.'

<p style="text-align:center">*　　*　　*　　*</p>

It is truly a strange feeling to have her in my arms, her head on my breast; I kiss her, and she is smiling. It is as though I have woken from a feverish nightmare, or as though I was shipwrecked, fighting with the waves which threaten to engulf me, and finally I am thrown on to dry land.

'I hate this town of Florence where you were so unhappy,' she said as I wished her goodnight, 'I wish to leave tomorrow. Please be good enough to write a few letters for me whilst I go into town to take my leave. Do you agree?'

'Of course, my dear, good wife.'

Early next morning she knocked on my door and asked me how I had slept. Her kindness is truly enchanting, and I would never have thought that she could be so gentle.

She's been away now for four hours; I finished the letters a long time ago and am sitting in the gallery looking down at the street to see if I can spot her carriage in the distance. I am somewhat concerned about her, yet, God knows, I have no cause for doubts or fears. Yet I can't

shake it off and it lies heavily upon me: perhaps it is the sufferings of the last few days which cast their shadows across my soul.

But here she is, radiant with happiness and contentment.

'Well, did all go according to plan?' I asked, kissing her hand tenderly.

'Yes, my love,' she replied. 'We are going tonight, help me pack my case.

*　　*　　*　　*

Towards evening she came in person to ask me to go to the post-office and send the letters. I take her carriage and am back in an hour.

'Madame was asking after you,' said the negress, smiling, as I climb the wide marble staircase.

'Was anybody here?'

'Nobody,' she replied, and crouched low upon the steps like a black cat.

I walk slowly through the room and am standing before the door of her bedroom.

Why is my heart beating so? Am I not happy?

I open the door quietly and pull back the curtain. Wanda is lying on the ottoman and seems not to notice me. How lovely she is in her robe of silvery grey silk which clings to her splendid figure, revealing her wonderful bust, her beautiful arms. Her hair is tied and interwoven with a black velvet ribbon. A great fire is burning in the hearth and the lamp casts its reddish light: the whole room is swimming in blood.

'Wanda!' I exclaimed after a few moments.

'O Severin!' she cried joyfully, 'I have been waiting impatiently for you.' She jumps up and embraces me; she slips down into the deep pillows and seeks to pull me with her, yet I fall at her feet and bury my head in her lap.

'Do you know that I love you very much today?' she murmurs, brushing a few loose hairs from my brow and kissing my eyes.

'How beautiful your eyes are . . . they have always been your best part, but today they absolutely intoxicate me.

54

Look I'm expiring . . .' and she stretched her lovely limbs and gazed at me tenderly through her red lashes. 'And you, how cold you are, you are holding me as though I were a piece of wood . . . Just wait, I'll make you infatuated!' she cried, and hung upon my lips, soft and caressing. 'So, I don't please you any more . . . I must be cruel to you again, I was too kind today, apparently. Do you know, you silly little man, I think I'll beat you a little . . .'

'But, darling . . .'

'I want to.'

'Wanda!'

'Come, let me tie you up,' she continued, and ran around the room, mischievously. 'I want to see you truly in love, do you understand? Here are the ropes. I wonder if I can still do it?'

She began tying my feet, then she tied my hands firmly behind my back and then bound my arms like a prisoner.

'So,' she said, serene and eager, 'can you move?'

'No.'

'Good.'

She made a lasso of a strong piece of rope, threw it over my head and drew it down to my hips; she pulled it tight and tied me to a pillar.

'I have the feeling that I am being executed,' I said quietly.

'You're going to get a real whipping today again,' cried Wanda.

'But, please,' I said, 'put on the fur jacket.'

'Well, I can give you that pleasure,' she replied, brought forth the jacket and slipped it on, smiling; then she stood there, her arms crossed on her breast and gazed at me, her eyes half closed.

'Do you know the story of the Ox of Dionys?' she asked.

'Only vaguely . . . What is it?'

'One of the courtiers dreamed up this new torture-instrument for the despot of Syracuse, an ox made of iron in which they would place the condemned man before putting

the whole thing into the fire. When the iron ox began to glow red-hot the prisoner inside would start to scream, and his agony sounded like the roaring of an ox. Dionys smiled graciously at the inventor and in order to make the first demonstration forced the courtier inside his own invention. This is a very useful precept. It was you, you see, who inoculated me with selfishness, arrogance and cruelty and so *you shall be my first victim.* I really find pleasure in having a human being who thinks, feels and succumbs to my power, particularly a man who is physically and mentally stronger than I am, in order to ill-treat him, and above all a man who loves me.'

'To distraction!' I cried.

'All the better,' she said, 'and you'll find all the more pleasure in that which is about to happen to you.'

'What is wrong?' I asked. 'I don't understand you, there really seems to be a cruel gleam in your eyes, and you are strangely beautiful, like Venus in Furs . . .'

Without answering she put her arms about my neck and kissed me. At this moment I was seized again with the full madness of my passion.

'Well, where is the whip?' I asked.

Wanda took two steps backward, and laughed.

'You really want to be beaten?' she cried, tossing her head back proudly

'Yes!'

Suddenly Wanda's face changed, twisted in anger, and for a second she seemed almost ugly.

'Beat him, Alexis!' she screamed.

At that moment the handsome Greek thrust his head between the curtains of the four-poster bed. I was struck dumb, rigid. The situation was extremely comical and I would have laughed aloud if it had not been at the same time so desperately sad and shameful for me. And my blood ran cold when my rival stepped forth in his riding boots, his tight white trousers, his close-fitting velvet coat, and my glance fell on his athletic body.

'You are cruel, indeed,' he said, turning to Wanda.

'I am only a hedonist' she replied with a wild sense of humour. 'Only pleasure makes life worthwhile; only the one who enjoys life departs unwillingly from it; he who suffers and pines greets death as a friend. He who wishes to enjoy life must accept it serenely, as the ancients did: he must not fear to enjoy life at others' expense, he must never show pity and must yoke others like animals before his carriage, his plough, others who feel, who would fain enjoy life – he must make them his slaves, he must exploit them for his own ends, his own pleasure, without remorse; he must not ask whether they are suffering, or whether they will perish. He must always remember this: if I were in *their* hands they would do the same, and *I* would have to pay with my sweat, my blood, for their souls delight. That was the world of the Ancients; pleasure and cruelty, freedom and bondage went hand in hand. Those who wished to live as Olympian gods *had* to have slaves whom they could fling into their fishponds and gladiators who would fight whilst they themselves ate opulent meals and never worried if they were sprayed with spurting blood.'

Her words brought me fully to my senses. 'Let me loose!' I screamed angrily.

'Are you not my slave, my property?' Wanda retorted. 'Shall I show you our agreement?'

'Let me free!' I threatened, 'otherwise –' I tore at the bonds.

'Can he break free?' she asked. 'He's threatened to kill me.'

'Don't worry,' the Greek replied, inspecting the knots.

'I'll scream for help,' I continued.

'Nobody will hear you,' said Wanda, 'and nobody will stop me from abusing your noblest feelings and playing a frivolous game with you . . .' She continued to speak with a diabolical contempt, repeating the phrases of my letter. 'Do you now find me simply cruel and merciless, or am I about to become *common*? Tell me, do you still love me, or are you starting to hate me, to despise me? Take the whip . . .' and she gave it to the Greek who quickly stepped up to me.

'Don't you dare!' I yelled, trembling with rage, 'I won't take anything from *you*!'

'You're only saying that because I'm not wearing fur,' the Greek replies, smiling frivolously, and picking his short sable jacket from the bed.

'You are divine!' Wanda cried, kissing him and helping him into the fur.

'May I really whip him?' he asked.

'Do whatever you want with him.'

'You beast!' I shouted.

The Greek fixed me with his cold eyes, like a tiger and tried out the whip; his muscles rippled as he cracked it, whilst I was tied there like Marsyas and was forced to watch Apollo preparing to skin me.

I looked around the room and fixed my gaze on the ceiling where Samson was being blinded at Delilah's feet. The picture now seemed a symbol or eternal parable of passion, of lust, of the love of man for woman. 'Each of us is essentially a Samson,' I thought, 'and will be betrayed by the woman he loves, whether she's wearing a homespun bodice or sable.'

'Now watch, Wanda, how I'm going to discipline him,' said the Greek. He bared his teeth and his face assumed that bloodthirsty expression that had terrified me the first time I saw him.

And he began to whip me, so ruthlessly, so dreadfully that I flinched at every blow, my whole body shuddering with pain, with tears pouring down my cheeks, whilst Wanda lay in her fur jacket on the ottoman, her head on her hand: she watched with cruel curiosity, her whole body shaking with laughter.

The feeling of being ill treated by a rival before the woman one worships is indescribable: I almost expired with shame and desperation.

And the most shameful thing was, that in my wretched helplessness, beneath Apollo's whip and the laughter of Venus, I felt a kind of fantastic, supersensory titillation – but Apollo soon beat this out of me, blow by blow, until I

finally bit my teeth in impotent rage and cursed myself, my lubricious fantasies, women and love.

With a fearful clarity I suddenly saw where blind passion, where lust could lead a man, since the days of Holofernes and Agamemnon – into the sack, the net, the hands of a treacherous woman, into misery, subjection, death.

It was as though I had woken from a dream.

My blood was already spurting beneath his lashes, I was writhing like a worm which one stamps upon, but he continued to beat me, to whip me mercilessly, and she kept on laughing, mercilessly, as she closed the packed suitcases and slipped into her travelling furs; she was still laughing as she went down the stairs on his arm and got into the carriage.

Then it was still for a moment.

I listened, breathless.

The carriage door slammed shut, the horses started, the wheels rolled – then all was silent.

Extracts from *Venus im Pelz. Mit einer Studie über den Masochismus von Gilles Deleuze..*
Insel Taschenbuch 469.

Hermann Bahr: *The School of Love*

The Dandy

Rocking back and forward in his armchair while he manicured his fingernails, he found it pleasantly titillating to imagine the girl – she had not even told him her name – clinging to him under the blossoming apple trees as a gentle breeze wafted over them, or in the evening, gliding homewards over the water, her quivering body pressed against his in the narrow boat. 'Tant pis pour elle', he said as he stood up, throwing the nail-scissors in an arc towards the table. 'I'm not running after her. There are plenty more like that.'

In fact, it was a piece of luck. Good-natured as he was, and with his inability to resist any mood, the most that would have come of it would have been some banal entanglement. The one thing that was certain was that she was not his style

No, she was not his ideal woman, not even a distant cousin a hundred times removed. Now, as he threw off his dressing gown and settled down in front of the mirror, legs spread-eagled over the cushion, to work on the masterpiece of his *toilette*, carefully twisting his locks into dreamy curls, drawing out the proud lance of his Vandyke, long, very long, with much brilliantine, and subjecting himself to a loving and satisfied scrutiny, now, once again, his ideal appeared before him with almost tangible clarity, so imperial and junoesque; and then this shy, innocent swallow beside her, the image of Gérard's Psyché, yes, really, even – he remembered – the same ringlets in her hair, at the front, falling down over her forehead. No, there was no comparison; she might well be very sweet, for modest requirements, but he, unfortunately, was already spoken for, sorry and all that.

He lingered for a long time among these pleasant images because, in accordance with his bad habit, he lingered for a long time in front of the mirror, until his mane was finally tamed and his elaborate cravat, with its multicoloured, fluttering points, was tied in its artistic knot. He burst out laughing when he saw from the clock that he had once again wasted two hours prettifying himself – like a *cocotte*, his friends said, only she makes a profit out of it. They could not get over his vanity.

But no, his was not the common vanity they imagined. Yes, he loved dressing up, and he was happy if he could wear something different, something out of the ordinary, striking and amusing. Yes, he did have a luxurious lace shirt with a soft, broad, turn-down collar, with glorious embroidery such as would have made old d'Aubrevilly green with envy. And yes, he did have a pearl-grey sombrero with a huge brim, such as only the proudest Andalusian picador would wear, so that some people took him for a porter from *les Halles*. But he did not wear them to please the crowd, nor did he calculate on attracting women's glances. It was just that he was tormented by the desire to differentiate himself from the rest in his external appearance, just as he knew how incomparably different he was in his inner being. He was different from the rest, why should he not appear so? And every day he needed this reassurance, this confirmation, to counter his pressing doubts as to whether he really was one of a kind and did not belong to the mass. How else could he ever perfect his art?

Ennui

Moody they called him. Yes, why did they not leave him alone, why were they always interfering with him, and why did everyone try to mould him, and everyone want to change him, and everyone want to force him to follow their own prescription, why was no one happy with him as he was! Then of course he ended up losing all his *sang-*

froid and beating his wings against the floor and ceiling, bemused, fluttering round in circles by fits and starts, staggering about in mortal fear of the constant, unceasing drumming and hammering against all the bars of the cage, an infernal din. Why could they not leave him as he was – truly, a modest desire - why not let him follow his own nature, listen to his own wishes, obey his own intentions, why could they not let him be? This was what had spoilt him, this alone and no fault of his, that everywhere the tyranny of the outside world, nothing other than this eternal tyranny, stupid, coarse, imperious, was lying in wait for him in a thousand ambushes, now attacking him like a brigand with open violence, now treacherously camouflaged in flattering counsel, garbed in sympathy and friendship, but unyielding in its daily attacks; no wonder he had finally succumbed to this persecution mania with which he tormented himself and others, bewildered, distrustful, suspicious of the whole world.

* * * *

Bondage and service – that was what they all demanded, and from everyone. This craving to find themselves in another, to subjugate and appropriate foreign territory, to create a new field for their own will in a second body, foreign flesh for their own soul; this greedy, consuming hunger devoured every other desire, and they called it friendship! And he, who was fainting with this nameless longing for a real friend, he who, instead of always wanting only to take, would have surrendered to a friend and enriched his soul instead of pillaging it with fire and sword, like some insatiable vampire!

Alone, alone – why would they not leave one alone? Was there not pain enough without one having to suffer this cruel, merciless torture, all life through, this bitter, tormenting nausea at those around one? But their meddling fingers tore him apart, and he could see no hope and despaired, and often they spoilt even animals for him, even things, in fact everything that was not a product of his mind.

Yes, finally all this had brought him to a state where he hated everything that was not of his own imagining. He could not bear it. And he remembered that insignificant things, ridiculously insignificant things had unleashed a rabid fury within him – a tune whistled in the street that stuck in his ear, frightening away his own thoughts and resisting all his attempts to shake it off, to drive it out; or a longed-for letter which just would not come with the post, even though it had long since arrived in his imagination; or when he was held up by the crush of people at a counter, while in his mind he had already completed the business; all these endless, loathsome memories, every day, so that he was never alone, was never free.

Then sometimes he was overcome with the feeling that he wanted to smash everything to pieces, all around, to lay waste to every sign of life with fire and sword, to raze to the ground like the Vandals all traces of others, just to put an end to this perpetual, insupportable ordering about by people and things, to create a desert around him, a still, silent desert.

The Artist

Alone, alone – somewhere high up in the ice or deep down on the bed of the bellowing sea, where none of the insistent noise of everyday life could reach him and he would be safe from the coarse, grasping claws of others! Ordinary, common people – yes, they might be able to put up with their self being stolen and replaced with an alien, they did not need their self. But the artist – how could he live without this tool of his craft?

Clearly it was the artist, the artist within him, from which all this suffering came. This comforted him and awoke within him an almost cosy mental image in which he wearily wrapped himself up on the heavy, wide, luxurious divan, above which his wild Japanese masks looked out with their mocking grins, their shaggy horsehair moustaches and twisted mouths. It comforted him because it could not be called suffering if it was a sign of art.

Yes, clearly, the artist within him, the artist . . . he never tired of repeating it in order to reassure himself. Of course others did not have this sense of self, so fervent and boundless, nor this dogged defiance the moment anything tried to approach it, nor this mortal fear, breathless and feverish, of losing it. They did not care whether they possessed it or not, because they never made use of it, could easily do without it and not even notice. They could be happy. But the artist!?

True, it was a comfort because it satisfied his pride, but he could not conceal from himself the logical conclusion that this meant his suffering was unavoidable, without help, hopeless, not mere chance, which might change, but necessary, unalterable fate, if it came not from the malice of the world, but from himself and his art. And that again annoyed him, not the fact that it was so, but that he knew it. That took the heart out of him, all his power of decision and even his cheerful hatred of mankind and the world, which at least provided, mingled with hope and sorrow as it was, some pleasant exercise for the soul. As long as he deceived himself about the truth, he could blame fortune and have confidence in the future. Now the clouds of madness were closing round his mind.

But it was one of his unfortunate habits, which he could never escape however many resolutions he made, to spend whole days on the sofa, swinging up and down on the trapeze of his thoughts, to dizzier and dizzier heights, and to insist on poking round in his brain, probing deeper and deeper, right down to its hidden roots. This curiosity about himself was something he had had since his youth, and of course it was the artist again, always the artist, who never tired of thus hearing his confession every day and of exploring every corner of his conscience. But how else could he have any hope of eventually discovering the great mystery that was sleeping and would not wake, somewhere deep down in the depths of his soul.

So he explored, explored within himself, scanning himself with a lamp, as if it were not himself at all but some

strange monster that he had been commanded to guard. Holding his breath and leaning forward in concentration, he listened, to see whether the miracle would happen and it would finally show signs of life. In the meantime at least he recorded every detail of what he found, in order to assure himself that he really was an exceptional individual, a superior nature, an *homme d'élite*.

Thus he put his soul in front of the mirror, combed it out and groomed it.

The Girl

It was too late to start anything before dinner.

Reading: nothing but obscenities and idiocies; he knew them off by heart.

Up and down, to and fro. Smoking, smoking. At least tobacco kept its promises, that was one thing that was still honest and true – smoking, smoking.

Start again from the beginning, that breathless trek through his thoughts?

Must he always, always be thinking? Those rosebuds outside, they had no thoughts. But they gave off their scent and they would bloom.

A woman, a woman! Whatever Marius might say. It was all very well for him to advocate *cocottes*, a different one every night, never the same one twice – yes, when one had reached the same stage as him! But he was nowhere near that, thank God . . . unfortunately. A woman, a woman!

Then he would have peace, would have some rest. That would be bliss, bliss!

Work, as long as the mood flowed. Then, when it came to a halt, away with the paints on the spot to go out with the little woman, out, one day into the country, the next dancing, but always finding oblivion.

Sometimes he was so tired of the eternal struggle, so sick of his eternal cravings. He longed for the bliss of a quiet, undemanding friendship. And most of his socks had holes in them, as well.

Bliss, bliss!

The only snag was the beginning, until everything was running smoothly: looking round, searching, taking trouble, wavering, deciding on one, then deciding on another.

It was a nuisance that she had not come back with him. But to wait for a week and then rush to a rendezvous that, perhaps, she had already forgotten by now – well, perhaps if he were head over heels in love!

But he could write, it suddenly occurred to him; he would write to her as he had promised. A long, detailed letter that would fill in the hour that he still had before it was time for his absinthe. A crazy love-letter. Was he still up to it? One didn't forget that easily how to lie.

It amused him. He chose the most delightful declarations and sought out the most precious gems of language. From these he composed such a beseeching prayer to his guardian angel, of such fervour and humility, that when he read it he was moved to tears of pity for himself. Let him see one of those novelists do that, and they were paid for it! He really had the gift, though only on paper. Face to face he was awkward and embarrassed; it put him off that they would not keep quiet and let him work himself up into the right mood, gradually, from one sentence to the next.

The letter contained a lot of flattery and a lot of passion. He described to her how he saw her now, in the yearning of his loneliness, as a heavenly nymph, the first pleasant, alluring vision on this sullen, miserable day. And as he read out the words to himself again, savouring their delicate flavour, he was astonished that she was so beautiful, and that he liked her as she was; it was only now that he realised it.

Expectation

But at the end of the month, when he had seen her every Sunday and then, during the last week, accompanied her home from work every evening, when that week was

66

over, on the last day, something happened. He waited for her in vain, at the corner, beneath the crooked lamp, in the wind. She did not come, nor the next day, nor on the third day.

From the unutterable fear that struck him – was she ill? was she unfaithful? – and from the way the volcanic letter erupted from his lacerated soul, he realised it was not the problem that concerned him, it was love. But no answer came to his letter. In the store where she worked they knew nothing. 'She no longer works here.'

On the fourth day, at the tenth hour of the morning, as he was wrestling with his wild dreams, there was a gentle knock at the door, like an embarrassed beggar, or a model looking for work, then another, and after he had repeated his surly grunt and was already preparing a crude rebuff, then, after a while, she came in, tiptoed up to his bed, her bemused gaze stumbling inquisitively over the jumble of dingy *bibelots*, and, after she had given him a hearty kiss, sat down on the edge and said, a little timidly and despondently, 'You see, I've left my cousin's, because I can't live without you . . . it was the most sensible thing to do . . . last Saturday.'

Then he let out a howl, like a hungry beast that has finally caught its prey, and tore her to him and threw himself onto her and ran his trembling fingers over every inch of her and rolled back and forth with her, giving short, shrill, hoarse whistles of ecstasy and covering her whole body with biting kisses, as if he wanted to tear her to pieces.

But she twisted out of his arms. for she was wearing her new hat, the one made of black lace with a spray of roses and anemones hanging down at the back, very crushable, very fragile. And sitting in front of the mirror, smoothing herself out and putting up her hair, she said, 'You always wanted to go out into the country . . . just look outside, today, the sun.'

His first impulse was not to let her go before he had tasted of her flesh, that glowing, quivering, rosy flesh, the

67

overpowering, sultry scent of which he was greedily suck-
ing in with wide-stretched nostrils like some exquisite
oriental spice; not before his thirsty embrace had sipped of
her blood from the lips, breasts and loins he had already
gnawed; not before this unutterable craving to devour her,
to drink her dry, to enjoy her with each separate sense,
was finally, finally satisfied. But he pulled himself together
and let her be. He realised he did not want to spoil the bliss
that had finally arrived. No, now was the time to prove
that he knew how to enjoy happiness by not hastily
swallowing it in large gulps, but by savouring its sweet
berries on his palate, slowly, deliberately, letting them seep
into his every pore, jealous of every drop, so as not to lose
the least atom of its full flavour. He wanted to tend his
bliss, methodically, systematically, so as to gather in a lush
harvest.

He would spend the whole day imagining it, the whole,
long, summer's day, filling his mind with detailed images.
The whole day he would sleep with her in his mind,
constantly assuring himself, through kisses and embraces,
that that night he would sleep with her body. The whole
day he would luxuriate in the rapturous certainty that in
the evening he would finally luxuriate in the rapture which
had for so long been uncertain. He kept fondling her in his
mind with such tireless antitheses, just as he kept fondling
her with tender, lustful, fumbling fingers. And he would
have wished the day everlasting and eternal, spread out
over aeons, without end, because already he was filled with
fearful doubts, which, however, did not dare moan out
loud; already he was afraid of the fulfilment: could it,
could it ever match up to his expectation?

Fulfilment

As protection against the cool evening air, he threw his
coat round them and they each enveloped themselves in
the other, their two bodies growing into one. He had his
arm round her neck and could feel the warm buds of her

breasts. And everything she said, every word, was like the heavenly music of happy angels, and he was most astonished, for the first time he realised what spring was. He would have liked to have stayed sitting on the rock and died.

Slowly, very slowly, after their meal in the little garden by the river – surrounded by buds; a nightingale sang – they returned home up the Seine, through the brightly coloured flames of the Exhibition. It was even more beautiful than he had expected. Slowly they walked along the boulevard to his apartment.

He lit the light, she tied the flowers into a large bouquet and put them in water. As she undressed, he smoked one more cigar and drank in the odour of the flowers and of her flesh. Neither spoke a word, she just softly hummed an old air from the Auvergne as she sat at the mirror releasing her tresses. Then, as if they had long been accustomed to it, they went to bed. And it was with a sudden shock, almost horror, that he realised he had made love to a virgin.

Stuttering and stammering, overcome with confusion, he raised himself to his knees, 'Oh, you . . . how then . . . You didn't mention that . . . is it . . . can it really . . .?

She sat up, buttoning up her bodice again, her gaze fixed on the far distance, as if seeking help against some inconceivable danger, and with quivering lips, 'You thought I was one of those?!' And she turned to the wall and cried, cried bitterly. But soon sleep took pity on her.

But he, in a feverish turmoil, could not find peace. He tossed and turned, looking for coolness in the sultry pillows. His throat was burning.

He jumped out of bed, craving water, took a deep draught, wet his eyes and plunged his face into the bowl; he wanted to swim out into the wide ocean until this parching, choking thirst was cooled. And then, closing the curtain round the bed so as not to wake her, he lit the light and walked and walked, breathless, if only he could have climbed the mountains, straight up into the ice, if only he could escape somewhere. And he wondered what all this could be.

Yes, it was bliss, his reason could prove it. It was bliss, ultimate bliss. It was just that he was not yet used to it.

<center>*　　*　　*　　*</center>

Outside, dawn was breaking and the trees were shaking themselves. Gently he pulled back the curtain of the bed. She was breathing softly. He knelt down and placed an ardent kiss on the rosy-pink sole of her foot, which was peeping out of the bedclothes. And thus, in the attitude of prayer, he fell asleep.

Blessing or Curse?

Often when, the morning rays saluting her, covering her hyacinth flesh with golden scales, she sat upright in front of the mirror braiding her hair, his desire flickering round her, and slowly, with plucking fingers that gleamed like swift snakes, gently and insistently pulled at her tangled lashes, her recalcitrant brows, damped and shaped them, her lips pursed in a silent whistle whilst her restless tongue flickered out quickly and darted back in with a soft smacking, and then, lids closed, bending forward as if in prayerful humility, softly, carefully, tenderly she wiped the powder puff – her little nose, fearful of the dust, twisting to the side – over her lowered cheeks, assiduously, many times and with a very serious, solemn, sacred expression, as if performing an act of worship; or at other times when, going out on an errand, she left him alone in bed, among the traces of her smell in the sultry hollows from which clouds of delightful images rose up, intoxicating, ecstatic shapes; or in the peace of the evening, as they were waiting for night, as, slowly, the soft memory of light faded, and conversation was already asleep and only a song from some childish game flitted shyly across her lips – then, sometimes, he could have soared up to the stars in exultation, with boundless joy, because he felt so unutterably happy.

But at other times, immediately after, abruptly, he felt the urge to throttle her, to whip her, to tear her apart, his fingers ripping into her hated flesh, until she was gone,

<center>70</center>

eradicated, in his anger, fury and disgust; and he could not have said what the reason was, there was no reason, the urge just came to him, no idea where from, it was a turmoil which overcame him, alarming, irresistible, at the mere sight of her, catching him unawares, sometimes at moments when his happiness seemed complete.

So he never knew where he was with himself, because it was like a sickness which kept reappearing with different horrors, and he did not know what to do, he could not settle to a constant, reliable feeling towards her and was ever anxious and apprehensive as to what might happen next, the next moment, and never, through all his eager curiosity, was it settled whether it was a blessing or a curse.

The Sign of the Whip

No, it meant nothing, there was no need to get worked up. It was just one of Fifi's dreadful habits – he knew them well enough by now – that she could not sit still for a moment, but took every opportunity to be jumping up and down, now looking in the mirror if a bow were coming undone, or going to fetch water, salt, vinegar, or the newspaper to read the theatre reviews – and her ringlets bobbed up and down, and her hips swayed, and her fingers clicked. And out in the street she could never quietly walk straight along the pavement, but had to look in every shop window; she always walked down both sides of the street at the same time, as Marius put it; across, back, an incessant zigzag.

And then, she just wanted to tease him a little.

Probably.

Because of the lecture he had given her about table manners, about the way she used to eat things with her knife.

That was it.

She wouldnt forgive him for that. Very prickly.

She couldnt stand it when he reminded her of her lowly origins, that she hadn't been brought up properly.

Took her revenge.

She was doing it deliberately.

But he wouldn't fall for that. It showed just how little she knew him!

On the contrary. She amused him, with all her vain stratagems, which he could see through straight away.

Barking up the wrong tree!

Just grin and bear it. Dont react. The two men were already at coffee. That would make her the one to look silly.

He'd have a good laugh at her.

No he wouldn't, he still felt sorry for her, after all that fuss about the knife, which was really all nonsense. And how charming she was, the way she was pulling the leaves off the artichoke, dipping them, tasting the sauce, with those roguishly innocent eyes.

Why torment her? Have patience, educate her – and love, lots of love.

You have to treat women like children.

More sweets than the whip.

And it was better for him, too, better for his digestion.

The two swells had finally left and gone into the smoking room.

Make it up. Take her to a grand theatre to see the latest play.

And buy roses. She couldn't resist flowers. Everything would be back to normal.

And then, just as he was making these noble resolutions, she was away, jumped up, knocked her chair over, dress streaming out behind her, and took the three steps down into the salon in one leap.

Like a bird taking off.

Like a shooting star.

And she was gone. All that was left was the echo of her giggle.

Music, of course. She got carried away, her legs simply took over.

It was a little inconsiderate towards him, though. After all, he was her lover!

72

Then why didn't he dance, ever? His own fault. Him and his *idées fixes*.

She was not the kind of girl who would be silly enough to to let that ruin her life. There was nothing like a lively waltz.

So there she was, jigging about the floor with 'Twisted Nose' while 'Iodoform' played the piano.

He fell into such a rage that he smashed the bottle of cognac.

Rushed out and tore her from 'Twisted Nose's' arms, so violently that he went tottering across the floor.

If he had said one word, one single word of protest!

Nothing but cowards, the whole lot of them. Just stared in amazement. And women fall for such pathetic specimens!

She just turned very pale, and bit her lips to stop herself crying out as he dragged her with him, and held back the tears that came to her eyes because he was hurting her so much.

He did not let go, the whole way home, but hauled her along like an obstinate calf. She did not dare say a word, nor cry out loud. She was filled with great fear, and with great love, because he was strong.

When they arrived home he was exhausted and trembling, and all he could say was, 'You whore!'

Then her defiance returned, and she tried to humiliate him, scoffing, 'Well go and find another one, then, if you can find one who'll take you!'

Then he hit her in the face with his clenched fist. As she had no other way of defending herself, she spat at him.

He ripped off her clothes, tearing them to rags, bent her over and set about her with his dog-whip. He wanted to scourge her till the flesh fell from her bones, till there was no trace left of her and he was free. His mind was empty apart from this one irresistible desire, and he could not stop until it was assuaged.

Just blood, blood. He only came to himself again when it was dripping down from the weals.

Then he forced her to make love and chastised her with kisses, while she pushed at him, spat and bared her teeth.

Until they fell into an insensible, death-like stupor.

Outside, their cat, which had fled, glided softly over the brightly lit roof, beneath the silent, shimmering sky.

From that day on their relationship was transformed, under the sign of the whip. Their caresses turned into blows, and every kiss, like a lash with thorns, tore open stinging cuts, from which their flesh began to fester, as if from the contagion of their shame. It was a cruel and depraved torture, insatiable lust, the waves of which pounded more and more furiously with each renewal, inventive in cruelty, sensuality that had lost its way and was heading towards madness. They could no longer find satisfaction unless they were glued together with blood; they had to dig into each others vitals with clenched fingernails and tear at their innards just to elicit a response from their deadened, debilitated nerves, pounded, ridden to exhaustion by so much passion. And again and again, restless and unyielding, their panting, never-satisfied senses howled 'More, more!'

He worked out a new theory about it, that they were on the trail of a new kind of love: through torment.

And then that would flush the new art out of its hiding place.

As if they first had to destroy their bodies so that their souls could come together, freed from base flesh and happy.

Yes, strangle each other so their souls might be resurrected.

That was it – more or less, he had not yet worked it out in detail, only that first of all they had to kill the flesh which held them imprisoned.

* * * *

Yes, he was on the right track: through torment.

First of all he had to destroy his old consciousness, so that the new love could awaken.

To sink – first of all everything had to sink, to flicker out, to be extinguished.

First they had to strangle each other, so they could rise again.

It gave him a mystical, religious lust – he could not express it in words because it was confused, beyond language.

They just had to hold out, they were so near.

They had to blast each other to pieces. Then they would be able to grasp it, grasp it and hold it.

And hourly he fell upon her in his butchering rage with some new humiliation and devastated her with some new atrocity and crucified her on some new perversion.

And when once more he had crushed her and drained himself dry, so that their pale corpses merely twitched with dull spasms, then suddenly, at the back of his brain, a bright light appeared, very bright, with a comforting, faery brightness.

Then again they would brood for silent hours that limped by, and neither would dare look the other in the eye, because they were so deep in filth.

Once she said, with horror, 'You will finish by completely depraving me', and shuddered with shame and disgust.

But he could not give in because it was his last hope. There was no vice, no murder he shrank from because it was for art, for its awakening.

Until his body rebelled.

His body drove him away from her with disgust and horror. His body ejected love like a poisonous infection which the healthy fluids would not stand.

It was a fever to save his life.

Ill, for weeks on end, with sudden, obstinate visions. He felt he was seeping out and draining away, he could not hold himself together. He was very frightened that his head might split in two, right down the middle; then he would be two persons and none at all. He was driven around restlessly by a shrill roaring that grew and grew. All his thoughts tripped and staggered and rolled into a tangle; they stumbled along lopsidedly, feeling their way,

as if in an obstinate, drunken stupor. He supported his forehead, which seemed to have been transformed into lead, on his hands. Dank clouds of dreams hung on his lids, pulling them down; but when he lay in bed, sleep withdrew and only came in fits and starts, with icy shivers that ate into the marrow, a ghastly tossing and turning under a cruel glare, as if there were some inexorable vice pushing the walls of his brain together, closer and closer, narrower and narrower, tighter and tighter, until any moment they would meet and crush his mind to a pulp.

* * * *

And he bathed his fevered brain in absinthe and drugged himself with sultry, stupefying odours, so that he lost all consciousness of himself. He neglected himself, like a hated and useless burden, and was alienated from himself and took no care for himself, because he could no longer understand nor control himself. And he kept on thinking that he would divide into two. It was certain it would happen, quite certain, and one day he would wake up split into two halves. And from then on he would only be the other one, the new one that came out of the left side of the brain, and the old one he would throw out, together with her.

Together with her. She was only a delusion of his damaged mind.

And he felt much better when he imagined all this, how he would be a new, free man. The man he would be would know nothing of the past, nothing of her. He would free himself from her.

To free himself from her. That was the object of his avid longing.

To live in hope, to wait for the miracle to happen. He could not do it on his own because his strength was exhausted. It had to come as a blessing from outside.

To free himself from her, to free himself from all women, and then he would never again have anything to do with love, for nothing came of it.

To use her to purify himself, but only as one takes a

bitter, nasty medicine, getting rid of it as soon as the infection is over. The last thing he wanted was love. He had been cured, thoroughly cured, of the superstition that love might exist.

No, for this generation there was no such thing as love. Of the old kind they only knew from books and could not feel it, whatever efforts their minds might make. And the new kind of love – yes, perhaps later, but it had not appeared yet; they were only deceiving themselves.

<center>*　　*　　*　　*</center>

Women made one unclean. Being with them made the soul dirty. His throat filled with phlegm at the mere thought.

Often he had a terrible, tormenting fantasy. In a spacious hall, that was decorated with bile and spittle, all the women with whom he had ever slept were gathered together. He could not count them: there were beautiful ones, with eglantine in their hair and pearly smiles, cajoling like the starry nights of an Andalusian summer; and there were aloof ones, who appeared chaste on the outside, with hidden allurements; and misshapen, hunchback ones whose features revealed the smirk of rare and poisonous vices; there were curious children and nymphomaniac old women; some who did it for lust and some to quell their hunger. And all of them, naked, crumpled from lascivious exercises, thronged round him with practised gestures and shouted propositions, vying with each other, arousing him to a turmoil of lust, until, in great fear, he swooned. Then an abrupt fall woke him, trembling, as if at the roaring of a hot, dry wind, soaked through from all the turmoil and horror.

If only he could free himself of her!

<center>*　　*　　*　　*</center>

And so they lived alongside each other, brooding, turned in upon themselves, preoccupied with their soul's misery, through leaden, stranded days; rigidly avoiding words and glances, they gnawed at their hatred. And each was furtively waiting to see if the other would start, fearing it and

<center>77</center>

craving it. And then, because their life was unbearable, suddenly, just so that something would happen in the dreadful desert of their emotions, uttering shrill curses, they would assault each other with love, with a hurried, wild, grimacing love that made them disgusted with themselves, and they buried themselves in each other until they were conscious of nothing, nothing.

Free Again!

At last he was rid of her, and for good. He was free again. The feeling of oppression left him, the yoke split, he could breathe a sigh of relief. He was his own man again. He could devote himself to art once more.

And it had come about through her, through no fault of his, without his help, without his complicity, the break had come through her alone; not a whiff of reproach touched him. No one could accuse him of having rejected her; he had no responsibility, nothing to repent. It was she who had left him, deliberately and of her own free will.

All that was very nice.

Just as he had hoped in his wildest imaginings. He could enjoy the gift of freedom with an easy conscience. It was impossible to regret it, because it was impossible to avoid it.

And that was something else one should bear in mind, that she had not left him for a more handsome, younger or more amusing lover, but for a vulgar monster, a blackamoor, because he was rich, very rich. It would have wounded his pride if she had transferred her affections; something like that is humiliating. But she had left him for money, purely for money; no need to feel hurt about that.

<p style="text-align:center">★　　★　　★　　★</p>

So he clung to his work and began again his wild, breathless wrestling with the brush.

He hammered himself with ambition and greed and all the stimulants he could find. He boiled his nerves in poems, in music. He goaded himself with the phantoms of his dead hopes.

Nothing helped.

Then he slumped again and and despaired even of art.

That, too, was nothing but a sham. He would never be able to achieve Beauty and Truth. And even if he could, then it was certain that no one would understand him.

What was the point, then?

If he was just common and low like the rest, then he could not produce art. But if he was not common and low, then for the rest the art he produced would be incomprehensible and contrary to all reason. What was the point, then?

<div align="center">

* * * *

</div>

Be common like the rest, have money and play baccarat for his digestion – that was it!

And get drunk, thoroughly drunk, soak his brain until it left him in peace, strangle his nerves until they were silent.

And after a week the whole *quartier* knew of his tempestuous nights in all the dives where there was nothing but wild carousing with brazen whores. And they just called him 'the crazy painter' because he 'was such a lot of fun', tireless in his inexhaustible repertoire of practical jokes They all envied him his crackling, fizzling, sparkling humour and his happy-go-lucky temperament; especially when he talked about his 'little tart' who had run off with a 'blackamour', how very *fin de siècle*. He always told that story because it cheered him up.

<div align="center">

* * * *

</div>

When he felt in the crack under the door that morning, he found two letters there. The first was large, soft, grey; he recognised those curt insults just from the handwriting: from his tailor, the fellow had become insolent lately; and anyway, it was just the same old story about money. Quickly he tore open the other letter.

'My darling pet rabbit,

Just time for a few hurried lines, I have still to get dressed, and the chimpanzee is going to buy me some pictures now, since they made all that fuss about Monet's daub of the Soledad Fougère, but of course, I wouldn't

stand for that, and then I remembered, it makes no difference to me but it might be your big chance, he's already promised and will pay anything you ask so don't be shy, make him pay through the nose, send three or four, whatever you happen to have, but send them straight away and with as much bare flesh as possible.

Hearty kisses all over – must dash now – from your ever-loving Fifi.'

<p align="center">★ ★ ★ ★</p>

He was pleased that the decision had been made for him. He preferred to think of all the money, all the money in shimmering piles, how it would glitter and chink, bright, cheery ... money, money ... he sucked at the slippery, slimy words that brought the water to his mouth and licked at them with all his thoughts.

He set off home to deal with it straight away, so that it would be done, unalterable, packed up the four paintings and sent them off that very day. The next day, in the morning, punctually with the first post, came his price, in clean notes which felt good to the touch and crackled with soft suggestions as he stroked them tenderly. He found their delicate blue positively relaxing; now at least he could afford to give his tailor a piece of his mind.

The first thing, though, was to turn himself into a respectable human being. He was tired of this gypsy life: debts and ideals. He suddenly felt – God knows where they came from – powerful urges drawing him away from all this nonconformity and pushing him towards conventionality, and they felt good because they were something new; he had really rather overindulged in the other kinds of feelings on the menu, He suddenly found himself so reasonable, so mature, so adult, having put away all his silly pranks, far, far away, and so composed; from now on he was going to concentrate on reality, on tangible enjoyment, which could enrich both nerves and senses, on being positive like other people; all that head-in-the-clouds striving led nowhere.

His new clothes had their effect. He spent his days

rehearsing the new *homme de chic*. It was only now that he realised that you really do think differently in patent leather shoes and kid gloves, the brain is shunted onto another track; it was obviously the homespun that had caused his former confused idealism, now his feelings came from finest English worsted, lined with satin.

* * * *

Yes, the school of love taught true wisdom. You got quite badly mauled, but in the end it did mean you had all the nonsense knocked out of you. What you learnt there, you learnt for the rest of your life.

Taking it all in all, there was no need for him to regret his affair with Fifi. The six months had not been wasted; they had brought him to his senses. They had cleared away all his romantic nonsense and turned him into the natural representative of the age.

And now he could live his own life. He concentrated on his baccarat and, after he had bought himself a pair of yellow trousers, learnt to ride. So as not to neglect the artist within him completely, he sometimes composed outfits to wear.

He was firmly resolved never again to take anything seriously apart from himself

* * * *

Often, as he gazed out on the declining days of autumn, he thought how agreeable, how relaxing the coming winter would be, full of well-earned pleasure.

Extracts from Hermann Bahr: *Die gute Schule*, S. Fischer, Berlin, 1890.

81

Arthur Holitscher: *The Poisoned Well*

There are certain individuals who pass through the crowd like a whiplash. They dart like a tongue, painful and shrill, they gash, insult and incense as they pass, and leave behind wounds which only close with difficulty. They themselves seem to have no awareness of the powers which they possess; they are like instruments lying upon the workbench of some higher Master, obedient to his will, a Master who will use them according to inscrutable laws. Their constitution encourages a compliance with the Master's wishes, they are good, reliable tools in his hand – perhaps he created them himself with materials whose essence and origin are known only to him.

A young woman who turned up towards the beginning of March in Monte Carlo in the year 188- called forth similar observations in those who were able to distance themselves from the hurly-burly of frivolous and numbing distractions by entering a more profound excitation. Her appearance was such that many whose path she had crossed suddenly, and with lightning clarity, believed that they were able to discover the closer affinities between men and the tropical forms of nature around them; those who had been driven to Monte Carlo out of boredom suddenly gazed into the world with cheerful animation; the frivolous became melancholy, the melancholy frivolous, and there was certainly not a man in the place who could resist the enchantment which her personality radiated like a mysterious power, animating and attracting all things. She always appeared – in contrast to the fashion which prevailed at the time, preferring faded colours and delicate half-tones in which the society that prescribed them began to give expression of its own lassitude – in a dazzling white silk dress and a large Florentine hat surrounded by white feathers, and strolled up and down the avenues of brown-

black pines and olives, of purple magnolias and lush green cacti, against the deep blue background of the sea and the Italian sky. Her tall, indeed very tall, figure stood in gleaming contrast: she seemed almost extended above her true height, white as all the colours of the South together, almost bluish, like a threatening flame. The only splash of colour was provided by her luxuriant, copper-coloured hair that was so rich and heavy that it seemed as if it would pull the slim body backwards, her blood-red lips and her beautiful, expressive eyes whose colour no man could determine with precision because none could tolerate her gaze long enough. These eyes also changed colour according to her moods, from the tired blue of the turquoise to the drunken azure of the sapphire. A posy of brightest anemones and lilac was stuck in her white leather belt, flowers whose intoxicating perfume rose like wishes both passionate and silent. A white Russian greyhound never left the young woman's side, a graceful creature answering to the name of Only. It was easily discovered that she was called Désirée, that the letters she received were written by a man and had a German postage stamp and that her chamber maid spoke the purest Parisian French. More than that it was difficult to assess. She had her meals in her room, always went out alone and even the most daring of men caught his breath at the thought of approaching her. She was surrounded by a powerful magnetic field of unapproachability, but outside this circle passions raged wherever she showed herself.

[. . .]

One day – it was early autumn – the French maid entered the boudoir holding a visiting card in her hands which had just been left with the porter. Désirée took it, read its name, and looked at it again. She looked at the maid for a moment, who lowered her eyes. Then she ordered the stranger to be admitted into the Grey Room. The card bore the name: 'Sulzwasser, Doctor of Chemistry'.

Sulzwasser gave his hat and cane and followed the groom, a pretty pubescent boy dressed in a black livery

and ballroom slippers, through the antechamber into a high, circular room whose light was received through a dome-shaped roof of translucent glass. As he walked through the room he noticed that the walls, from top to bottom, were concealed by old Flemish Gobelins with illustrations portraying in a light and simple manner the legend of the fountain of youth; the tapestry showed the young climbing out of the spring on the right and moving like an hour hand through all the phases of life until they reached the other side, senile and decrepit, staggering towards the spring again.

The youth lifted the tapestry which portrayed the fountain itself and Sulzwasser found himself in a spacious, oblong room which likewise seemed to be bathed in grey light. He noticed first of all a splendid, life-size portrait in a deep blue frame which took up one side of the narrower wall opposite. It showed an elderly, alert man in a white nightshirt and blue cap, stepping energetically towards the viewer from an orange background; undoubtedly the work of the Scotsman Whistler [sic]. Through the wide window of the left-hand wall, half-covered with curtains of light-grey Indian silk and before which stood a Steinway grand piano, one could see the English Garden's ancient plane-trees whose foliage, in variegated autumn hues, thrust against the panes.

But on the right-hand side, flanked by a large bejewelled ebony Buddha, into whose base a portable, triptych altar by van Eyck had been inset, and a worm-eaten Queen Anne cabinet whose cut-glass panels revealed a plenitude of priceless bric à brac (Italian musical instruments, Greek lamps, old French books of devotion with richly coloured binding, statuettes of jaspis and gold, ceramic fetishes of peoples long dead, worn away in monstrous rituals, Rococo fans and swords from Toledo covered in patina, an hour-glass by Cellini with softly sifting sand) there stood a narrow Gothic throne on three steep, purple steps. It only had one seat, supported by slim columns and crowned by a narrow pointed baldachin; it stood there, the

strict rectitude of its form accentuating in a mysterious way the eroticism of the room.

With arms crossed and lips pursed, Sulzwasser approached the regal accoutrement and studied the ivy which climbed to the top of the columns where it embraced an open centifolia with red, silver and green foliage, created to cast a mysterious radiance upon the head of the enthroned [. . .] On the back of the throne, at head-height, a round majolica disc had been inserted, whose gleaming metallic shimmer gave the impression of an eternal halo. Sulzwasser's attention was drawn to this object and he took out his pince-nez and scrutinised the plate more clearly. It was an antique piece from the school of Andreoli from Gubbio, a so-called 'bridal dish' composed of the head of a blonde, august woman: the similarity to the head of Désirée Wilmoth drew an expression of surprise from Sulzwasser's lips. In addition the eyes of the sculpture were formed by metallic colours of such a composition that they looked down upon the supplicant with the same coruscation that had followed him with unabated intensity for the last seven years and had not left him . . .

Around the head the following inscription could be read, on a fluttering ribbon:

> Mona Desiderata Melio De Lo
> Sole Bella E De Lo Disio!

He heard a gentle rustling and before he had time to put back his pince-nez a figure had walked past him and mounted the throne. He stepped back and stood with his head bowed, struggling to master the confusion which had suddenly seized him. When he looked up he was calm and cool, and read the words 'Melio De Lo Sole' above Désirée's head. She was looking at him.

[. . .]

It had meanwhile grown dark; Désirée pressed a secret button and a quadrant of lights on the ceiling threw forth their radiance. Now Sulzwasser could study the rest of the room, and this he did at a leisurely pace in order to let

Désirée study his appearance, one which certainly had not grown more attractive over the last seven years. He slowly turned round. Apart from the curtain through which he had stepped – a heavy brocade by William Morris coloured in gold, light grey and matt olive representing pineapples in light foliage in which birds were sitting – the fourth wall had as its sole decoration an antique Venetian mirror whose glass, however, was clouded. It was placed exactly opposite the portrait of an elderly gentleman but, of course, did not reflect it; it seemed, rather, to capture within its splendid frame a circumscribed and perished world.

On the floor were soft grey carpets; the walls were composed of ash-wood panelling which ran right round the room to the height of a man, and above this was a narrow gallery on which stood thirty-five jugs of various shapes but roughly the same height – Etrurian amphoras of clay with black decoration, Greek wine bowls of pure gold, vases of leek-green jade worked in a delicate filigree, stone Indian jugs, wooden tankards with ivory inlaid work, urns representing horses' skulls derived from Gaelic warriors' tombs as well as contemporary products, such as delicate Copenhagen glasses which seemed to be painted in mist, Tiffany glass glowing in light and the work of a Flemish potter who produced jugs composed of obscene entanglements of human figures; there was also work from the workshop of the Gulf of St. John which shimmered in colours which we find normally only in dreams. All these jars were filled with water which tempered the atmosphere and killed the miasmas of this room, a room dedicated to transience, so that only the transfigured memories remained between men and things, clear, unoppressive and gently illuminated by the lamplight.

[. . .]

Since early morning the poet Sebastian Sasse had been wandering through the awakening city. The weather was dreary, the autumn dying under winter's onslaughts. The young man walked and walked, clutching his coat tightly against him. He had reached the edge of the English

Garden and here, for some reason, he stood still and took his notebook out of his pocket, a large, awkward book that you can buy anywhere in small markets or village shops, along with bandages and sugar-coated biscuits, a large notebook with a slot to hold a pencil. It also contained the letter from Meinewelt, his publisher, a letter which he had read more than a dozen of times. He did no more than twist it absent-mindedly between his fingers and turned down a narrow path, staring at the pages without taking them in. The few words which he *did* see, and which had been written more energetically on the paper as though Meinewelt had almost gouged them out to give them greater emphasis, stood out boldly before his eyes, and as he turned the pages he saw them again: Life, Life, Life, Life.

He put the letter and the notebook quickly into his pocket and strode over the wet gravel, covered by innumerable brown snails, tiny living creatures who had crawled from the safety of the grass and covered the path, causing Sebastian to concentrate upon their protection. This word Life! The last few weeks had been full of it. He remembered the anxious, unquiet days back home, the cupboards and chests, the wood-panelling and the beams in the roof where there had been such a throbbing and groaning, and when the letter arrived he knew that these noises were sighs, were moans at his departure. And now everything moaned, spoke, rejoiced and wept: Life! Life! The ticking wall clock in the empty house, the doors with creaking hinges, then the drops of rain which flew against the carriage window, the wheels that roared in time with the wind, which blew across the empty spaces, and now his soles on the gravel: they knew nothing but to announce this one word which had anchored itself so deeply in his consciousness. It had stood before his soul for years like something mysterious and superhuman, something that one had to honour without knowing what it was, what it consisted of (it was a little bit nearer than God, but no less powerful and terrible): yes, it was something, perhaps, that

one did not wish to understand because one feared it, something to which one paid tribute lest it should feel offended and seize one, body and soul. Like a remote, invisible idol of whom the Rumanian peasants at home had claimed had brought the thundering avalanches, like that bear which the gentle lambs had worshipped on the forest-girt pastures; this is how Sebastian had envisaged that mighty destiny over there which was called 'Life', and of which he was now a victim.

He sat down on a bench before an empty expanse of grass whose furthest edge merged with a gentle rise, a hill whose top was crowned with a snow-white cupola on a circle of pillars standing before a dense clump of trees in variegated foliage. He was preoccupied with registering the first impressions which this unknown object had called forth in him. A rainy day which shrouded towns and villages in impenetrable mist, then a moonless night had brought him hither, so that the journey might appear as a lengthy sleep which had begun at home and ended with his awakening in this strange land. Perhaps this was the path into life and the best expression of the transformation which his existence was suffering. And now, Munich . . .

When he looked at it there had been much that had hurt him in the first few hours. On a square between two Greek temples built in the most classical style and whose appearance had filled him with a secret joy, and through a monumental gate which he immediately recognized as an imitation of the Propylaen there had blundered a mob of rough labourers in overalls plastered with mortar and heavy boots: their coarse shouting had echoed between the columns. Before a Baroque palace with delicately twisted columns and gilded railings he had seen a soldier, stiff as a ram-rod, present arms with the angular precision of an automaton. And even the tone and the expressions of Meinewelt's letter, which he had just held in his hands, did not seem quite so sincere and convincing as before, now that the feeling of expectation and the onslaught of novelty had sharpened his senses to a higher receptivity. And why had he enclosed the money?

He became restless. A thousand tiny shocks drove him to his feet and forced him onwards, the dread, as it were, of that which was close at hand, the image, growing larger, and more disturbing, of some great destiny, some great danger which tempted, tempted like a siren and did not let go, so that the cries of doubt and terror slowly transmuted into cries of ecstasy.

He hurried forwards, blindly, and smiled to himself when he noticed that the path he was treading ran in a wide sweep up to the Monopteros on the hill. He also realised now why it was that he had come to Munich: it was not so much his own personality that mattered, as Meinewelt's desire to show him what life meant among the people here; what was more important was the role he, Sebastian, had to play in serving this vaster, more mysterious force, far vaster than life itself, this pulsing and incomprehensible vitalism which spoke through him to the people, which belonged to him as fervently and intimately as the soul belonged to the body, and it formed his own indispensable possession, like his eyes, his voice, those dreams that visited him at night . . . And as he felt how he himself was stepping into the background, was effacing himself before this greater purpose the restlessness left him, and his heart became quieter, more serene.

He had now reached the circular columns and gazed down at the wide meadows at the foot of the hill, and the avenues of trees that confined them. It must have been nine o'clock: the pointed towers of a church whose misty outline was visible behind the trees sang forth an indistinct carillon. Thin veils of cloud scudded across the sky, crossing, parting, and a ray of sunlight intermittently found its way through the greyness and a golden mist crawled along the meadows. Yes, it was much better here than in the oppressive streets where one had to force one's way against the fronts of houses. The trees, the valley and the wide horizon beyond the trees, the rustling in the branches from which drops of rain were dripping: all this reminded him of the eloquent silence of the forest at home which had

provided him with his finest inspiration. If he felt better here in the park than in the streets he must feel closer to the trees than to houses! and as a violinist, immediately he gets out of bed, runs in his shirt and bare feet towards his fiddle to hear its tone, and to convince himself that he still possesses his skills as an instrumentalist, so Sebastian allowed the impressions of this landscape to overcome him, to see if a new melody would arise within him.

The forest gleamed reddish and brown, with splashes of sulphurous yellow among the blackish-green pine needles. In the distance a narrow canal with dirty, fast-running water flowed through the meadow, and this meadow was covered with millions of autumn crocuses, sparkling in the dew like tiny flames of phosphorous ... it was not a harmonious constellation of colour. But now were the days of decay, the days of — he suddenly felt a rhythm gently rise within him, rocking gently before him ... in these days ...

He leaned against a pillar and listened. From afar, from across the meadows, a poem came on wings towards him. He pulled out his book and wrote:

> 'These are the days when all the roses fade.
> In gardens, on the leafy covered lawns
> I see the scores of autumn crocuses.
> Nature is dying, and she crowns her head
> With amethyst and topaz, this I see
> In autumn, autumn . . .'

Into his mind there crept the gentle memory of the previous autumn when he had followed the coffins of his mother and his father into the cemetery, and had returned alone to the deserted house;

> I listen: 'The autumn is a mirror of my soul,
> Which loves to float in melancholy air.
> Grey through canals you lonely waters flow
> Like misery across an ancient brow.'

He gazed in front of him and tried to find what it was that

the wind was saying to him which blew from the woods and whispered through the columns:

> 'I stand and listen in the morning winds
> Which whisper timid words into mine ear
> Of people whom I've loved and early lost
> And those I seek, and those I'll never find . . .'

He paused, surprised, and read the last few words again: they were the opposite of what his hopes, those hopes which had accompanied him here, had announced, loud and unequivocal. Was it an omen? He tore the poem into little pieces, and let it flutter with the wind. For he had learned to despise all those thoughts which had formed within him and which did not exactly correspond with the language which his soul was speaking at the moment of their genesis. Yet it also became apparent to him that that greatness which he had recognised as his master may have manifested itself in these verses, and he may perhaps have been a poor servant in that he no longer stood in a harmonious relationship with the words of the poem . . .?

Deep in thought he gazed at the white specks which the wind blew away, and he felt that nagging feeling of doubt again, that uncertainty, when suddenly he noticed on the narrow footpath which ran through the meadow the delicate, slender form of a young girl who was dressed in the same colours as the crocuses and who was walking towards the Monopteros, looking in the direction from which the whirling scraps of paper were blowing.

In her features the spatial difference between them was transcended; her appearance seemed to Sebastian to be those of a tall, slender autumn crocus between all the other flowers, except that this one was moving across the grass instead of being rooted there, more hovering than moving, in that gentle rhythm in which the meadow rose to a hill, in which the path meandered amongst the lonely trees, and this rhythm caused the girl to slip into the lawn when she bent to pick a crocus, and glide forth again when she rose and added the flower to the ones which her left hand was

pressing tightly to her breast. Sebastian walked down the path, slowly at first, but then quicker, towards the meadow, gazing at this apparition and delighting in the harmonious accord which existed between it and the landscape round about. He was drawn to think of the timid, silent creatures of the forest whose colouring so cunningly imitated the ferns and the foliage that one saw a pair of motionless eyes gazing from the thicket without noticing the animal to which they belonged and which inspired confidence rather than fear, for it was the sighing, peaceful forest itself which seemed to gaze into the eyes of the lonely wanderer [. . .] He followed the girl with the crocuses some way behind; he came closer, and saw her face as she stepped on to the meadow to pick some more.

It was as fair and lovely as the morning, but also as overcast, and she looked at Sebastian with a dispassionate calm, and his heart found no cause to beat faster. Strange! She was like a fairy from his homeland, transported to these alien shores. And in his imagination he carried her to his room in the parental home, seeing how well the faded colours of her dress and her ash-blonde hair matched the olive hues of the wallpaper, the worn brown of the cupboards, chairs and panelling, and the gleam of the polished brass. So what was it: Life? He knew that he could not express it positively, in a neat formula. Previously he had thought it meant: Out There. But now that he had turned his back on his roots the concept Life had become blurred, and the attributes that he had previously bestowed upon it became confused, dangerous and ambiguous. The reason for this, perhaps, was that he and his parents had led such isolated lives; the reason that he was a poet was certainly more convincing. He looked at the girl carefully and sought for a name more fitting to her, a name which his soul could use to call her, to tell her what it was that oppressed her. Often, so often at home had loneliness slipped past him in many forms, through the room in which he was sitting, and whose ceiling its intensity had raised even higher, through the forest where he had wan-

dered and whose treetops it had shaken more violently than the wind was wont to do, and he repeated to himself the fantastic names which he had sought to give it, names compounded of shimmering consonants and vowels in which light and shadow mixed in a cunning chiaroscuro. He would give this girl the name, Olivia, she was so gentle, and one can speak tender words to an Olivia. One could say to her: look, it would be lovely to take you in my arms and fly home with you, without having experienced – suffered, or enjoyed – what beckons, for you, Olivia, with your autumn crocuses, you are: *cowardliness.* Yes, I know you! And so I must avoid you, like peace, and dreams of my room at home, like the spirits of the forest and its silence, because I must not fall asleep or lose myself in the peace of insubstantial harmonies. If I had met you in the street I would have overlooked you or I might perhaps have taken you for a part of all that strangeness, but here you remind me too much of those things I should not think about. Meinewelt – who calls himself my friend – wrote about the shrillness of life, about dissonances which I was meant to tame, and to form into harmonies for my own use, and he continued that the poet was a conqueror of life's utterances, not an idle listener to the endlessly harmonic tone of remoteness, and into this chord you would only bring a deep, scarcely audible note to which my ear would soon become accustomed, and I would be lulled more peacefully by that unchanging sound, that scarcely amplified chord if you were to slip into my loneliness! I know it well, when men are asked the question: what is Life? they have the answer ready: a Woman! They think of life as an act of communion, enacted with this woman, a companionship experienced day and night, a countenance kept close to theirs, ageing at their side with the passing of the years, but whose brow remains watchful, raised, when they cannot protect theirs, growing tireder, sinking to their breast, but I. . . .

A cloud of fantastic visions beat about him, fed by the flame of his wishes, his desires, his hopes for the future, and

the gentle, quiet tone of the autumnal landscape, together with the pale violet of the crocuses, and only the sated and deeper tints remained, those colours which he saw at home beyond the range of mountains, in the mists which gathered across the setting sun and in which the eye saw such amazing, over-powering images – giants that fought, danced, murdered and loved – when it forgot the silence of nature over which night was breaking.

When Sebastian reached the cross-roads, one path leading to the town, the other deeper into the English Garden, and thought of the girl again she was not to be seen, no matter in which direction he looked. But he recalled her apparition with gratitude and vowed to return to this part of the park, and at this same hour, whenever he needed the peace that she had given him today.

And then he took the road into the town.

[. . .]

As they were seeking their places in the darkened auditorium the last bars of the overture signalled the raising of the curtain. A muted melody rose from the orchestra, and the finely-cut features of Richard Strauss could be seen against the background of the players.

Dressed in white, a crowd of lamenting ephebes, maidens and elders swarmed around a marble altar in a dark funereal grove, with torches and wreaths in their hands; everyday faces, singing songs of night, threnodies in an archaistic minuet, passions forced into a lace jabot à la Louis Quinze . . . and suddenly the isolated cry 'Euridice!' from a man with a woman's hips and a high voice, the whole impression muted, mannered and mild, like an Ionic column with a Baroque capital. 'Orpheus is written for an alto voice,' Meinewelt whispered, 'Isn't that a wonderful piece of alienation? We hear a woman representing a man who is lamenting the beloved.'

The chorus now separated to perform sombre, stately measures: a youth mounted the steps to the altar and extinguished his torch at the top. All were silent, and laid their wreaths at the base of the sacred, memorial flame,

94

disappearing silently into the undergrowth; gradually the orchestra died into silence. Orpheus alone remained. He gazed around him, then up at the architraves, at the painted trees and the dead torch before the white altar whose flame – a real one – flared and twisted. Abstractedly he seized his lyre and plucked the strings which gave forth a quiet, humming sound, he raised his brow and the footlights cast light and darkness across his delicate features. He was singing a recitative, quiet, sustained and dignified, misted over darkly by the irretrievable loss of the lamented one.

'I hope you like it?' Meinewelt asked quietly. 'By the way, I've just seen her, she's here!'

'Who? Euridice?'

'Her, Désirée, the woman I told you about in the foyer. How she sits there, God, how she sits there!'

Sebastian gazed steadfastly at Orpheus who had thrown away his lyre and broken out into sobs of desperation. How strange it all is, mused Sebastian . . . Where is the stage? Where am I? I have been brought into a theatre before I have really seen what reality is: and am I to trust his, Meinewelt's guidance? At home I didn't recognize any division between dream and reality, between myself as poet and man, my twin brother. And now all this new confusion! Am I Orpheus, or is he me? I am sitting here motionless between all these people, my senses alert to what is happening, and through me are flooding the feelings of centuries! [. . .] My God, why do I feel like this? I cannot shake it off, why don't the trees bow before him and the wild animals creep from the bushes when they hear such laments? But of course, it's only a stage in a theatre . . . And in real life? But I'm forgetting, it's only a legend. And yet, he – or she – has tears in her eyes and she weeps for a woman, and it affects me so deeply. What's Hecuba to her? And she knows that she'll win Euridice, and then lose her, because she's learned her lines. The spectators sit in silence and listen, entranced.

[. . .]

Désirée Wilmoth was sitting in a box in the stalls: she was wearing her cameo which was gleaming on her heart against the deep-violet background of her plain brocade dress, cut low in the Florentine manner; the cameo shone in a milky iridescence. Her throat was visible, as was a narrow strip of her splendid bosom. Meinewelt saw and heard nothing of the opera, and only had eyes for the gleaming spot on her heart: his imagination seized hold of it, and he soon saw her gleaming white body, hard, with classical outlines: one unique jewel [. . .] 'Let's go,' he whispered, before the final scene. 'There's the final apotheosis, I know, but let's get out . . . Come.' They left the theatre on tiptoe. And in the street Sebastian stood still. 'Meinewelt, who is she?' The editor looked at him. A radiance had spread over this young countenance, and candles were flickering in his eyes as though the joy of life had set them in the windows when the Queen was passing. Meinewelt slipped his arm through Sebastian's and pulled him forwards. 'Come, let's go and see her. She said I should, after the performance. We'll go there now . . .' They set off, and as they walked Sebastian asked about Sulzwasser, whom Meinewelt had pointed out before the opera began, and who had exchanged a few words. 'Well, what did he say to you, Sebastian?'

'He didn't look me in the face. He looked down at me, and his gaze had a biting quality, I felt it on my skin . . . and then he gazed at the lady in the box. It offended me that he kept staring at the box as though he had no interest at all in what he was saying to me. It was the same old stuff, young man, young poet, and in a mixture of pity and irony. But who *is* she, Meinewelt? I beg you, tell me, and who is this man?'

'Oh, someone who plays the stock exchange, some millionaire, I don't know. Certainly he has a name, and is talented; he invented something once . . . He's one of those youthful acquaintances that stick to you for ever afterwards like a burr which you can't shake off.'

'He was talking about Parsifal, I couldn't quite make out

the context, Parsifal and Kundry, Orpheus and the Maenads
. . . I couldn't understand a word, yet there seemed to be
some sort of intelligence at work. But, my God, why did
he seem to be so repulsive? He also claimed that Orpheus
was the first *décadent* and that you had done well to take
me to this opera above all, there was no other work which
made the listener feel so close to the hero . . .'
[. . .]
He strode forward impetuously, and Meinewelt had diffi-
culty in keeping in step with him . . . The smooth facade of
the Imperial Library reared up before them with the pointed
twin towers of the Ludwigskirche in the background.
During the ride to the theatre, and also that morning,
Sebastian had been struck by a sudden vision of Venice, and
had recalled an old print that his father had had in an album
at home and which he had often looked at – Venice, a
section of the Doge's Palace with the thin needle of the
Campanile behind; and this had sufficed to still the yearning
of a youthful soul, the flight towards beauty, the past, the
sun – and this gentle reminiscence made him tremble with
ecstasy. To glide along the canals in a black gondola, past the
Lido, out into the rocking plain of the lagoons, half sitting,
half reclining, his cheek resting against a warm hand, a
round knee, and on the lids of his eyes, eyes turned inwards,
towards happiness, to feel mild blessing rain, to hold back
the verses which would break forth under an unspeakable
pressure, to restrain them so that the holy, silent hour should
not be tainted; to know nothing of the presence of the world
than the music of the waves and the cries of the gondolier,
melancholy and melodious, and to glide through the year-
long evening hours, with no wishes, no desires, endless . . .
 'Look!'
 Meinewelt had seized his arm. An English coupé was
driving past them, drawn by two greyish yellow horses,
and the figure within the carriage became visible as it
passed beneath a street lamp. Startled, Sebastian doffed his
cap and gazed after the carriage, which drew all his dreams
with it and was soon swallowed up by the darkness.

'Meinewelt, don't torment me!'

'It was Désirée Wilmoth.'

'You've already mentioned that name.'

'And the name is enough. I'm not a poet, and can't drag all sorts of adjectives from my brain; besides, she's not the sort of woman who needs any. Do we not say Astarte? Semiramis? Sarah Bernhardt? I simply say, Désirée Wilmoth. That should suffice. That is nothing more, and nothing less, than everything.'

'But does she write? Is she a poetess?'

The editor laughed aloud at the recumbent statues of philosophers which decorated the driveway to the library which they were just passing. 'No, God knows, she isn't that, she is a poem, rather [. . .] And how old are you? Twenty-three? Very well, let me tell you this. He who keeps her after he's twenty-five will remain a wretched cripple for the rest of his life, but woe to him who's never possessed her!'

[. . .]

A small table with sandwiches, tea and fruit was standing in the round room with the tapestries, the overhead lighting and the gleaming parquet floor. The groom ushered in the visitors, told them to help themselves, waited in the doorway, then carried the table out. The two men were alone, and waited for the mistress of the house.

There was another table in the room, more of a large, oval ebony plate standing upon a dainty taboret base; on this table there were something in the region of twenty porcelain figures, milk-white and exceptionally dainty. There were gentlemen with elegant swords and elegant lace falling over their wrists, and ladies in enormous crinolines who were curtseying to each other or standing engrossed in porcelain conversations; others, young aristocrats by their appearance, were dancing a minuet in the corner to the strains of a small orchestra (one could hear the fine, glazed harmonies of fiddle, viola d'amore and flute); an aged roué, with tricorne under his arm, was looking through a lorgnette raised in a most affected manner at the

98

young ladies before him who graciously bowed their heads with their enormous castles of hair and rested their thin arms on their crinolines; finally another beau with a wrinkled face and a jet black beauty-spot beneath the right-hand corner of his mouth, the only splash of colour in this milk-white world.

'You wished to say something?'

'No – no . . . Oh please, don't say anything to me at this moment.'

Sebastian had stepped to the side and was standing against the Gobelins which portrayed the fountain of youth: he was standing next to the group of senile decrepits who were staggering with heads bowed down the steps. Strange . . . very strange . . . Had he not experienced all this before? The hours of this day had passed like a procession of veiled memories; now all was still, and he could look the last in the eye. And silently he grasped its insubstantial form. This name, Désirée; this room; no light and yet such lightness, no life and yet this long procession of elongated figures, moving in a circle, and then the tiny dance of white figurines, comical and serious, moving in a delicate dance, and he in the middle, with that name upon his lips, silent, slumbering, yet weaving a glittering, gossamer thread around it all, a web from which the soul called forth names, colours, movements, dimly at first, yet firmer in its plenitude, a rich cornucopia of dream-like seas, which the soul could drink, long, long, longer than from any other earthly pabulum . . . In a trance he compared the room in which he was now unquestionably standing with a room miles from here which he had glimpsed in a dream one July night, and piece by piece he recognised it all again and within this implausible reality there was that word *Desiderata*, a word he had seen the day before in a Latin textbook and from which, like a calyx in a dream, this whole miraculous world had blossomed. [. . .] This is what it was! Sebastian had found it. He gently repeated the word: Desiderata . . . that which, after it had passed through the refining power of nocturnal dreams had lodged in the

imagination of the sixteen-year-old as the expression and the essence of all that time might have in store for him, and all that, unclear at first, would crystallize as yearnings within him. For weeks he had wandered through the forests surrounding the castle, with this word as his only companion: it hovered high and erect beside him, a slender figure of supernatural solemnity, with earnest eyes, eyes which he could well imagine gazing from Lady Wilmoth's countenance.

But he had seen, one night towards the end of August, a splendid rain of meteors through the tree tops, and as he watched the dying, falling stars (stars which he had woven as a diadem in the phantom's hair) he remembered the Latin word 'sidera', and was darkly aware of the ambiguity of the name 'Desiderata' – the one who is desired, but also far! Very well, yes, a pun, a subtle word play of a young student, the febrile juggling with concepts of a boy in puberty, but a melancholy logic formed a bridge between synonyms and conclusion: that desire removes everything that it touches. This insight for a long time drove Sebastian to the point of despair. Now, indeed, he had to laugh at such childish notions, but it was poignant to feel their roots deep within his heart [. . .]

He suddenly blushed to the roots of his hair, for it was only now that he noticed Désirée, who had entered some minutes before.

'Dreamer!' laughed Meinewelt, and Désirée was also smiling. But only for a second; she invited both to sit and took her place on a high armchair which was standing next to the table with the Nymphenburg figurines and across the back of which a length of purple cloth fell in folds to the floor. She had kept on her violet gown but was not wearing her cameo on her heart. She sat there, her chin resting in her left hand, her hand resting on the arm of the chair whilst her slim right hand, white, and concealed by the narrow sleeve to the base of her thumb, rested upon her lap.

[. . .]

They were riding, driving in a small, warm square of cosiness through the small windows of which, to left and right, they could look out at the alien, frosty world outside; they drove through streets and alleys, across a square, beneath an archway through all the changing images of the city, lulled by the gentle feeling of enclosure and remoteness and the drumming of the horse's hooves upon the snow. It had begun to grow dark outside and the darkness in the coupé gathered even more tangibly between the two people. It stopped before the Imperial Library and the Ludwigskirche, that 'piece of old Venice'. The groom jumped from the carriage to light the lanterns, and in the light Désirée could see a troubled expression on Sebastian's face. It was at this spot that he had caught the first glimpse of her, in this same carriage, silently gliding away from him . . .

[. . .]

The carriage turned into a side street and before them lay the English Garden with its gleaming masses of snow, white despite the darkness, and the glittering starkness of its ancient trees which, like half-frozen giants, were pulling the night from the skies to cover themselves. The horse's hooves were muffled by the snow and, rocked in silence, they galloped along the paths of the English Garden. Melancholy overcame them both, and, taking her hand, Sebastian slid on to his knees and buried his face in her lap.

'I am suffering, Désirée, I don't know where to turn. The world does not treat me kindly, and an alien poison creeps through my veins, ceaselessly. There are so many good deeds that I could do, but fear to do them, as I might seem abject to myself. My heart is wounded and I can no longer create as once I could. I must . . . share you with other people, yes, I must, Désirée, and my breath is tainted with envy and bitterness.'

'But, my little one, with whom must you share my heart?'

'I used to write as I breathed – naturally, freely – but now I am oppressed. The verses that I once wrote were

101

like a crystal edifice in which I saw myself as the centre: now all is dim, and I can no longer see myself in my work.'

'My little one, with whom must you share my heart?'

'I don't know ... with him, Sulzwasser, with everyone ...'

'What foolishness! My little one, what do these people mean to me? Can you not see how limited they are in their expressions? And are there any boundaries between us?' She let go of his hand and pressed her cheek to his head, speaking gently.

'I love you. Why worry about the rest? If your poetry cannot satisfy you, then think of a more faithful beloved.'

'No, no, you mustn't ask me to do that, how base do you think I am, Désirée?'

'I want you for myself, do you understand? You must belong to me and nobody else, for with me alone can you find what eludes you. You must deny everything that does not have my name on it ... You must think of nothing but me, as long as I wish it. This is the secret!'

This last sentence she spoke loudly, solemnly, over his head, as though it were an incantation. and then she added, gently, as though she were speaking to an invalid: 'All your doubts will disappear when you surrender yourself to me.'

Her hands were gently stroking the top of his head; beneath the warmth of her fingers which had lightly dishevelled his hair Sebastian had the feeling that his thoughts, feelings and energies were spun together into one thread which gradually, and without his being able to say how it happened, enfolded the nerves of this woman like the strings of an instrument, so that they sounded fuller, stronger as he himself was sinking, limp and broken. She was still talking with her even, quiet voice whose comments were never overheard. Sebastian was overwhelmed by the yielding softness of resignation: he no longer sought to understand the sense of the words whose gentle music, fused into one, was passing over him. [. . .]

He noticed a place in Désirée's fur jacket where the fine hairs of the cloth opened and closed as her breast rose and fell. With wide-open nostrils he breathed the perfume with which her underclothes were always sprinkled and which swam in the warm atmosphere of the carriage like a damp cloud. The bevelled panes of the windows were also haunting with their frames which were of a reddish-brown colour, whilst outside the coupé was painted a dark green. You could see the snowy lawns outside the carriage refracted into rainbow colours through the bevelled glass edges, a delightful play of colours, a melting landscape, something to which he would love to sink, in oleaginous softness, expire, die . . .

He dimly felt that he was starting to lose his reason beneath the caresses of these warm fingers which were paralysing him, sucking him dry, destroying him: a slackness had suffused him, making his joints liquid, his sinews limp . . . 'Give me all that you have withheld from me, give me the last thing of all, I shall belong to you for ever' . . . the voice was singing, and when she had finished he felt her hands lifted from his head and, awoke.

[. . .]

With the first mild days of Spring the greyhound, Only, began to creep around the house in a sick, miserable manner, and he became so ill that the doctor had to put the faithful animal out of its misery in the garden in front of the villa. Désirée watched the execution from the window. Next day she sent the French maid to an animal dealer in Bogenhausen and she returned with a large, splendid cat with long black fur and a pink fleck between its eyes: Désirée gave it the name Pandora.

Pandora soon got used to her mistress, as Désirée did to her, and they were soon inseparable, the cat following her through all the rooms of the house, day and night. But towards Sebastian it nurtured a secret hatred.

Often, in the twilight, he would suddenly see two flames of phosphorous staring at him and which, without making the slightest sound, changed their place from a

103

corner, a cupboard, or the folds of the curtain. He had always been a keen animal lover and tried to play with the animal (even though he had been startled, upset when he first caught sight of it): he stroked its fine, rustling fur, which crackled and sparked, rubbed the pink spot and the soft folds of its neck and put it on his shoulder, or let it sit purring on his knees, but he soon detected in the animal's movements, as it accepted his caresses, a silent hatred and sometimes, indeed, an instinctive irony. When it felt his presence it arched its back, rubbing itself against the nearest object and only turning its head with the great yellow-green eyes to spy on his movements. He finally chased it from the room whenever he found it. But as a rule the creature only left its place when it saw the threatening hand descend or felt in advance the impending kick, and then only phlegmatically, without haste, with an almost rational compliance. Its favourite place was the conservatory, beneath a yucca tree where the maid (and there was something feline about her discreet and creeping gait, her slyly humble expression and her miaowing French) had made it a silky bed of cotton wool and padding, next to the opulent Roman couch on which Désirée liked to spend her afternoons.

The reason was obscure, but Sebastian felt hmself gradually overcome by a feeling of shame, of degradation and weakness. One morning he had watched, concealed, the two women and the cat during Désirée's morning toilette and had tiptoed back to his room, overwhelmed by the tormenting awareness that there was a certain similarity between himself and the animal and that the animal displayed its affiliation to the house with a greater ease, indeed propriety than he did. Pandora was quite at home here, and quite uninhibited, and it was he, in comparison, who was behaving like an intruder.

Later on that day, when he saw the two eyes gleaming once more in the shadows he suddenly, enraged, flung a thick book at them, but missed and then began a frenzied hunt for Pandora. But it seemed to him that the creature's

movements were relaxed, composed, with a Stoic modera-
tion and not the slightest symptoms of panic, whilst he was
staggering through the room, gasping and flustered. When
he finally caught the cat and had hurled it with all his
strength through a half-opened window into the garden he
heard it miaow for the first time: a single, sharp, minatory
tone . . . A few minutes later he met it again, crouching on
Désirée's shoulder and gazing at him with steely, glittering
eyes.

Spring had set in uncommonly early that year and the
nerves of nature and of men were both badly affected by
the abrupt change of seasons: it had rained incessantly for a
week, snow and ice had melted within the space of hours
and the river Isar had flooded and devastated the English
Garden and the low-lying suburbs. A bridge had collapsed
and one day the body of a baby had been washed against
the gates of the park which stood upon a moderate rise.
The labourers who had been building a dam in the park,
together with the gardener who was inspecting it early one
morning found the baby and reported it to Sebastian, who
naturally concealed it from Désirée. But a prophecy that
the mad Swede Esplund had made came forcibly to mind,
and he was seized by a strange unease. Although the rain
continued it seemed as though the waters were receding
and the danger for park and villa was past. But the endless
stream of tepid, monotonous rain which fell on the gravel
path and window panes (the windows stood wide open
even though the house was heated for the nights might still
be cold) had such an enervating quality that arguments
broke out in the servants' quarters at the least instigation,
and both cook and coachman, who were both infatuated
by the maid, gave in their notice out of the blue. With
disquiet Sebastian noticed that Désirée had started to initiate
him into these domestic matters, matters about which he
wished to remain ignorant and whose discussion wounded
him. There was a short, but ugly, scene which at least
brought the tension hanging over the house to a head and,
in order to distract his irritability, Sebastian decided to pay

a visit to a hamlet in the Isar valley where the floods had inundated the fields in a most picturesque manner.

He set off early in the morning and met Meinewelt at the station, together with the painter Saarmünster who were going for the same reason. He also came across a crowd of Munich bohemians who gathered together when they heard his name and started whispering. The furtive glances and the smiles, the badly concealed envy and the stupid gazes conveyed to Sebastian the topic of their conversation. Meinewelt was sitting with a schoolteacher from Pomerania whose poems had started to appear in the journal, a tousled individual with a Tyrolean hat, leggings and waterproofs who offered a sweaty hand and who almost crushed Sebastian's in a demonstrative exhibition of strength. Sebastian returned to Munich on the next train.

After he had wandered aimlessly around the streets, and crept past his own flat without entering, he made his way to the villa. His dissatisfaction had turned into churning resentment which completely filled him, a grudge against everyone, the world, Désirée, himself ... In the empty compartment on the way back to Munich he had used the moment of composure to pinpoint this particular mood, and a poem in prose emerged with the title 'To be sung to a Lute', which contained the following sentence: 'My soul is a sunflower in the night.' He spoke the words out loud, and sought to express as much scorn as woe. For he was seeking for some strident word, a crude gesture, for something shrill and rending with which to lacerate his sensitivity, the dreamy vagueness of his daily moods. He sought for some naked spot, somewhere to drive in this goad, for something deep and inviolate in order to lash it, but it was apparent that everything was twitching and raw on the surface, and that the beauty in the depths had long since been dissipated. He tore open his coat, seized the paper and read it, in the middle of the street, among the jostling crowd ...

'My soul is a large, dark concert hall, the music has died away, the lights are extinguished and the listeners have gone. The doors are open to the darkness, my soul is dark, deserted and empty, and only dead sounds haunt my soul.

My soul is a small, wintry field next to the mountain lake of my homeland, and in the summer grass grew in this field, and boats rested on the shore, and lovely shadows danced among the high grasses. Now there is snow on my soul, snow in the clouds which press upon the mountains, and the icy mantle of the lake is groaning beneath the weight of snow.

My soul is the veil which conceals its chastity, and my soul still trembles from the far warmth of its chaste nakedness.

My soul is a sunflower in the night.

The mist that hangs over the town, putridity, incense and sweat, laughter, sighing, trembles in my soul. A torn page upon which a poem was written, or was it a prayer?

My soul is . . .'

Sebastian was still holding the paper when, bent, he ran up the steps into the villa. It was only when he saw Désirée in the conservatory, under the yucca tree, that he screwed it up and threw it into the small, bubbling waterfall beside the steps which seized it, swirling it through the channel of the little stream, around the artificial island and into the concealed drain, then out, out into the swollen Isar between the tree trunks and the drowned.

The fine sand of the pathway deadened his footsteps, and he noticed how Désirée started, happily, when he appeared before her. She was lying on the couch, half on one side, reading a book bound in pale pink vellum which resembled human skin. She was resting in a charming attitude propped on her right hand, the sleeve, slipping to her elbow, revealing a white arm, smooth yet muscular; her left hand was holding her loosened hair in a knot above her head.

She sat up when he appeared, pulled up her knees and let her hair tumble over her breast and shoulders. The book slid from the pillows and Pandora, who had been playing with a golden comb, jumped out and hid behind Désirée, purring and baring its teeth, and fixing its claws in the purple cloth.

'Where have you been? You bring such cold with you! Your shoes are wet, you've been wading through puddles.'

There was no trace of displeasure in her voice, and her eyes were shining as she looked at Sebastian. He sat silently on an edge of the couch, picked the book up and browsed through it, avoiding Désirée's glances. It was the *Chansons de Bilitis* by Pierre Louys. Sebastian did not know the work but guessed its contents for he knew how little Désirée would tolerate anything near her which would contradict the mood of the moment or assert its individuality in defiance, whether it be an inanimate object, a living, rational creature or a work of art. Yes, she was mistress, mistress of all: the rest of the world could choose between avoiding her or surrendering to her. And with that mistrust towards all her creatures Sebastian felt once again that he was nothing more than the cat, the cameo on her gown, the golden comb in her hair, and the book on her purple couch. He had leafed through the book in a distraught, prejudicial manner, thinking more of his own suffering rather than the poems which were painted on fine, matt parchment, but suddenly everything faded when he caught sight of the title 'Bilitis' under the heading *Bucoliques en Pamphylie*:

'One woman covers herself with white wool ... Another dresses in silk and gold, a third in flowers, green leaves and grapes ... But I, I can only live naked ...'

And following an old habit of his, and one which filled the rooms at home with verses, rhymes and rhythms, Sebastian continued, reading out loud:

'My lover, take me as I am, without garments, jewels, sandals, here I am, Bilitis, alone ...
 My hair is black of their black, my lips red of their red.
 My locks flow around my head as plumes ...
 Take me as my mother made me, in a night of love long ago and if I please you thus, do not fail to tell me.'

He stopped, and put the book down ... The world of the Greeks.

108

A chord of the deep music of Greece resounded in this book, and there was something reminiscent of that great, pure, fructifying sensuality which had given birth to the gods and to the marble temples on the mountains. Strange that the music of this poetry had moved him so, and that the atmosphere of this conservatory, the foliage and the perfume which the proximity of her body, her loosed hair exhaled, should announce to his senses the same breath of this knowledge ... But why was it that that strange illusion of Greece should seem more familiar to him than the colourful, overwhelming reality which surrounded him? That the printed word should entrance him, whereas the living song should call forth a secret bitterness which drove him to despise himself?

[. . .]

He gazed in distress at Désirée, and from mute discord his soul stretched out its arms towards her, hoping to hear from her lips the answers which his confused senses withheld. She was combing her hair and tying it into a Grecian knot, and this new hair-style gave her features an unfamiliar look which surprised Sebastian. Her face became reposed and a serene nobility altered her very contenance. Her eyes met Sebastian's, and everything was spoken in this gaze. It was very still in the hall and only water, only eyes were speaking. Answer! Answer! The palms stood so silent and so tall in the suffocating heat of the conservatory and the light was so soft and subdued through the glass in the ceiling. And this beautiful woman, what answer was needed?

Désirée was thinking of Bilitis. She turned her eyes from Sebastian and quickly glanced at the statue of the god Pan, and then at the yucca with its wide leaves and cup-like, light green blossoms which grew in profusion between the branches. Was it not all so lovely, so peaceful? Had not a poem been real? And after Désirée had ordered her hair she loosened her belt and laid it on the couch. In a few seconds her robe had dropped to the sand, and she rose from the floods of dark purple, from the foam of fine rustling silk,

109

smiling quietly, and totally naked. Then she picked many of the yucca blossoms, pressed them with both hands between her breasts and waded through the narrow stream to the statue of Pan, laying the light green chalices upon the high pedestal. She stood so for a moment, the rosy splendour of her limbs displayed against the marble pallor of the stone.

Hellas! Not a word had been spoken between them since he had read the poem aloud, and all that inner conflict which had tormented him with a thousand questions had been answered, by the clear and untroubled enjoyment of poetry in the form of Désirée, an enjoyment whose consistency and necessity no longer stood in doubt: 'Without garments, jewels, sandals, here I am, Bilitis, alone . . .' She gave him the answer he was waiting for from the very depths of her nature, unsolicited, unambiguous: it was Life, unfathomable as everything is that is unified and whole. He could see her profile: her right arm rested on the pedestal and was embracing the feet of the marble god, the tulips on which she had trod were bent and crushed beneath her toes and a faint reflection of her nakedness could be seen in the flowing water which separated the steep little island as though it were a vision risen from the flood and remote from reality.

Sebastian lay on the couch and looked across at the island, at Désirée, his chin propped between his hands. He longed for her to stay as she was, in the charming pose of the classical courtesan, stepping before Priapus with her sacrificial offering. The cool water had made her skin paler and she stood before the marble, almost white except for her hair which gleamed with golden life, with a more perfect beauty than art was able to bestow on marble images. He saw all this and uttered it to himself.

And whilst he saw it and uttered it he suddenly realised that he was not gazing at this woman with the eyes of a lover, but with the eyes of an artist . . .

[. . .]

Then something extraordinary happened. Pandora, who

110

had remained quiet up till now, leapt with one bound from the couch across the stream, with a second bound was up on the pedestal and, before Sebastian could stop it, it was crouching on Désirée's naked shoulder.

She started, with a light cry, and took her arm from the pedestal in order to hold the cat. She came laughing through the stream which washed the black earth from her feet; she shivered, frisked and laughed, her laughter coming like yelps of joy. She was standing in front of Sebastian, her mouth, open in laughter, showing her strong white teeth. The cat had pressed its body against the golden locks and its eyes were gleaming in the same colour, glittering down at Sebastian.

'Pandora!' she laughed and rubbed her cheek against the warm coat. Her whole body shivered. Then she threw herself down upon the wide couch, almost crushing the cat beneath her. Sebastian heard the cat miaow and scrabble against the velvet cloth. He jumped to his feet. 'Get dressed,' he cried. 'For pity's sake, get dressed . . .'
[. . .]
He followed her uncertainly through the dusky rooms, trembling, scarcely able to control his senses. Pandora was rubbing against Désirée's skirts and slipped into the bedroom with her; the heavy folds of the curtain closed behind the animal and the woman. Sebastian waited in the boudoir for a few moments, then pulled it aside.

Here was the altar on which he had made his offerings to Life, in this small, low, windowless room and which was almost completely taken up by a large, low bed, in this room whose walls were covered with purple hangings with priceless embroidery from floor to ceiling: strange flowers, gigantic flowers, chrysanthemums which, rooted in the dark earth, shot upwards in snow white shafts and, just below the ceiling, burst into blossom, in blossoms of wild golden fire, whirling, an explosion of glittering colours . . . The inauthenticity of the throne-room, the exotic temple to Pan and the alien majesty of jewels were here compounded, and the fountain of Youth flowed into the

supple waters of silken pillows, sheets and coverings ...
and she had entered here, she who owed him an answer to
the question which arose from wounded depths. She was
standing at the head of the bed, her stretched fingers
reaching downwards and pressing small imprints into the
purple cover. She was still smiling, but it meant something
different from what it had in the room from which they
came. Sebastian realised that this smile was drawing its
nourishment from his anger, his despair, and it was only
gleaming in the anticipation of changing into a raging
rictus, of violent passion ... he knew all this as he clung to
the curtains with cold, sweating fingers.

Between these two people flared a vision of crimson –
the bed, the walls, the ceiling. But a black shadow lay in
the middle of all this purple, in the middle of the bed,
something black with glittering, silver-green eyes: it was
rolled into a ball, and ready to pounce ... Sebastian
stepped to one side, his foot touching something concealed
in a niche behind the arras: he dragged it, crying and
laughing, from its hiding place. It was an object, a piece of
furniture on three legs, something like a violin-case, an
instrument upon which Satan was playing his most beauti-
ful melodies ... With a tug he jerked it into the air by one
leg, swung it over his head and smashed it against the wall,
splitting the tapestry along its entire length. In the same
moment he heard a single sound behind him, inhuman,
high, shrill, tearing ... and felt something hot trickle
down his back from his neck. It was blood: the wild
animal had leapt at him and its claws were flaying his ear,
cheek and scalp.

[...]

'The Sphinx'

With trembling voice Sebastian declaimed the following:

'She was naked to the waist. She sat rigid and upright in
a tall black armchair in the middle of the room. Her hair
was red and, parted in the middle, fell over her shoulders

112

and across the back of the chair. Her eyes were of pale turquoise and of a deceptive gleam, her lips, which glowed like pomegranates, were cut of dark-violet amethysts. Her nipples, erectile, were of large rubies; a diamond sparkled in her navel. She sat like an Egyptian statue, her feet close together, and a dull golden brocaded cloth covered her loins and thighs. I do not know whether or not she saw me: there was no light in her dull, turquoise eyes. I walked back and forth before her, back and forth. I had a page in my hand on which a poem was written in red: I read it out aloud. But perhaps she did not hear it, she did not hear it, and I only saw her thick, fragrant hair. She was pale, silent. But the rhythm of my words inspired me, and I sang them from the paper. The sphinx sat motionless. I spoke fire, laughed smoke, and madness burst forth from my inspiration. The sphinx sat there in silence. My voice grew hoarse, and died away. My strength left me. I fell to the ground and my head hit the floor with a dull thud. But the sphinx gazed over me, motionless, into empty space. I regained consciousness and opened my eyes. I saw the sphinx sitting upright, her navel sparkling from her flesh like the sun from white banks of cloud. I dragged myself slowly towards her on my knees. I tried to stand. Finally I succeeded. I seized the brocade around her loins with hands that were cold, feverish: I put my last drop of strength into tearing that golden remnant from her body . . . I tore with violent desperation – it came away . . . I saw the sphinx before me, naked. The lower part of her body was made of stone. Thousands of years ago a chisel had given her the form of a female body.'

[. . .]

Sebastian approached the garden gate: it was locked, bolted and barred. He grabbed two of the iron railings and tried to bend them apart, then drew back his smarting hands, thick streaks of rust ran across his palms, from fingers to wrist.He took the long way round, along the wall, away from the main path into the bushes, along the stream and across slippery banks to the bridge, and at last he came to

113

the lawn behind the villa [. . .] With one bound he jumped the railing and landed on the ground. No skulking, into the house with you! It was only in the foyer that he grew quieter. Perhaps she too had watched and waited, for nights, and had only just started to dream. She owed you everything: hope, the present, sleep . . . but not your dreams. These are holy . . . quietly! quietly!

He was able to get into the boudoir without difficulty. It was pitch black but every step was familiar to him. Before the bedroom curtain – she was sleeping, he could hear her quiet breathing – his fingertips touched the large armchair that always stood there. He quietly sat, sitting upright despite his exhaustion after the exertions, his hands clutching the carved wood of the armrests. He sat, waiting for day to break.

A little after dawn Désirée appeared on the threshold. They stood looking at each other.

'I've been waiting for you.'

She repeated his words:

'You've, been waiting for me?' And then she cried aloud when she saw what his fingers, convulsively, were gripping . . . She tore the gun from his hands and held it stiffly, awkwardly, away from her, then raised it to her eyes which, wide open, seemed almost to be breathing.

'Yes, I've been waiting for you, me, me. I can't live any more, I don't belong to myself, I'm completely lost, without hope, a slave. I know everything . . . Your husband, Wilmoth . . . I know it all. Remember your words in the carriage . . . I bring you my last gift . . . take it, I'll throw it away, I don't want it . . . here . . .' He tore his coat open with both hands, his waistcoat, his shirt, and bared his chest, breathing wildly, as though his heart would burst . . . He seized Désirée's hand and forced the barrel up against his ribs, to his beating heart, and tried to pull the trigger, to fire, to carry out this strange command, this onslaught against his own life . . .

It was only when her finger tips felt the warmth of his body that she tore her gaze from the weapon and fixed her

eyes on his gaunt, naked, snow-white breast where the two circular discs were glowing . . . The pistol fell to the floor, knocked to the ground, and she kicked it away with her foot, her foot . . .

[. . .]

For some time now Désirée Wilmoth had been brooding on the problem of how to replace the somewhat stilted choreography which one frequently saw in theatres in the Venusberg scene of *Tannhäuser* with wild, lascivious dances, dances more appropriate to the passionate beauty of the music yet which did not offend the sacred allurement of pagan sensuality. She often summoned Meinewelt to her to learn from him, listen to his advice and pick his brains, for the editor had once spent months with Eugénie Fougère in his youth (an unhappy time, and one which he rarely spoke about) touring the cities and towns of the continent and remembered a lot from this time. He now became wildly enthusiastic, put all his time and energy at Désirée's disposal and raved about her genius, her intuition, her dancing which would revolutionize the discredited choreography of the present and for ever sweep away the sort of ballet which theatres churned out. He immediately composed a series of articles which, illustrated by Saarmünster (this was Désirée's idea), would appear in 'The Holy Grove' and reach out into the world, disseminating her ideas and accomplishments.

Meinewelt detected behind all this a profound change which had taken place in the woman's soul over the last four weeks, and swore to be vigilant. She suddenly demonstrated a remarkable interest in the world outside her villa, sought any expedient to fill her days and demanded all sorts of things that she had hitherto either denied or simply not noticed. She sought the admiration of the crowd, a general approbation, or confirmation; she sought to make good some spiritual defect by external stimuli, and even repeated the idea that after rehearsing certain eurhythmic movements within her four walls she would hire a gigantic hall in the city in which, to the strains of an invisible

orchestra, she would dance a solo on a stage covered with fabrics, exotic flowers and shrubbery . . . She would dance before artists, and before the common people, she would travel and perform in Paris, Rome, London and America . . . Intoxicated with these notions she demonstrated increasingly a yearning for vast, free movements on colossal stages, movements which would consume her dancing, her emotions . . . and spoke about all this with the earnest conviction of an absolute necessity, forgetting to mention the motive why she had given up dancing in happier times: it was now a case of whirling some great and permanent restlessness from her soul by vast and passionate agitation. [. . .]

One morning Sebastian surprised her in her Grey Room, walking amongst a heap of the most remarkable fabrics, tissues, material, veils of all sorts which were cast about the room, some colours shouting and discordant, others shading into the finest, most subtle nuances . . . They were thrown all over the throne, hung down to the ground from the piano and lay scattered over carpets, chairs and chests in piles of varying sizes, depriving the room of its earnest monotony. She was walking, slim, agitated, dressed in white, amongst all these colours: she bent down to pick up this piece of cloth or that, and draped it round herself, her waist or her shoulders; she let it fall from her breasts, then she would seize with both hands into the heap of fabric, choosing, rejecting, considering, weighing up the most heterogeneous nuances and then, suddenly, draping herself in five different ones [. . .]

'I shall dance a poem!' she said, speaking more to herself, and in an overwrought manner. 'A poem which says "My soul longs to burst forth in incandescence!" Look, the first verse!'

She quickly seized three heavy, costly pieces of fabric – violet, purple and black, rich, dark colours – which made her look like mournful, imperious Cassandra, gazing back into the past, and forward into an inexorable future. Then she dropped the three colours, and behind her upright

figure, dressed in white, was writhing a long, silky, lemon-coloured veil, high above her head. 'This is the second: the resolution. And now – 'She ran to the mirror in its Venetian frame, gathered up a heap of disparate material and dragged it into the middle of the room, knocking aside anything that stood in her way. In a few seconds she had attached golden brocade, orange velvet, pale pink gauze and various Liberty veils of a sunflower yellow colour to her body; she stretched upwards, paused a moment, and then began to dance.

Sebastian had never seen anything like it, neither in life nor in his most secret dreams: it was also the first time that she had ever danced in front of him. It could, in fact, hardly be called a dance for her whole body seemed to dissolve into movement as the colours flowed one into the other. The gleam of her eyes, the wave of her hair, an expression on her lips – these were the only human entities. But even these had had to surrender their corporeal essence to the mysterious bond which, separate and independent, pulsed between dancer and spectator and whose name was: burning soul. It seemed to Sebastian that he could seize these contours in both hands, and grip them tight – contours which consumed themselves in endless rhythmical modulations, which dissolved, flickered, sank, and were again reborn – without so much as touching the dancer with his fingertips: *now* he understood what dancing meant to her. But she stopped, abruptly.

And the spirit, the phantom, reverted to its frame of flesh. Her arms fell to her hips, her eyelids drooped, her chin sank to her breast; her whole body was crushed with exhaustion. She gently shook her head, and her hands opened and closed in a spasmodic agony. Sebastian quietly rose from his seat and stood before her; sadly, gently, he ran his fingertips down the flaming glory of her garments. She let go of the yellow veils that she had tied to her wrists and they fell to the floor – a golden, trampled sun.

She had created four more dances: the cameo-dance, the ruby-dance, the diamond-dance and the dance of the pearls.

117

There was a fifth – and she called it the dance of death. This one gave her much tribulation. She did not like talking about it as it preoccupied her exclusively. She admitted to Sebasstian that it was meant to express the legend of Orpheus and Euridice and also something else – the dream of the sleep of death, in which she fervently believed, as do all who had believed so passionately in life . . . and also 'continuance, and visitation'.

She did not explain what these words meant – continuance . . . visitation . . .

But on the night of the nineteenth of May, which was the anniversary of Wilmoth's death, she invited Meinewelt as well, and Sulzwasser and Saarmünster, to her house and danced before them the dances of the four jewels as well as the dance of the 'burning soul' which now had a fourth stanza: the dance of ash . . .

[. . .]

Little town on the Belgian coast. Sebastian Sasse has been living here for days . . . months . . . years? The sun rises behind the dunes, stands high above them at midday, then sinks, golden-red, into the sea at evening. But such calculations are inappropriate for those who dwell along the coast. What is meant by 'day' or 'time' is determined by other insiders: nothing happens on the coast except the play of sun and wind, of moon and sea. It is only the millions upon millions of grains of sand that know this; the marram grass grows grey and tired and sinks to rest in the sand, for autumn moves to rest . . . Further inland the puddles have a thin crust which splinters like glass when one's foot slips from the furrow. Autumn on the coast.

[. . .]

Evening after evening, as the moon was rising behind the slim belfry and climbing the heavens, Sebastian would put down his pen and gaze out of his attic window in the 'Swan of Brabant' at the tower in which the cluster of little bells was hanging like ripe grapes. Behind these tiny objects, heavy with the sweetest melodies, the sky gradually became clearer, pale-blue or amethyst, and the delicate

118

gossamers of the radiant moonbeams wove their tender web between the walls, a hazy delicacy like elfin wings, or elfin hair, then suddenly light and shadow parted and there was a sound, then another, and then a jingling, resounding carillon. Then the hundreds of heavy bells followed, all over the town, in a sturdy, solemn procession, like worthy city dignitaries in black, the gleaming ruff around their necks, the ebony mace, decorated in silver, carried before them – a long procession of old, venerable notabilities, whose hearts were weighing weighty matters, civic and corporate and who were now moving towards the cathedral, deep in prayer already. But the jingling carillon was running before them like a frisky white puppy who was showing them the way, barking and running across the ancient squares and bridges.

It was in vain that Sebastian brooded on whether or not he could share the great, silent piety that pressed upon the town like a lowering cloud, never leaving it, and which brought that peace which reigned with equal severity over men, stones and the swans which floated on the brackish water in the canals. On Sundays he had often joined the groups of men and women who, silent and hooded, darted from their small neat houses and scurried almost fearfully into the many churches. What were they confessing? What were they supplicating? Behind those tiny doors with their brightly polished knockers, behind those thick green curtains, framed in black, which hung between the two windows to prevent the curious from looking in one only saw pale, dead faces gazing solemnly downwards, and if a passer-by did look into one of the numerous peepholes which looked down the street he would only see a section of a face which would have grey, tired eyes, a face which expressed dread rather than curiosity or, indeed, anticipation.

At every hour thousands are kneeling in these enormous churches, churches whose towers stand like inverted wooden dice-shakers (and the die is already cast, perhaps, for this country); they kneel and murmur their endless

119

litanies between folded hands whilst the bells alone dare to resound. He knelt with the thousands of others and waited, feeling only the cold of the stone flags beneath him but never the warming breath which drifted across the congregation from censers and sermons. And the woe which he had sensed when gazing at the sea flared again, and forced him yet more deeply to the ground. And in one of the churches – a church where his brow had touched the floor – there he saw it: an old, dark altar piece by a pupil of Memling which represented the virgin sitting on the grass outside the town between the gates, the Beguinenhof and the small lake called the Minnewater. She was sitting on a stone, and her long slim hands were not holding her Son, but a bunch of anemones, which she was pressing to her breast . . .

Extracts from Arthur Holitscher: *Der vergiftete Brunnen*, Munich, 1900.

Georg Trakl: *Desolation*

(1)

There is nothing left to disturb the silence of desolation. The clouds sail above the dark masses of ancient trees and are reflected in the greenish-blue waters of the tarn which seems to be bottomless. And the surface rests, day in, day out, sunk in a mournful submissiveness.

In the middle of the silent tarn stands the castle, rearing its pointed, crumbling roofs and towers towards the clouds. Rank weeds grope across the blackened, shattered walls, and the sunlight breaks on the round, dull windows. Doves fly around the dark, gloomy courtyards, seeking a hiding place in the cracked masonry.

They seem to fear something for they constantly fly, startled and agitated, past the windows. The fountain splashes in the courtyard below, gently, delicately. And the thirsty doves intermittently drink from the bronze basin.

Now and then a breath of febrile decay wafts through the dusty corridors of the castle; the bats fly up, terrified. Nothing else disturbs the deep silence.

The rooms are black with dust. They are high, and bare, and cold, full of dead things. Occasionally a tiny beam of light enters the clouded windows, but the darkness swallows it up again. The past has died here.

It froze here one day, petrified into a single twisted rose. Now time, impervious, passes over its insubstantiality.

And the silence of desolation suffuses all.

(2)

Nobody can now enter the park. The branches of the trees embrace each other with a thousand arms: the park is now nothing but a single, monstrous living thing.

Eternal night weighs heavily beneath the gigantic bald-aquin of foliage. And deep silence! And the air trembles with putrescent miasmas!

Yet sometimes the park awakens from its heavy dreams. A memory is born, a memory of cool starry nights, of dark, secret places where feverish kisses were once seen, and embraces; summer nights full of radiant splendour, when the moon conjured forth crazy pictures on the dark background; men and women walking back and forth, elegant, gallant, rhythmical in their movements beneath the panoply of leaves, whispering mad, sweet words, and smiling seductively.

And then the park sank back into its sleep of death again.

The shadows of copper beech and conifers rock on the surface of the waters, and from the depth of the tarn arises a dark mournful murmuring.

Swans move through the gleaming water, slowly, stately, lifting their slim stiff necks. They move onwards, day in, day out, encircling the deserted castle.

On the edge of the tarn pale asphodels are standing amongst the livid grasses. And their reflections in the water are even paler.

And when they die others arise from the depths. And they are like the little hands of dead women.

Great fish swim around the pale flowers with staring, glassy eyes – then silently they dive into the depths.

And the silence of desolation suffuses all.

(3)

And the Count is sitting, day in, day out, in his crumbling tower. He gazes after the clouds which sail above the tops of the trees, gleaming and pure. He loves to watch the setting sun glowing in the clouds at evening. He listens to the sounds above him: the cry of a bird flying past the tower or the moaning wind, sweeping the castle.

He sees how the park is sleeping, dull and heavy, and he

looks at the swans moving through the glittering waters which surround the castle, day in, day out . . .

And the waters are gleaming greenish-blue. But the clouds that sail over the castle are reflected in the waters, and their shadows gleam as they do, radiant and pure. The water lilies beckon like the small hands of dead women and they move, sadly dreaming in the gently moaning wind.

The wretched Count gazes at everything that surrounds him, dying, like a lost child overwhelmed by a great destiny and who no longer has the strength to live, a child who fades and passes like the shades of morning.

He listens more and more to the still, sad melody of his soul: transience!

When it is evening he lights his old sooty lamp and reads in massive, faded volumes of ancient glories, ancient splendours.

He reads with a feverish, pounding heart until the present, which is not his home, fades and passes. And the shadows of the past arise – gigantic. And he lives the life, splendid, glorious, of his ancestors.

At night, when the storm shrieks around the tower and the walls boom in the foundations, when the birds scream in fear outside his window, the Count is seized by a nameless melancholy.

Destiny crushes his soul, his tired, tired soul on which the weight of centuries is lying.

And he presses his face against the window and gazes out into the night. And everything seems monstrous to him, dream-like, ghostly! And terrible. He hears the storm howl through the castle as though it wished to sweep away all that was moribund and scatter it in the wind.

Yet when the confused illusion of night recedes like a shade conjured from the earth the silence of desolation again suffuses all.

Georg Trakl: *Verlassenheit*. In Dichtung und Briefe,.
Otto Müller Verlag, Salzburg,
1969, Vol. I, pp. 199–201.

Paul Leppin: *Blaugast*

When he left the whores' bar with Wanda, it was almost day. Dawn was still crouching between the houses, well wrapped up. Only the roof-ridges and the outlines of protruding balconies stood out more sharply in the greyness.

Without a word and feeling like a refugee, Blaugast set off along the road, which disappeared into the fog. Improbably, the day, which had been lurking behind blankets of cloud, dawned.

Wanda met his scrutinising glance with a laugh. 'Your sweetheart is a bit grubby, my friend. My maid has been on holiday for a long time. You mustn't look at me.'

'You'll have a bath and comb your hair. I'll give you some underwear and clothes. You will be beautiful.'

At the door to his rooms, turning the key to push back the bolt, he was for a second overcome by the feeling that he was about to be confronted with something unspeakable. When faced with a locked door he was always assailed by this irresolution, which struck him with urgency, a hapless voice threatening him. It had been so as a child, climbing down ramshackle stairs to the coal-cellar, when the crying of a lost cat had seduced him into an heroic enterprise. That was the way the corridors of disreputable taverns had received him, where as a twenty-year-old he had been in pursuit of sensual pleasure. And later when, drained by the atmosphere of the office, he had headed for the haven where his partner was waiting to welcome him, he had done so breathlessly, and the door-knob of their apartment had an insolent glint that he had found insidiously intimidating.

When he pressed the electric switch in the vestibule and the white star of the ceiling lamp bathed the stone flags in its peaceful light, the oppressive feeling vanished. He busied

himself fetching coal and firewood and lit a crackling fire under the bathroom boiler. For a moment he felt a spurt of compunction as he grasped the underwear in the cupboard. Once more a wave of tenderness surged through him which he accepted as a rebuke, before which he stood in humble contrition. The days that this linen-cupboard represented came back to him, the gentleness of a life that was no longer around him, that death had ambushed and taken from him.

When he handed Wanda the bundle, she took it without thanks and set off for the bathroom with the air of one long familiar with the apartment. Blaugast heard the rush of water from the tap, splashing noises and humming came, pervading his languor like a tumult after the quiet of the last few weeks. Beyond the curtains the daylight appeared, glaring, unrelenting and raw. He picked up the books, pieces of paper and clothes that were scattered round the room and put them away in the cupboard, made his bed and sat down by the window. The blanket in which he wrapped himself still gave off a trace of his fever-heat and it felt agreeable.

Only now, as a new episode was getting under way with the concreteness which he had always secretly disliked about the things of the real world, did he try to account for his actions, to look for a meaning. The night's encounter took command of his mind, which had for the moment been clouded by banks of haze and physical weariness. With a bitterness that hurt, shattered him once more, he saw clearly what had happened. There was a woman in these familiar surroundings who was washing her besmirched body in his bathroom, a creature from the joyless realms, animal, unconcerned and vain.

'Why on earth? – Why?' he asked irritably, searching without success for a reply.

The withered face of his dead companion looked out from a fragile frame.

She was not like this. She had been the point of repose that had deceived him, a sweet refuge of gold-flowered

bliss. But now it was back. The stammering and the fear that since his boyhood years had driven him along out-of-the-way paths, the blind gaping at uncomprehended wishes, Siberian frost and tropical dangers. He recalled the insolent curtness of the words with which his old school-friend had fingered his confusion, 'Interested in catastrophes?'

For the time it took to draw breath, Blaugast was aware of a little flame dancing along in front of him, brightly coloured and appealing, that he had dug out of the rubble of the past. Was it not an act of charity to offer a bed for the night to a fallen woman? Had he not felt a tender-hearted quiver of kindness when he heard her address him with the familiar *du*? Had he not always, a pilgrim among the filth, been a follower of the star of mercy?

No, no and no. Between man and woman no covenant was possible, no gospel of dignity. It was the woman's breasts that had compelled him, obscene breasts under faded cotton, dreams of hate from the seamy depths seething with the red breath of youth. It was the curse that was torturing him which had made him take her into his home.

One last shred of pride, burdened with the shabbiness of one of the unsung poor, resisted self-deception. He remembered one day, long since crushed to dust by the mill-wheel of the years, which lay, weighed out against guilt and responsibility, faded and forgotten in the arsenal of eternity. Its poison, distilled through time, still seethed in his blood. He had gone with his crony, the painter, to the one-room lodgings of a street musician who sometimes rented out his proletarian profile by the hour as a model. He was not at home, only his old wife was clumping over the floorboards with her wooden leg. Beside the kitchen range their daughter was lying in a bed covered with a patchwork blanket, coughing.

'It's her lungs', explained the one-legged old woman, as she stood in front of the bed, while the painter gave his instructions. 'The doctor says the poor thing ought to be stronger, but God will help us; were poor people –'

The smell of sweat and cold boiled potatoes made the

room unpleasant. The painter threw a few coins on the unwashed table and turned to leave. But Blaugast had gone over to the girls bed; she watched him with restless eyes. She tugged at the covers, but the blanket was old and narrow. The threadbare rags slipped from her leg, baring it to the knee. It was a scrawny, wiry leg, that aroused him with a deadly attraction. In the hollows of the joints, below the curve of its taut sinews, were highlights that he recognised.

The painter was standing impatiently, his hat already on, between the two doors. Blaugast had felt in his pocket and put a banknote into the sick girl's hand, much more than the occasion warranted, much too much for his financial situation. The consumptive girl thanked him with a greedy expression round her dry lips. Timidly, the old woman kissed the sleeve of his jacket as he followed his friend out into the street, feeling he had been caught in some impropriety.

There he said goodbye, rejecting the puzzled remonstrations at his generosity with an embarrassed laugh. An acid taste on his tongue had made him feel sick. The tributes the painter shouted after him he took as insults. The feeling of shame that drove him away was biting and impure. It had always been so, ever since he had been conscious of thought. This planet was a market-place where evil tugged murderously at its chain. Its spies were everywhere. At windy corners where young girls with knowing children's faces were selling flowers and matches, on the operating tables of the hospitals, in the slums, at railway stations, under viaducts. Lust was masked as pity, concupiscence as good deeds. (. . .) Once more, for the thousandth time, he had asked the question of a godless world: where was love? –

Shivering, Blaugast huddled up in his armchair. He felt oppressed by the weight of a great, hollow solitude. He looked round the room where the first light had stripped all the cosiness from the walls. A sobbing, without tears, burst his chest, so that he bent forward, his arms groping

127

in the empty air, and fell face first onto the carpet. (...)
Once more, perhaps for the last time, a burning longing
raised its head. His hand was clenched and would not
open. The pointlessness of his torment gathered in his
throat so that, without knowing why, he bit wildly into
the weave of the carpet and groaned.

A sound made him stop. Wanda had finished her bath
and was standing before him, in a fluffy dressing gown,
refreshed and disapproving.

'Are you drunk?'

Her black hair was wet, combed and parted. Her eye-
brows were brought together by a frown as she held out
her robust foot in its slipper.

'Fasten my sandal tighter. And be sensible.'

Slowly, with difficulty, Blaugast raised himself to his
knees. A searing pain shot across his back and shoulders as he
tied the leather thong over her skin. Sighing, his mouth sank
lower and lower, until his forehead touched the firm curve
of her leg, until his lips abandoned themselves to the kiss.

Wanda looked down in silence on the bent figure of
Blaugast.

'Stand up', she commanded, almost in a whisper.

And as he swayed, from lack of sleep and the invisible
burden, she let the dressing gown slip to the floor. Tall,
big-boned, naked, she stood before him. Beneath the hairs
of her eyelashes he could see her dull pupils dilate. The
nipples of her vulgar breasts hardened to lustful points as
he spread out his arms and took possession with a cry of
sorrow, flaring up in a searing blaze.

Pangs of conscience, hunger, disgust were all swept
away in the flood.

From out of the tunnel of the night Destiny had come
to Blaugast, an apocalyptic woman taking him into her
power. From somewhere a storm brought a raging din,
funeral music, blood from the depths. Like a lifeless stone,
he sank to the bottom. To the dungeons of sex, to the
madness of his fate, to the sleep of the pariah.

<p style="text-align:center">*　　*　　*　　*</p>

Right at the beginning of their relationship Wanda had spied the trapdoor that barred the way to the lumber-room of his repressions. With her cunning, she realised that the wholesome fare which supplied the meals of diners who were satisfied with whatever was put in front of them would not feed the hunger that was wearing him away. She knew that his desire flowed from springs hidden in mystical clouds, that, in order to dazzle this tormented man, to bind this nomad, she must be inventive in the way her favours were granted.

[. . .]

Blaugast was a compliant resident in the unkempt hothouse of her willing sexuality. The small change of skilfully engineered paroxysms with which she supplied him, seemed riches indeed to his impoverished life. Good taste, which was far removed from her coarse-grained disposition, she replaced with experience. Hers was an adaptable genius, her amenability in some cases bordering on the extravagant. Once when, as they were walking along the street, she noticed how his eyes were drawn to the bare knees of a schoolgirl, she spent the morning, while he was brooding away the apathetic hours at the office, making herself a daring gym-slip, in which she was waiting for him when he returned, with ankle-socks that left a generous expanse of leg exposed.

She tackled the depressions that cast all kinds of shadows over his alert sex with arts which, born of shamelessness, ensured high pressure. She had the heroism of the courtesans of the age of cavaliers, when the dignity of kings had been transformed into submissive vassaldom in their mistresses' boudoir, and had not been afraid to yoke the amorous arts of other women to her triumphal car. She would choose the right moment to loan out her property, in order to possess it all the more completely, renouncing the gossamer nets of jealousy, whose only effect is to reduce the value of the sacrificial lamb. Like a slave-mistress, who regards the health and well-being of her charges with pleasure and avoids maltreating them, so as not to

damage valuable flesh, she was busy fattening up her partner's demands with enticing prospects. She was not merely happy to allow his restlessness the complete freedom of action which he needed in sexual matters, she was constantly on the look-out for ways of recharging the battery of his passion and picking up windfalls from his pleasure by looking on. Her contacts with the *demi-monde* and the adjacent terrain were a worm-eaten bridge which Blaugast, encouraged by her approbation, set off along with the ambition of breaking cynically listed records.

[. . .]

Wanda brought him *cocottes* who were practised in every nuance of bashful protest, and irrepressible *bourgeoises* who had retained a modicum of decency in the frenzy of their nocturnal industry, blushing unseen between demand and supply.

[. . .]

Blaugast suddenly found himself at the centre of a bustle of activity to which he yielded passively and which washed up some very dubious jetsam at the sluice gates of his world of ideas. The curious swarm of love-goblins whispered abroad the news of his endeavour, which, once it had been given free rein, was not allowed to rest. There were page-girls in boy's jackets and coy velvet knickers who served at banquets which, following a pedantically drilled ceremonial, degenerated into orgies. The spark of puberty smouldered in the faces of debauched children, wanton kisses inflamed the memory of bridal fears. (. . .) Lesbians demonstrated their lingering raptures. The cheap schnapps that Wanda poured down his throat destroyed his will-power, his upright gait and his honesty of spirit. Habit and the boorishness of the vulgar fastened their claws on him.

* * * *

When, irritated by distaste for work and dissipation, he gave up his job in the office, Wanda had her own way of dealing with the changed situation. Initially she met his

apathy, which accepted adversity without taking any measures to deal with it, with undisguised contempt. In her anger at the sudden unreliability of a refuge she was determined not to abandon, in her disappointment at the inglorious collapse of her economic security, she forgot the basis of their elective companionship. She did not even attempt to shake him out of his lethargy, to foster his will to live and set him in the right direction. Abruptly and unambiguously she refused him the tribute that was the justification for their union. Her body, which still had the power to arouse him, was no longer in his possession. Unconcerned about the problem of his physical needs which tore him to shreds, she obstinately repulsed him until he was nothing more than an idle mouth among the junk of her household goods, a parasite who felt the wrath of her displeasure. And her colleagues, whom previously she had spurred on to minister to the beseeching Blaugast, now kept their fearful distance since the rumour of his collapse had gone round the district. (. . .) Who did come, occasionally at first, then in increasing numbers, were the men. It was the clients from Wanda's infamous practice who now visited her in her room, paying for their robust pleasures with money from which, on lucrative days, there was a pittance to spare for her now useless companion.

Blaugast's response to the reversal towards which his condition was heading was a mysterious paralysis. The disease to which he was succumbing, was torturing him with treacherous spasms, undermining him, sucking away his strength to defend himself. The lascivious secrets of the next room first came to his notice in the form of stifled whispers that disturbed his sleep. Listless and dishevelled, dazed from sedatives, hair unkempt, he had appeared in the doorway of her chamber with its insistently vulgar scent of eau de cologne and cosmetics, gaudy paper flowers and its russet lampshade. A burly fellow, his made-up tie twisted over his collar, was standing there, legs astride, buttoning his braces.

Wanda was sitting with her back to him on the stool in

front of the dressing table, powdering her breasts. She did not turn round, as he leant against the door-post, unshaven, with swollen eyelids and his shirt all undone. Only her strong teeth gnawed at her lower lip as he surveyed the scene, dumbfounded, until his eye met her imperious expression in the mirror. 'Who's that?' asked the burly fellow, smoothing out a crumpled handkerchief with his thumb, then blowing his nose noisily.

'That's my landlord; he also acts as my servant', Wanda replied, without turning round.

'He can fetch us some hot water from the kitchen.'

When Blaugast just stood there, shoulders sagging, his vertebra giving way, with a stupid look on his face, unable to comprehend, she suddenly snapped at him, baring her tongue, which was covered in spittle, 'Didn't you hear, you moron? You're to bring water for me and the gentleman –'

Blaugast nodded. Something gigantic, pale and horrible rose up before him, like a dust-cloud before a storm, enveloping him, darkening his mind. Finally he understood. Wearily, legs bent, he shuffled into the kitchen. Like an obedient automaton, mechanically responding to the drive from the motor, he filled the crockery from the pan warming on the stove. Washing-up water, lukewarm and stale, dribbled in a disgusting trickle down his fingers. He ignored it. Clumsily, woodenly, as if his body were fixed with hinges, he carried the jug and basin back into the room.

That was the beginning. . . .

<p style="text-align:center">*　　*　　*　　*</p>

With a tin that had lost its lid and that he had found on the rubbish tip behind the cemeteries, Blaugast walked along the rows of benches in the parks selling matches. His stock, half a dozen battered wooden boxes, was not reduced by this activity. As if by mutual agreement, the pensioners warming their arthritic limbs in the sun, the redundant and the unemployed who whiled away their involuntary holidays here alongside mothers and nursemaids, all left his

paltry merchandise untouched. The coppers, which never-theless appeared on the bottom of the container, automatic profit for which no noticeable service was returned, were the deposit of unknown partners or good-natured specula-tors. Blaugast's complete silence gave his appearance, which was neglected, though not intentionally, a special nuance which was more effective than any wheedling, and invited charity. The inimitable technique of scarcely visible move-ments of the lips, eyes directed to one side, the spittle-glazed corners of his mouth set in a silent appeal, was a profitable investment that brought interest and dividends. There was still a trace of elegance and vanity about his person, giving him a slightly comic air, which acted as a bizarre provocation, eliciting the mockery of passers-by. The goose-step of his uncontrollable legs caused by con-sumption of the spinal chord, the changed look in his eyes from paralysis of the pupils and the ragged formality of his preferred attire all brought him the nickname of 'Little Baron', a title to which he would respond with a stiff bow. The children who ran after him in the streets knew it, and the customers of the beer-gardens and popular taverns who called out when the patient beggar appeared and made him the butt of all sorts of pranks and jokes. The grocers and other shopkeepers, standing respectfully behind their counters, their blood sluggish from servility towards their customers, welcomed the opportunity to work off their repressed desire to tyrannise others afforded by his willing-ness to conform to any conditions their charity might impose.

'Little Baron, how delightful to see you!' the regulars would exclaim whenever his bent figure hesitantly ap-proached the table where they were eating. Now the moment was come for them to release the unbearably high tension of their dammed-up sadism into a harmless earth wire, to show off their superiority in front of the tipsy ladies. Purses were opened, crown coins glinted in the light of the ceiling lamp, for all to see. The atmosphere was electrified by the orgasm with which the strong and secure

are overcome when confronted with the visible frailty of someone worse off than themselves

'Be a good chap, Little Baron, and do the bird for us.'

Then Blaugast would grasp his nose with the fingers of his left hand, stick his right arm like a beak through the gap made by his elbow and hop around squawking. It was a feeble, ridiculous sound, a gobbling whine, that gave added spice to many a tipsy customer's evening glass. It was a screech that flew up and grated against iron bars and other obstacles, dying away in a hoarse cooing that was trampled underfoot by the braying laughter of his audience. That was the 'Little Baron's' speciality. Tolerated by indulgent landlords and prized by wags as a poultry impersonator, he made his twitching way, a pedlar peddling his own degradation, through those realms where boredom was ever ready to pounce, and which he seemed heaven-sent to repel.

In the night clubs, the private rooms of wine-bars and clipjoints they went even further. The regulars there had recognised the tragic connection which still linked this wreck of a human being to the depraved lust and intemperance of his sex. As the champagne corks popped and modesty lost its way in the prison of drunkenness, the waiter, on the look-out for any service he could render, captured the wandering beggar outside the door of the joint and brought him to his customers. The half-naked women in the arms of their gentlemen amused themselves with the bewildered 'Little Baron'. It sometimes happened, after he had downed a generous number of free schnapps, that he was engaged, for a fixed sum, to masturbate onto a plate. His groans and his ejaculation produced roars of delight. That was the second speciality which brought Blaugast renown, and which, when he woke up on the following morning, set a barbed-wire fence round even the most shabby of paradises, which caused him sorrow and inescapable torment.

One evening, under the veranda of a popular brewery, where the sooty acacias of a sand-strewn courtyard tried to

create the illusion of rural solitude and back-to-nature freshness, he came across Wanda and her cronies. They were amorous husbands, drapers from the stores of the old town who, in her company, were frittering away the last remains of their respectability on their way to bankruptcy. One of them, in whom the malty strong ale had lit a spark of self-knowledge, grasped Blaugast by the lapel as he tried to make his escape.

'Tell me I'm a swine, Little Baron.'

Blaugast staggered. The balance, which his ailing legs could only maintain in a steady shuffle, was disturbed by the grasping fist of the draper, and he stumbled against the edge of the table. He squinted up at the bloated face of his assailant from beneath defiantly dishevelled eyebrows.

'Don't be a coward, say it right out. I'm a swine, aren't I, Little Baron?'

Blaugast bit on his tongue. Face to face with Wanda, who was subjecting him to a vengeful scrutiny, a rabid fury at his tormentor rose in his gorge. The one who had grabbed him by the lapel was lounging in his chair, waistcoat undone, baring his crooked fangs, giving off a stench of pickled fish and radish. His contempt for the criticism, which he invited loudmouthed, rendered him invulnerable.

'Leave the fellow alone', snapped Wanda viciously, squashing her cigarette-end in the pool in her saucer. 'The old goat's become rather unsavoury since he's taken to tossing off what's left of his brains onto night-club plates.'

The reference to the shame that was dragging him down into the bottomless depths, came sharp and violent, like a whiplash. A curtain was rent, sheaves of light sparked, and Blaugast saw a bright light.

'Of course you are a swine,' he said to the drunk, in a turmoil. 'You're all a bunch of swine, curs and bitches.'

A roar of applause greeted his answer. Snorts of laughter erupted from swollen bellies, garbage bubbled up to the surface, sluggish and scalding hot.

Only Wanda remained sour-faced, furious, indignant.

135

'And what are you? A cesspool prince on official business. A man who cleans shoes for whores –'

Blaugast turned and left. His rebellion against the false powers to which he was in thrall and which befouled his life, was only brief. The gap in the fire which had opened up before him, so that the twisted grimace on the face of existence had become visible through the play of the flames, narrowed to disappear completely. His back hurt and he could hear darkness breathing audibly. A few tables further on a pack of Czech students greeted him with howls of delight and demanded 'the bird'. Nerves in tatters, shipwrecked and clutching onto a spar, weakened by deprivation and terrified by relentless powers, he obeyed and did as they demanded. The man Wanda had spoken to followed him and penetrated the buzzing in his ears as far as the edge of his soul.

'Cesspool prince!' came the quavering old mans voice from his swollen lips.

[. . .]

Sometimes, in the cool corner of a shopping arcade, he would raise his fixed gaze from the ground and suddenly find himself face to face with photographs advertising a *thé dansant* or a ladies' bar with a jazz band, showing women in all sorts of provocative poses. His chin would lose its connection with his upper jaw and his mouth would gape wide.

On such days he would go to the parks on the far side of the Moldau bridge, where the secluded quiet of the paths assured solitary mornings. Only occasionally would the step of a stray passer-by crunch across the gravel. Red-cheeked schoolgirls dashed past, the black-and-white costumes of anaemic governesses shimmered through the leaves. Blaugast stood in the shadow of a bend overhung with luxuriating bushes. Like an animal, whose deranged instincts implanted uncontrollable actions, he lay in wait for his prey. Whenever the bright red of a sunshade, a swirling skirt or a chequered scarf announced the approach of a woman, he would step out of his niche and expose

himself. Arms outstretched, pale and infirm, he stood there motionless, barring passage. The horrified woman's flight, her hysterical fear, her horror at the sight of him gave him relief.

That was the last pleasure he enjoyed in his collapse, a game from the underworld, which was gradually asserting its power over him. The thorny road of his destiny, the fruit of his passion were lying outspread, were ripe for the end.

Extracts from Paul Leppin: *Blaugast: Ein Roman aus dem alten Prag* Langen/Müller, Munich/Vienna, 1984. (First published; originally intended for publication 1933).

Peter Hille: *Herodias. Novellette*

Guilty silence!

A delicate, alabaster-yellow finger thrusts itself into blue-black locks, an insatiable, knowing gaze pours out.

Before her hatred rises up the wild, handsome figure of the zealot faun, whom they call the Preacher of the Wilderness.

Adonis!

Within her, a rage of Venus finds its own justification.

The red lamp, stabbing, stabbing, stinging, stinging.

And the air as oppressive, as hot as the grass-sultry blood in her body.

'If he will make me suffer, me, the Princess, then he must die.'

'O John, John!'

A bath; precious ointments.

Intoxicating she was as she rose and went into the bright morning light, and full of desire as she went out of the bright morning light, bending into a dungeon full of the dread of destiny.

Well, you obstinate man, still the hard, strange words of penitence directed at the Jewess, when before you stands nothing but Roman reason and Greek manners?

Still the same obsessions under that tangled mane? And I, I want your sighs, your tower of strength, and the quivering of your powerful heart, you man apart, chaste and solitary. I want you to live for me, do you hear? Is that so hard?

And she smiles.

And John, a tall figure ripened to sinewy strength by the desert sun, rising from the fetterstone at the entrance of the daughter of the royal house, speaks in deep, soft, forceful tones, 'Princess, you know that there is no contempt

138

within me, for love touches me, and in return for your affection, wild and foolish though it be, I would give you the best I can wish: salvation. May my voice, the rough voice that prepares the way of the Lord, claw the frippery and wantonness from you, so that at last your soul may see the light and demand salvation and accept the sign of cleansing from me.

For I would make you a boundless gift of the highest thing I acknowledge in myself, my prayer, and prostrate myself with it day and night before the throne of God, that your grace might grow!'

'There you go again, preaching your baptism of repentance! Just wait, I'll send my own preacher, my love, the red preacher – the executioner!

Until then, my darling, fare thee well.'

And Samson was avenged of his Delilah.

An Aphrodite of a landscape rose in fragrance from round the pool and the sun breathed through the foliage, warm and coy, like a bride nestling against a happily beating breast.

Merrily mocking flowers, odoursome rising sap, ripe blue air!

Everything received its due – and she? Reduced to wretchedness for such a rough recluse!

Full of determination, she went in.

Now she wanted peace – a clean cut! Cut off the member that was irritating her, because of the hostile refusal in the mind of the man to whom it was attached! –

Puzzled, Herod looked up, Herod, who had not yet sacrificed the semitic, almost Assyrian splendour of his locks to curt Roman imperiousness.

What is she doing? And what does she look –

Then there is a chinking of fine chains, a glimmer, and a shimmer of the folds in the shot silk of the dancing, teasing garment; the arm, like a butterfly brushing the swaying cloth, the delicate arm, whispers, 'Do me no harm!'

Folds and limbs in grace, swing and begin to race. And movement blossoms into motion; the drift of a friendly

smile ... a Medusa turned friendly awhile – And once more menacing darkness clouds the features, which just now shone with such feigned allure ... a Medusa's head, with snakes garlanded, in noble-horrific-petrifying constancy.

And he awakes as from mesmeric sleep; sighing heavily, completely drained he almost has to pinch himself. And now, intoxicated, the seal of a sumptuous, thoroughly royal kiss is placed on cunning, smouldering, close-drawn patience.

And trembling almost, he throws open all the gates of generosity, 'What do you want, Herodias, what do you want for that, that, that marvellous, caressing dance; it has sucked out my soul, what do you want, my daughter?'

'What it is worth, its due reward – the head of John!'

'Then take it!'

Ill and exhausted, at the end of both desire and affection, Herod turns away and staggers up.

But content, indeed intensely happy, ignoring her step-father's moroseness, indifferent now to it, Herodias hurries off with the rhythm of the dance still in her step, so to speak, one of the Horae on an errand of vengeance, a Pandora pleased with her gracefully destructive mission.

And she hurries to him herself.

He does not look at her, he kneels down and prays.

She stands there for a while then goes out – embarrassed. Almost all pleasure in her triumph has gone, so little effect it has had.

Great, noble, alone between himself and the Almighty, John remains buttoned up in happy contemplation since no longer distracted from himself by his office of the voice crying in the wilderness of the royal city, no longer directed towards this petty, alien earth, which keeps opening up in its course; thus he remains, strong, robust, too much a man and full of the simplicity of solitude for piety as such, thus he remains until the evening darkens and the red preacher quietly beckons.

And it turned doubly red.

Warm with pity, the early evening curved down like the cheek of a dreaming angel.

And now there is blood on their love, blood on their nights. She does not groan with remorse. But she feels so unsatisfied, restless, strange, so transformed into desolation. Such a soulless life, so faustinian, so anointed with fear, of such Ovidian sultriness. She has to anaesthetise herself, draw up her ruler's pride around her, something which before, in voluptuous evil, though actually virginal innocence, she did not need to do.

She finds herself at bottom so petty, so petty, so sick and timid.

But then again, it is as if something from the past, something deep and great, the blood that was spilt that night, were raising her up from afar, at the same time ennobling her.

And when she is old and grey and counts on death, something fearful and soft comes into her thoughts, as if she is to meet again the strange man who rejected her.

To *meet* again?

Peter Hille: 'Herodias. Novellette' first published in *Moderner Musen-Almanach*, E. Albert, Munich, 1893.

Stanislaus Przybyszewski: *Androgyne*

It was late at night when he returned.

He sat down at the writing desk and stared without thinking at the magnificent bouquet, tied with a broad red ribbon.

At one end was inscribed, in golden letters, a mystical, woman's name.

Nothing more.

And again he felt the long, lilac-soft *frisson* which overwhelmed him when he had received this bouquet on the podium.

They had thrown flowers at him, and bouquets had rained down at his feet – but this one, with the red ribbon and the mystical name: who could have sent it?

He did not know.

It was as though a small warm hand had touched his, no, not touched, had caressed it lasciviously, had kissed it with hot fingers . . .

And she, whose name had so confused him . . .

Perhaps she had kissed the flowers before receiving them, had pressed her face into the soft flowery nest before arranging them as a bouquet, had pressed the rich floral tribute to her heart and rolled, naked and panting with passion, across the flowery bed . . .

And the flowers still exhaled the perfume of her body and trembled still with the furtive, hot whispers of her desire . . .

She must have loved him, had known him for many, many days and, shuddering, had considered long before daring to send him these flowers . . . He knew it, he was certain of it . . . He was certain that she loved him, for only girls who are in love could send such flowers.

He closed his eyes and listened.

He saw enormous, magical roses, black, bloodthirsty,

white, on long stems, roses that swayed back and forth. They bent down, lower and lower, then reared proudly upwards, tempting and laughing, exulting in their glory.

He saw tuberose plants, white as Bethlehem stars, with fine delicate stems with bluish veins ... He saw ancient trees of white and red azaleas, heavily weighted with a mass of white, downy blossom, lovely to see, as lovely as the ball gowns on the wondrous maiden-figures of noble ladies long since dead ... he saw orchids on lips, hot and gaping, lustful, poisonous lips, and lilies with wombs wide and waiting for chaste delights, saw narcissi and begonias and camelias: a tidal wave of intoxicating, poisonous colour and drunken, sucking perfume overwhelmed him ...

The gentle, May-like scent of lilac poured forth within him, mixing with the still, child-like serenade of shepherds' pipes in the warm nights of Spring, the shrill purple of the roses roared like a lustful howl of triumph ... the lilies embraced his heart with their chaste arms ... orchids sucked lubriciously at him with their red tongues ... the tuberoses danced around him with a white, cold gleam ... the drunken scent of acacia blossoms poured their aphrodisiac poison into him, impregnated with the lightning-hot storms of summer; and all these perfumes, cool and soft as the eyes of girls ignorant of their sexuality, hot and lustful as the arms of raving courtesans, poisonous and screaming as the gaze of a trampled otter; all this poured itself into him, soaked through him, saturated him: he was intoxicated, weakened ... he felt unable to move his limbs, unable to distinguish one impression from another; he saw no colours, sensed no odours, everything was one.

In the depths a wide, open stubble field arose within him, barren, sad, heavy as the groaning of bells in the Maundy Thursday dusk, in the distance was gleaming the glittering edge of a distant lake, bedded in the sleep-heavy heat of midday, here and there the slim stem of a mullein rose up as though it had broken through the earth's searing crust and was threatening the heavens with a triumphant

fist; here and there a few stunted juniper bushes were growing, twisted into strange shapes as though they were sick with the poisons of corpses which once manured the earth; and here and there in the stretches of sand there dreamed the blue calyces of chicory, longing for the sunset when they might close their blossoms and drink in, shuddering, the graveyard magic of the lonely heath . . .

And he also saw cross-roads on the tracks between the swamps and the steep ditches. The hour of midnight was approaching, full of horror and torment . . . A will o' the wisp flickered up, quick as thought, above the marshy pools, a silent, mysterious effulgence . . . and a dog started to bark in a neighbouring village, then another, answering with a long, drawn-out whine, and then the sharp sound of the night watchman's horn, and then silence again, silence which penetrated, deep and black, into the darkest abysses, drawing everything into itself, my Today, my Tomorrow, laming every step and every movement, and making me so lonely, so remote and a stranger to reality.

And before his eyes his homeland arose in a whole variety of pictures: a gigantic sheet, ripped and torn into green rags of barley, into white fields of heather, golden carpets of rye, blood-red fields of wheat with ears as heavy as whips . . . the whole earth is drunk with May, lustful in its glorious blossom, monstrous in its creative madness, in the nuptial majesty of pious love, the whole earth, right up to the boundary of the white church upon the hill.

The bells poured their broad streams of euphony down upon the flat land and the waves of a mighty hymn washed through the fields during the Corpus Christi procession: the white dresses of the girls are gleaming between the black bushes and the thick foliage, girls who are scattering flowers at the feet of the priests carrying the Holy Sacrament, and the long peasant coats are blue, tied with a wide red sash . . .

He twitched and started up, lusting for greater longing . . .

Endless . . . in miraculous configurations, a wedding

144

procession on a day in July. The broad sobbing of the violins, made from the bark of the lime-tree, the hoarse groaning of the basses which jangle with the coins that the bridegroom has tossed into them, and a jubilant cry which cuts through the air at regular intervals: Hooray! And then again a funeral procession in late autumn on rain-sodden country roads ... A couple of girls are carrying the white coffin of a child and then a solemn pilgrimage wending its way to the miraculous picture of a Saint, then again ... oh, endless, measureless ...

His eyes slowly darkened; only a few vague, ragged pictures slid sluggishly and tentatively across his brain ... His soul grew dusky, rocked in tender dreaming and extinguished – until suddenly rearing up in a mighty song.

The malicious enchantment of the flowers, the intoxicating poison of exotic blooms, and the paradise of his homeland made his soul resound with the thundering, brazen steps of knights who seemed to be cast in bronze and who made the earth tremble under their victorious, exultant marching, and then his soul melted in the sobbing moans of a mother lamenting the death of her first-born ... his soul grew verdant in the myrtle wreath of epithalamia, it raged and roared in the drunken tavern dance, stamping and shouting, it shot upwards with a wild shriek like the mullein's bloom upon the searing hot earth of the fallow field, the whole song paved itself into a dark, wild bed, it dried, drew backwards, yet only to burst forth again more powerfully and finally flooded the plain itself ...

A monstrous force seized him in its arms. The rabid frenzy of the storm gripped him with the groaning of damnation, hurled him on to the seething spume of an abysmal whirlpool, raged in him, howling, crashing and hurled him howling up the steep cliffs like a wreck, and in the depths, down in the bottomless depths of a funnel he heard a bright sound which faded, returned, sank down and came again like the reflection of a pale star in the churning uproar of dark waves.

This bright radiance had long fought against the spray

of the flood, against the storm of mountainous waves, but it continued to spread its light in long, slim beams dancing over the turmoil in graceful, serpentine convolutions, contracting, then expanding again like a feather which rolls and unrolls: still, yearning gentle waves of light hovered above the storm-tormented abyss, above the desperate moaning and shrieking, above the anguish, the howling and the screaming of the insane uproar ... Waves of tranquillity grew and became ever wider, waves of lightness and denial, of joy and salvation, embracing the storm, the shrieking terror, in holy maternal arms, pressing it in an eternal love, and rocking it in a supernatural longing, in a swooning dream of ecstasy.

There:

A girl's face appeared, a bright, holy chord in the black, stormy uproar, the light reflection of a pale star in the churning froth of dark waves ... he had never seen it before, but he knew it, he knew it well, this female countenance ... He awoke, he rubbed his eyes and walked up and down the room, but could not dispel the vision of this face, half child, half woman.

Yes, it must be she! It was she who had had the flowers handed to him on the podium.

He asked himself how he was so certain that it was she.

Some stranger had handed him the flowers.

And he thought, and brooded ...

So she was there, she was sitting in the front row, and the dark dual stars of her eyes had shone into his soul, leaving their radiance within him. At that time, when the whole world was dissolving before my eyes into wraiths of mist, when everything was seething in the hurricane which was howling beneath my fingers, the power of longing had fixed the radiance of her eyes within me ... It was I also who formed the countenance to these eyes, for it is only this face and none other that can glow in the radiance of such eyes ...

And the radiance embraced him from all sides, it poured into his blood and swept through his veins, a hot tremor

146

shuddered through him; he was trembling in an unknown ecstasy of joy.

For there are indeed strange signs and portents before the hour of salvation, he muttered to himself: the whole of mother earth has awakened within me, the whole of life has slid with the speed of lightning across the firmament of my soul, the whole desperate joy of my life has spread its heavy, wounded pinions before mine eyes, from one end to the other . . .

He stopped, and stared for a long time at the bouquet with the wide red ribbon and the mystical name . . .

Yes, she is as slim and supple as the stem of the tuber, and her eyes are as pure as the white stars of Bethlehem which rest on him and move dreamily to and fro . . .

But where did I get the vision of this countenance, half child, half woman?

He thought:

This is the mysterious hour, before the sun awakens.

He gazed for a long time out of the window at the snowy fields of the suburbs . . . The snow was turning blue in the first flush of dawn . . . A stripe of bright hues was writhing along the horizon, disappeared, then came again and caught the East in an ever wider embrace . . .

From this time onwards the vision of that tender, delicate countenance constantly hovered in front of him, a face that cast its radiance into his blood . . . He constantly saw that slim girlish figure, half woman, half child, like a tuberose, which rocked upon its stalk two white blossoms, two white eyes of Bethlehem.

He sat for hours, thinking of her, dreaming . . .

The same pictures kept coming back before his eyes: in the depth of his soul the images of his homeland were inextricably enmeshed with the secret dances of sounds and songs, the scent of flowers, the dark storm and the reflection of pale stars in the maelstrom of heaving waters.

He could not understand the connection – nevertheless – it seemed as though she were his homeland in the exultation of spring, the flowers that she gave him, the dress, eternally

new yet eternally the same, of her soul, the eternal form of her being, that the eyes, her eyes . . .

He deliberately severed the flux of his thoughts, he seized the flowers, threw them at himself, thrust his feverish hands into their midst and dreamed of her, and sought for her.

He was already holding her in his arms, crushing her against his breast in a sick ecstasy, kissing her, kissing . . .

And then he made up his mind, he had to find her!

He must!

To catch one glance from her eyes, only one gleam, a trembling light in her gaze – and he would recognise her, he would certainly recognise her if her eyes should gleam for a thousandth of a second . . .

He wandered for days around the streets of the town, hanging around for hours in the parks that ringed the city. Thousands of people slipped past his gaze, he thought he recognised her in every girl he saw, every glance seemed to arouse the same joy in his blood as her eyes had done, the same wounding of the heart, but in vain: always the same disappointment! It was not her!

And yet, in the dusk, he sometimes heard footsteps close behind him, like the beating of restless wings, wings that were ready to take flight . . . sometimes he saw the quick, furtive gleam of a dark pair of eyes, penetrating his soul from near or from far – and once the touch of a soft, tender *hand* caressed him as he stood in the darkness of a church, enjoying the secret, precious gift of twilight prayers, but when he turned round, seeking to rend the darkness with his eyes, the vision dissolved, there was only a shaking luminescence, only warm *breath* of a febrile *hand*, and along his nerves the feeling of a slim tuberose with two white stars.

He was a King, yes, a King and a powerful ruler . . .

O the sick, tormented joy of sleepless nights, as he lay on the terrace of his palace, gazing at the luxurious splendour of the star-strewn heavens!

Tropical ivy grew in rank profusion; golden tufted

148

blossoms rose from dark foliage; calyces like brazen bells, flowers surrounded by leaves which shimmered like polished cast-iron or molten brass ... There were flowers with lightly haired pudenda, virgins blooming with eternal life, flowers which laughed with the eyes of living, knowing courtesans, or which stared and searched with the lost eyes of dying, exhausted seagulls and white albatrosses ... He saw stalks and stems like lilies growing from dead hearts or from potatoes like skulls ... Tongues leered forth from the syphilitic maws of incredible orchids, monstrous shapes strewn with purple fever pustules, tongues, which crept outwards and seemed to smear their poison across the carpet of flowers.

As far as the eye could see there were monstrous forests of primeval darkness, tangled, entwined, knotted in a dense, impenetrable mass, with ropes and cords of ivy, lianas, bindweed and creeping vines; and this heaving mass of parasitical growth twisted around the darkened ferns and bracken, the Isaurian palm trees, the coconut trees and breadfruit; it wove them into wickerwork and tangled them inextricably into each other; from the top of the terrace it looked like a mass of otters creeping out of the primeval magma.

And in this nocturnal darkness, star-longing, light-lusting, in this abysmal fever of matted forms, of sick perfumes and of colours seen as if in the delirium of opium the king dreamt of her, her, the only one ... He crawled on the thick soft carpets, his fingers gripping the feet of the chairs, he drew in the poison exuded by the most monstrous of the flowers, and he screamed for her.

In vain!

Until:

He ordered the most beautiful virgins to be brought to his palace; in the vast hall he sat them in two rows which stretched from the throne into the gloom of the gardens ...

And, dressed in incredible regal splendour he sat for a long time on his throne, cradled his face in both hands and

gazed at the virgins who were trembling with hope and anticipation, each of whom would have surrendered to him and, in highest ecstasy, become his slave.

He looked at them, looked at them, and he wondered:

Which one is it?

How could he find her in this sea of heads, blonde, dark, auburn?

Is it she, whose eyes glow like belladonna growing amongst the debris?

Or is it she whose soft eyes suddenly glitter with the bloodthirsty gaze of a tame jaguar?

Or that one perhaps whose brow is lit by a lightning flash, a gleam of light born in her heart and which casts an endless sorrow across her face?

That one, whose arms hung slackly like tired lilies, or that one who held the lustful fruits of her body in a seductive embrace, perhaps that one there, with the gleaming suppleness of a snake, or that one, who arose from the womb of a lotus, or that one, far away, blooming out of a starry calyx, born from the radiance of moonlight?

He buried his face deeper in his hands, painfully, for he felt that he would not find her, the chaos of shapes, one dissolving into the other, forms, faces, eyes, darkened the King's soul.

He climbed down the steps from the throne, and the virgins bowed like a white row of birch trees, freshly blooming, when the wind blew through it.

The heads bowed like precious ears of corn in the searing midday heat when a hot breath suddenly passes over them; the whole room seemed to gasp in the intensity of expectation and the bated breath of hope.

Three times he walked up and down the rows of the most beautiful maidens of his realm, more slowly, and sadder, until he finally sat once more on the throne: he waved his hand, and was alone.

The hall grew dark. The king buried himself in his despair: he pressed his face against his clenched fists, and brooded.

Then suddenly he felt that someone was creeping along the pillars which supported the vaulted roof, somebody was sliding through the dusk, and behind himself he noticed the white gleam of a naked body.

The kind proudly lifted his head, for no mortal had ever dared to gaze at him in his desperation.

He clapped his hands, and from an invisible source of light a cold metallic gleam cast its illumination into the room, and in the half-light he saw that a Syrian slave-trader was creeping towards the throne, dragging a naked girl behind him.

Bangles embraced her arms, golden snakes, and golden snakes twisted around her ankles, and a golden girdle held her hips, its clasp was in the form of a lotus flower, set with precious stones.

The king looked at her, astonished.

He did not see her face, for she crossed her arms before it: he only saw her figure, her slim, supple limbs, a tuberose with two white stars behind the lilies of her arms.

With bated breath the king gazed at the magical wonder of the maiden's body, trembling in dread lest the dream should evaporate, he saw her rocking back and forth as if in a fire of fear and shame: her hair was flowing over the white lilies of her body like a molten stream, and suddenly she was kneeling and gazing up at him.

She, it was she!

He gripped the arms of his throne with both hands and whispered, trembling:

Did you give me the flowers?

She nodded . . .

With a hot scream he stretched out his hands towards her, and everything vanished . . .

He rubbed his brow . . .

He *was* awake.

Indeed he was, but only to fall again into a deeper, still wilder dream.

Now he was a magician, all-mighty, all-powerful, a servant of his Lord and, at the same time, a God . . .

Yes, ipse philosophus, magus, Deus et omnia . . .

He had prepared himself for his incantation for three days and three nights. For three days and three nights he had studied the magic books, deciphered the holy runes and unlocked the seven seals of apocalyptic vision. He committed to memory the fearful spells which would make him the master of unknown powers, for three days and three nights he drew in the intoxicating, poisonous vapours brewed from plants and roots which bloom mysteriously on midsummer night until he felt within himself the power to accelerate the growth of plants, to stop a river in its course, to make a womb infertile, yea, even to bring thunder down onto earth.

And in the hour of the great Arcana he put on the precious robes of his high office which once his ancestor Samyasa had donned: he tied his hair with the seven-fold knotted head-band, took his sword in his hand, drew a circle, wrote mystical formulae in it and stood in the middle, before a large mirror, declaiming loudly:

O Ashtaroth, Ashtaroth!
Mother of love, thou who devourest my heart with the poison of longing and desire, thou who pourest the fire of an insane torment into my veins; unique Mother, who tearest from the strings of my soul the anguished moaning of hopes that are vain and shrieks of desire; thou fearful Mother who hath stretched me upon the hellish rack of futile writhing –
Have mercy upon me!
O Ashtaroth, Ashtaroth!
Thou hellish Daughter of deceit and duplicity, thou who conjurest before mine eyes at night the most unspeakable lust and ecstasy, thou who throwest the woman I seek into the wild embrace of my limbs and melts her, shrieking, with my own flesh, thou fearful, cruel, Hell-Queen, sucking force and life from my blood in order to awaken me anew to new torments and despair –
Have pity on me!
O Ashtaroth, Ashtaroth!
Mother of perversity, guardian of the sterile womb and unfruitful desires, thou who hast implanted in my soul a yearning

which thou dost not still, into my bloody dreams that are not of this world, and into my brain the convulsions of lustfulness that darken my eyes with madness –

O harken unto me!

His hair rose up in an inhuman act of will . . . He shuddered and trembled as though every limb were possessed of its own life. It seemed to him as though he were stepping out of his own body as though, outside his body, he were incarnate anew, as though something were forming which was streaming forth from his soul, from his desire and from his most hideous torment.

A crash of thunder, as though a planet had torn itself from the sky to fall into an abyss of nothingness; a fearful storm had broken all the bonds, a hellish laughing, howling, shrieking was raging in his brain . . . In horror he saw a mist stream around the mirror, which glowed, shaped itself, took on palpable form . . . He saw it solidify, a body, breathing, pulsing with blood, alive!

The room was seized by streams of lightning, a clap of thunder smashed the mirror, there was a shriek and *she* threw herself at him, in wild, unconquerable lust, she whom he had sought so long and for whose sake he had forfeited his salvation . . .

O insane night of unquenchable desires!

<p style="text-align:center">* * * *</p>

These dreams terrified him.

He was unable to recognise himself. The connections and correlations within his soul separated, the threads were sundered . . . nothing meant anything to him any more, he only lived in his sick dreams and his hands crumpled the ribbon which had once decorated the bouquet which had long since faded.

It seemed to him that this ribbon had absorbed something of her being. He felt that it was alive. If he stroked it, it seemed as if his hands were caressing the velvet of her body; if he kissed it he was breathing in the perfume of her silken hair; if he tied it round his breast it seemed as though her limbs had wrapped themselves around his body . . .

Greater and greater grew the pain and the longing within him. He tormented himself with an impotent writhing. She who had given him the bouquet became a vampire who sucked all the blood from his veins.

And again he was wandering around the empty streets and squares, and when it grew dusk he crept into dark churches, for once it seemed as if a soft, loving, yearning hand had thrust itself in his with a passionate longing. He wandered amongst the trees in the park in Spring for once he heard footsteps behind him, her footsteps, like the beating of restless wings which seek to fly. For hours he stood at the window and peered out into the darkness for it seemed that he had once seen a pair of eyes – her eyes – seeking for his in fervent supplication.

Till finally:

Darkness was sinking heavily. Here and there, between the dark foliage of the trees, the restless flickering of the gas-lights was glistening like blood; the town was pulsing restlessly and a sultry, mournful brooding spread across the dark tree-tops. And suddenly he spotted her where two paths crossed.

He knew that it was she.

The same eyes that had burned into his soul that evening; the same face, for only such a face could gleam in the radiance which played about these eyes.

He started, stood still, and she did not move, frightened and confused.

Their eyes met, and fell silent.

He wanted to say something, but could not squeeze out a single word: his whole body trembled, and she shuddered.

She suddenly lowered her gaze; she stood for a moment, then walked unsteadily past him.

He awoke.

He walked behind her, quietly, carefully. He crept along the side of the trees, occasionally hiding behind a wide tree-trunk for he feared that she might look anxiously round and listen to see if he were following her.

He saw her shadow extend and contract by each of the street-lights that she passed. Ah! If only he could tear her shadow from the earth . . . her shadow . . . her shadow . . .

Suddenly he drew himself up to his full height and made the decision: reach her, seize her by the hands, stare into her eyes – long, deep, into her very soul, to crush her hands in his and ask her that One question: Did you give me the flowers?

But suddenly she turned and disappeared before he could put his decision into action.

He stared for a long time into the dark doorway.

For a moment it seemed as though she were standing in the dark passage way, leaning against the wall, waiting for him and beckoning with her eyes – he could see the white of her hands, and hear the rustling of her silk gown – but no: he was wrong.

Exhausted, dead tired, he wanted to go home.

A heavy, unspeakable sadness spread across his brain, poured into his heart and spread throughout the finest ramifications of his nerves.

He had never before experienced such tormenting sadness.

The miracle was fulfilled.

He loved her.

And, terrified, he asked himself: Is this love then?

He sat upon a bench and brooded.

And suddenly there shot before his eyes an ardent torrent of female figures, women whom he had known, whom he had pressed to his own body and who, in a wild fanfare of blood, had become one with him . . .

She, that one, unfathomable, enigmatic, with the glistening gleam of heavy silk, crouching, ready to leap as a panther . . .

Or that one, with eyes as soft as a dove and obscenity in her heart, gentle as a roe and hungry as a beast of prey . . .

Or that other one, whose body was as cool as a snake or the leaves of a water-lily . . .

The other, slim and splendid, drunk with her own loveliness . . .

Or the other, with the figure of a divine boy, like a flexible Damascus sword . . .

He had had them all, yet had never loved them.

He had left them without sadness, and had not been sad when they had deserted him, and when he looked back at his life he did not see a plucked and broken flower by the wayside, no shattered branch had spoken: Here a storm had raged.

This is love then, he whispered. The hour of the miracle has come.

Abruptly he flung from his mind the lascivious images of lubricious courtesans and innocent doves: with revulsion he gazed at the naked bodies receding into the distance, the chaos of arms and legs, lusting for fulfilment, the dying, twitching orgies of drunken sensuality, and with a child-like piety he gently murmured:

The hour of the miracle has come, the hour of the miracle . . .

And he brooded, endlessly . . .

Yes, he loved her.

Loved her as he had once loved the stream of light which poured out over the sea at night.

He clearly saw the massive granite lighthouse which he had once inhabited, high up upon the highest point of the cliffs.

And he could clearly distinguish the strange formation of the rock. As though a gigantic wave, hurling towards heaven, had suddenly become petrified at the very moment that its spray-lashed, spume-laden back should break and collapse into a monstrous abyss of water.

And on the jagged, shattered mane of the petrified hell-stallion there reared the granite tower.

For hours he would sit up there by the source of the electric light, gazing through the lantern's enormous glass prisms at the miraculous light formations on the sea below.

He saw the beam of light, like a wedge, cutting across the edge of the waves in the lost, dark, silent wilderness of water when the moon shone full.

A hand, drunk with light, rested with a gentle gleam on the maiden's lap, dissolved, slipped back and forth like longing, silent lips which wander on the trembling breasts of the beloved.

For nights on end he gazed at this eternally gentle, trembling caress, the gliding and the wandering of this dreamy hand, suffused with light.

And he saw again how the light spun golden threads into the wrinkled sea. As far as the eye could reach — nothing but golden gossamer, but the finest lace in an enormous opulence and splendour. The golden net spread into ever greater circles, and the rings enmeshed and entangled new and richer threads, wove new more complex patterns — and it seemed as if the lighthouse were a living creature, a sea-girt goddess, an empress who had spread the golden train of her nuptial gown across the sea.

Then he saw the light from the lighthouse desperately seeking to eat into the dark banks of fog. Greater and heavier masses of fog fell upon the sea, growing darker, denser, until they became a black, impenetrable wall. And this black mass stormed the light. The light hurled itself with powerful wedges against the black ramparts, striving to tear them down with gigantic claws, to break the darkness with an even greater radiation, to rend it from the sea, but in vain.

But he loved the light most tenderly when it performed a wild, insane St Vitus dance upon the foaming heads of the waves. When the foundations of the lighthouse were cracking as though shattered by an earthquake, and when the raving hurricane hurled monstrous masses of water against the prisms, then he wept with a boundless love for the light.

This, oh this was the light which had shone from her eyes into his soul.

Soft and caressing, like the white, gleaming hand which stroked the lap of the sea, longing with the ecstasy of silent lips brushing the chaste loveliness of virginal breasts, trembling and playing in the golden lace, the nuptial garments

which were spread across the sea, stormy and despairing in the powerless struggle with the black masses of fog, convulsed with pain in the battle of the Light-Dragon against the Loki of the ocean.

And in the same second, in the hour of the great miracle the whole world was reborn within him. Every form, every shape assumed the slim, supple shape of her splendid body; the whole torrent of colour, the whole universal ocean of light poured into the dark, hot radiance which played about her eyes; from the immeasurable chaos of sounds, movements, harmonies, from flux and form there blossomed a wondrous song, a song that was *she*, the only one.

Was this why the earth had brought him forth, so that her form should be etched into his soul, so that her lineaments should be incorporated into the one he sought, be poured into them like an entelechy, a predestined pattern?

Was this why the miracle of moonlight over barren fields, the pain of light above the sea and the leaping, shuddering blaze of sunlight at midday over the roofs of home had poured itself into his eyes, was this why the colours of the sun-burned steppes, of poisonous marsh-weeds, had eaten into him, so that only *her* gaze should bore into the depths of his soul, awakening his most innermost and holiest thoughts, so that only the shine of *her* hair should curl caressingly around his nerves, so that the sound of *her* body should play upon the harp of his soul with such a unique, an unknown ecstasy of divine harmony?

And that was why his earth was groaning and travailing in this unspeakably mournful lament, that was why the bells were tolling their sombre premonition, and the wind was moaning, telling of remote agonies in tune with the waving wheat, so that each tremor of her body, every fine and supple response should become one with the contours of his soul?

He rubbed his brow, unable to grasp it all.

That was why everything was alive around him, everything was shaped *so*, and exhorted his soul to create that shape which the Unknown One was to fill?

He rose and left.

His soul was filled with a silent triumph.

He walked on proudly, his head held high, like a general in the knowledge of an endless victory. Did he not carry a sun within his breast, – the cosmos, the deepest and most mysterious riddle of all.

He walked quietly, with greatness, for his soul had opened its deepest meaning to him, had let him read the most secret runes engraved upon its sheath, and he walked splendidly, glowing with the glory of sunlight within his heart.

He walked with increasing swiftness up the steep path, but he walked easily, as though carried by some mysterious power, until he finally reached the top of the rise.

He gazed down at the valley beneath his feet, this heaving sea of roofs that seemed to be bathed in a fine, light haze – this was his town.

And in the distance, behind the town, there was a range of jagged mountains, twisted in contortions, a confusion of meandering hills, abrupt and terrifying precipices, mountains like monstrous waves, spraying up from the depths of the horizon, breaking, towering up one above the other ... and the heights were covered in forests of chestnut trees. Green chestnut forests, covered by the snowy glory of blossoming candles. Ah! how the white requiem candles flickered on the green velvet which seemed to pour down from the sky on to the town below!

And suddenly his heart expanded in a feeling of unknown power. He was growing into the skies, he stretched out his arms, a wild shriek burst from him, destined to show the cosmos that sun which he held within his heart; he sensed that he was radiating light, as though an ocean of light were roaring around him; he felt that he had transcended Being, and was celebrating Ascension.

And, again, he collapsed.

159

Everything changed.

Home!

It was late. The lamps had been extinguished, and he wandered as in a dream through the gloomy twilight of the avenue of chestnut trees. He was walking, and was scarcely aware that he walked.

His soul was lacerated by raging desire; his brain seethed and boiled.

And yet he was carrying her within him, the sun, the cosmos — all this was contained within his heart. What, then, was he longing for?

He smiled quietly to himself.

Her face, so strangely light and transparent . . . her eyes, so large and startled . . . her figure, so slim and supple, like a young reed in the winds of Spring . . .

Fever devoured him.

He reached home, and threw himself on the bed . . .

The night grew rigid in the air. Night grew petrified, no ray of light could penetrate the heavy, granite vault of night, a massive black rainbow, bearing down upon the earth . . .

In the blackness of night great flowers screamed in anguish for the sun, twisted in fearful torment, arose, rearing upwards in the convulsions of rigidity, hurling themselves upon the earth in St Vitus writhings, bending into spiral coils in the delirium of obsession, and vast fields of white narcissi stared with bleeding eyes in a senseless despair.

White narcissi with eyes that burst, swelling with blood, blood that slowly ran down the stems in great black globules.

And above this white wilderness, sprinkled with the stains of bloody tears, there arose two proud, slim stems; two white stars were dancing in the air, rearing higher and higher and, with a joyful burst of hope, they rent the thicket of darkness: they gently moved their two heads together and their eyes entwined in the silence of holy premonition.

He stared for a long time at the lovely flowers, smiling, moving.

He forced his way with difficulty through a tangle of the most monstrous flowers, growths that seemed to have sucked from the earth every known poison, every possible putrefaction.

He was wandering through wet marshy weeds, beneath gigantic, dark-shadowing trees, exulting in a violet mournfulness; he walked past monstrous hedges of deadly nightshade, overladen with berries that gleamed like polished ebony, past bushes of hideous henbane whose dirty ash-coloured leaves shrieked with the horror of midnight; pale hemlock blocked his path; the thorn-apple terrified him with eyes that seemed glazed with grey glaucoma; tall bushes of belladonna whipped him in the face; he was blinded by ranunculus which was burning in the red glow of an Alpine fire.

And deeper and deeper he bored into himself, into this hideous realm of poison until he stopped, suddenly, petrified with fear.

The room narrowed around him; space hurtled towards him, constraining and constricting, closing in around him as a wall, and he suddenly found himself in a mysterious chamber, like the temple in Eleusis, where arcane mysteries were celebrated, or in a secret room of the cult of Isis, where the priestess offered her hymen to the consecrated goat, or in an underground vault dedicated to the goddess Kali, where the Thugs let poisonous snakes suck the eyes from their victims ... or, rather, he was in a ruined catacomb where Satan, with his two-pronged phallus, forced his beloved to bleed in inhuman lust, or he was in the crypt of a medieval chapel where blasphemous priests celebrated a Black Mass upon the naked body of their chatelaine ...

Astonished, terrified, he looked around him.

From the ceiling there hung a lamp, thickly clustered with rubies which looked like menstruating eggs, with diamonds as large as fists, suffused with the pale light of a

watery goitre, with precious stones which adhered to the lamp like lumps of cystoid ganglia, onyx, beryl, chrysolite – and through the foul waters of the sick jewellery there poured a flood of light, light suffused with expiring rubies and the green jack o' lantern of an emerald gulf-stream.

And in the dreadful magic of the light, a light which once, perhaps, lashed the febrile earth at its genesis into a senseless rut of procreation, when it was still seething with fire and furnace; by this dreadful light he gazed around the wall at a curious ornament which formed its cornice.

One and the same female countenance with an ever-changing expression, an ever renewed mourning, despair, passion, lust, longing . . .

But it was *her* face, and the eternal song of her soul, he thought, astonished.

He saw her, innocent and pure as a child with the eyes of a white tuberose, still as the reflection of pale stars in a dark stream, soft as the echo of a shepherd's pipe in a Spring night, steeped in the intoxicating perfume of the lilac . . .

But then again sad and sorrowing, like the blossom of a black rose in the suffocating heat of July – (and only occasionally does a wild cry burst from her soul, like the cracked tone of a broken chord which resounds across the sun-drenched, grassy sea of the steppes) –

Or again abrupt, yearning, like the poppy flower dying in the sacrifice of lust: as though through the dream-heavy, sultry woe a serpent should crawl again, a snake of greedy, smouldering music, breathing out lust and torment.

He once saw her eyes swimming in a haze of intoxication, then again bold and insolent as though they were in the grip of Indian hashish . . . In one vision he saw her mouth like the parted blossom of a mystical rose, then again gaping in the scream of an orchid's open calyx, proud and inaccessible as the blossom of an aglaophotis, and scornful as antirrhinum.

An endless row of heads – one and the same head – and all the expressions in an endless variety and alternation: an

endless scale of sadness from the first trembling of desire down to the deepest whirlpool of manic despair – the whole eternal song of love from the first tremor of the heart which fills the veins with blood, through the glow of ardent passion, through blind, greedy longing down to the hell of lust, which cannot satisfy, cannot *be* satisfied – the whole hurricane of insane eroticism from the first blossoming of the thoughts of joy which, spider-like, enfolds the brain, to that last dark, shrieking, torment-tossing chaos, when the soul loses itself, bursts, and explodes in fragments.

And suddenly: all these heads began to detach themselves from the wall and became alive, they started to form and assume shape, arms, lusting, drunken, shrieking arms stretched out towards him, naked female forms leaped from the walls, climbed down to him, threw themselves upon him and overwhelmed him with a sea of greedy bodies, bodies that promised the lust of the abyss; a hideous laughter, weeping, groaning, screaming burst from the room, echoing around the thousand corners and crevices, gasping arms embraced him, flinging him to and fro, and he was suffocating in the mad hysteria of flesh, in the rabid orgasm of an infernal rutting. He was enveloped in a horrendous orgy of tangled limbs which could not be separated, in the shrieking spasms of a hideous copulation – the most ghastly images of perverse sexuality blossomed before his eyes, a demented Sabbath of blood and sperm.

Then, in a trice, everything disappeared.

He saw her upon the crucifix, stretched in the full glory of her nakedness. Golden snakes twisted about her arms, her ankles, and a broad golden girdle embraced her hips, a girdle closed by a clasp which rested on her navel, a precious lotus-flower, sparkling with the rarest jewels. She gazed at him with her eyes half-closed, from under her long lashes lustful snakes were creeping, tempting with a flattering whisper . . . She was rocking back and forth on the cross in a lascivious ballet, her pudenda twitching, her breasts stretching towards him . . . Her voice was hot, sucking . . .

163

Do you recall how my father dragged me, naked and ashamed, before your throne?

Do you remember how you were sitting on the throne, shuddering, shrieking with lust, and stretching your arms towards me?

I was pure as the lotus blossom which gave birth to the god, you have shattered the holy lamp of my soul, poured out the ardour which was held in my veins, you have eaten away my soul with the acid of desire and wild, lustful dreams, and you then have crucified me.

Her voice was shrieking in panting lubriciousness.

Do you remember how your eunuchs pressed golden nails into the white lilies of my arms, blood was squirting in steaming spurts, and I scorned you, I spat curses and vituperation into your face, I bit into your soul with the poison of my jaws . . .

Come, come you poor slave of the blood, blood which you have whipped into a raving madness, come into my embrace which you have never tasted, come into the hell and the perversion which you have awakened within me; you have crucified me, and are rolling in the dust before me . . .

Creep closer, closer! Lick my feet, that they should twist in the febrile ardour of your lips, oh!, more!, more fervently, stronger!

He was creeping up to her . . .

And there was a hideous scream: 'O Ashtaroth, Ashtaroth! Mother of hell and lust!'

But at that moment his brow was touched by a breath, an eternal, pure, holy chaste exhalation from the still hands of lilies . . .

He feared to gaze upwards, he feared it might be a dream again, this time a holy dream of eternity . . .

The hellish horror disappeared without trace, he felt her hand caressing his brow and her still, chaste kisses closing his eyes, her silken hair spilling across his arms with a loving benediction.

He felt her hand in his, he saw the two stars of her eyes, and an unknown blissfulness poured into his heart . . .

Yes, it is she, she, as quiet as death, the chaste one, the holy one; it is she who once gave him the bouquet of flowers . . .

<p style="text-align:center">* * * *</p>

It was already late in the morning when he laboriously pulled himself out of bed, feverish and exhausted.

Why does she avoid me? He asked himself, despairingly. Why does she flee from me?

His thoughts grew confused: a thousand plans, a thousand decisions criss-crossed his brain, and a thousand images floated across his soul, until he finally sank, collapsing, on to the chair.

He could understand nothing.

He examined the entirety of his anguish, his ravings and his madness, since she gave him the flowers.

Pain arose within him, and a wild hatred.

I'll crucify her, crucify her! he repeated, with a demented smile.

He closed his eyes and revelled in the mortal terror of his slave.

In a gigantic palace courtyard, somewhere in Sais or Ekbathana.

Around him stood his warriors in their heavy silver armour and their golden helmets; the rings of their breast-plates were glinting in a blinding gleam, and their eyes were flashing with the bloodthirsty greed of wild beasts of prey.

Three times the trumpets sounded: the eunuchs dragged the poor slave into the courtyard.

She was mad with fear; her lips were bleeding; she gasped, fell backwards; the black slaves seized her by the arms and dragged her across the scorching, sun-drenched flagstones to the foot of the cross . . .

The King closed his eyes and gave the sign.

They swung her upwards on to the ebony wood of the cross; the executioner seized her hands, a slave held her tight by her hips, and one heard the blows of the hammer . . .

But at that moment the King roared like a rabid beast . . .

He tore her from the cross and held her like a child in his arms; the blood from her wounds dripped on to his raiment; he kissed her wounds and drank her blood . . .

The minions who dared to touch her were hanged, drawn and quartered; he made her a goddess, and brought sacrifices to her . . .

Yes, yes, she was his God, and the whole world should genuflect before her . . .

O God, how he loved his slave, he, her most abject slave!

And why should he torment himself so?

He decided quite suddenly to tear her out of his heart, never more to think of her, to throw out the flowers together with the red ribbon which reminded him of her with such anguish.

But when it grew dark he ran out to the house into which she had disappeared the day before, and waited . . .

He finally caught a glimpse of her as she stepped out of the doorway – she looked around, but did not notice him.

He followed her, quietly.

He must not frighten her! She must not disappear from view! He scarcely dared to breathe.

She was walking quickly, as though she sensed that someone was quietly creeping behind her: she increased her pace, the white gleam of her dress flickering in the dusky avenue of hot, blossoming acacia trees like a will o' the wisp between clumps of reeds in a dark swamp.

He was now almost certain that he would lose sight of her: he stepped up to her, half conscious and scarcely aware of what he was doing.

She stood stock still, terrified, and gazed speechlessly at him . . .

'I was afraid I might lose sight of you,' he said at last. 'You were walking so quickly.'

He was breathing deeply, and fell silent.

They were walking slowly next to each other.

166

He regained his composure.

'I don't know how I dared to hold you back, but at the moment I crossed your path I didn't know what was happening to me . . .'

He fell silent for a moment, then spoke quickly, abruptly, in a staccato fashion, and urgently, as though he wished finally to rid himself of his burden:

'You don't realise how much I have sought you. I've been wandering for days throughout the streets, in churches, parks and boulevards, just to catch a glimpse of you – not a glimpse, no, only the remotest impression, the most distant breath from your soul. I didn't know you, I've never seen you before, I only knew that I would find you amongst a million women. The one who gave me the flowers, whose eyes have kissed the depths of my soul, can only look like you.'

She walked even quicker and he begged, implored and whispered ardently:

'Oh, how I love you, my divine slave. You are my earth and my song, you are everything that is deep and pure within me. I carry you within me like a holy sun: you gleam in the depths of my soul like the radiance of a powerful star in an ocean tempest, your eyes are like two tuberose stars, and every night you embrace me with the willowy slimness of your limbs . . .'

She stopped, trembling, and let her head sink low.

'How often have I held you in my arms, how often have I touched your face with an infinite love, kissed your eyes, lifted you to my breast and drunk the divine joy of your lips!'

He grabbed her by the arm. She was trembling like a heart that has just been ripped from the breast.

'Say a word, just one word. I know that you love me, that you must love me, for she who sends such flowers must truly love. You know full well that you gave yourself to me when you gave those flowers.'

Again he fell silent, and only looked at her with an imploring gaze.

167

She said nothing, withdrew her hand and walked on quietly.

'Just say a word, he begged. If you wish, I'll never say another word to you – just permit me to follow you from afar, that I should catch a glimpse of you occasionally, that I should taste your form, the music of your steps, the endless harmony of your movements. Just grant your permission, you don't know the agony I'm in, what sorts of hideous dreams I have, driving me into madness, just say one word, at least tell me that I should go away . . .'

He became more and more confused, he stuttered, stammered, tormented himself unspeakably, tripped himself up and forgot what he wanted to say to her.

The tears were flowing across her face, but not a tremble, not a twitch of the muscles betrayed the fact that she was crying. She was quietly weeping the blood of her heart, weeping as a seagull weeps who has lost the way, who longs to return, but does not return . . .

He felt a whole world collapse in a thunderous crash within him. His heart was gripped by a wild, hopeless sadness: he walked alongside her as at the moment of their ultimate decline when the sun is extinguished for ever and an eternal night, shuddering, arches over the earth.

He walked as though he were walking to the end of the world, to be rowed across to that secret shore of shadowless trees, in a dead, cold cemetery air where motionless birds were resting with stretched and lifeless wings.

Something of his poured into her: perhaps she sensed the same endless sadness, the same premonition of an eternal emptiness and the silence of death; she shuddered, then she put her arm through his and pressed herself gently against him.

'I am frightened!' she whispered softly.

They gazed at each other in deepest horror . . . Breath froze in their hearts in the anticipation of something about to overwhelm them with the terror of the Day of Judgement.

And then, abruptly, there poured over his soul the

Golgotha of his last few days in a hideous flood of torment. Wild fury seethed in his brain, he seized both her hands in anger, pressing them in an iron grip, and screamed:

'I'll crucify you! Crucify you! Crucify you!'

She stood for a moment, trembling with terror like an aspen leaf, then twisted herself from his raging embrace and fled at tremendous speed.

He saw her run away, but everything seemed to spin in circles before his eyes, lightning transfixed the darkness, and a sun sank, crashing, into the abyss . . .

He fell silently to the ground, as though laid low by an invisible scythe . . .

<p style="text-align:center">★ ★ ★ ★</p>

Many days, many nights came and went.

He had shut himself away and admitted no one.

He was terrified of going out on to the street for he knew that he would meet her, and he knew that she also was looking for him, that she was wandering around, seeking him as he had sought her.

And when it was growing dark, and he had to go out, he would creep past the houses and the avenue of trees.

The least single noise filled him with dread, and the echo of distant footsteps made him start, for everything that surrounded him, the whole cosmos of thoughts and memories, the whole world which stalked him, was *she*.

He did not know why he was so frightened. He only felt that something terrible must happen should he meet her again.

And he had never longed for her so much; never tormented himself like this.

Whenever the world fell silent in an immeasurable stillness, when the blessing of light blossomed forth in the starry chalices and poured down on him, when the sadness of the moon bled between the chestnut trees: then ah! he would stretch out his hands towards her in a shriek of desperation, his soul dying in wild convulsions, and he crept towards her, for it seemed that the distance would melt away between them, and that she would climb down

to him, embraced by the precious perfume of the most splendid flowers that he had ever experienced in his dreams, and dressed in the supernatural enchantment of divine azure, she would descend and soothe his fevered brow with her radiant hands, and embrace him, and caress him, and kiss him . . .

Or, alternatively: she will pour over him with an indescribable benediction of silence and calm, will pour into him with forgetfulness and intone in his soul the high song of silver dreams.

Or, alternatively: she will come to him with the muted resonance of distant bells which will spread within his soul the green carpets of his homeland and make his heart drunk with the gleam of lovely childhood memories when, on his mother's lap, he could still dream of a wondrous world, a world still holy within his virginal breast, and could listen to the song which the lake at home was singing to him at the midnight hour, and gaze up at the birds spreading their heavy wings silently over the mysterious graves, and he could wander in the garden, gardens precious with black trees from whose monstrous umbels heavy gold blossoms were hanging.

He was longing for her, yet was terrified to see her.

Once he thought he saw her through the window. She was pressing her face against the panes and was gazing at him with eyes like a dying double star.

He felt a pain so deep that he felt unable to shriek, or groan. There was only an ashen, dying log in the grate, only the last flickering of the requiem candles at the catafalque from which the coffin had been removed, only the last gasp of the wind which fell to earth and moans through the autumnal stubble fields.

He gazed in deepest dread, and recoiled, only the eyes remained in her transparent face, the two dying stars. He leaned, shuddering, against the wall and everything suddenly disappeared: he was gazing in unspeakable dread into the deepest suburban darkness.

Days, and nights, passed like this.

Until the pain ceased, and he overcame his sick longing.

He only had to say something to her in parting, to scream forth his last utterance.

When he stepped on to the podium he saw nobody: he only felt the hot breath of the thousands beneath him. The green light of gigantic chandeliers flickered before his eyes, and for a second his brain trembled with thoughts of her – he wanted to see where she was sitting, where she *must* be sitting; he felt her gaze wandering, demented, over him – but then everything dissolved and unspeakable stillness spread throughout his soul.

The stillness and calm before creation.

A superhuman melody streamed from his hands.

He was sitting on Golgotha at the feet of crucified humanity. Centuries of torment, of hideous martyrdom poured like a hurricane over his soul, an eternity of damnation and suffering, of screams, howling for redemption; there were curses, infernal curses and convulsions of roaring, of screaming for one second of happiness. Within his soul the whole of Being celebrated a sombre mass, full of horror . . .

He was sitting at the foot of the cross and staring into stygian darkness; above him, the sun, hung with black draperies.

He was battering the doors of heaven with raging fists, was cursing destiny, that destiny which made him live, made him writhe in deprivation, spew revulsion and disgust and putrefy in the hell of insatiable sensual lust.

An impotent rage of vengeance was howling in his brain, an impotent desire for retribution was seething in his blood, and a hideous shriek was ripped from his hoarse throat: Where is the end? Where the beginning? What is the cause, the aim?!

He was wandering, the star of madness on his brow, and leading with a bloody torch a mob behind him, sick, terrified and shuddering with fear. Covered in blood he works his way through the thicket of night beneath ghostly horrors until he reaches the subterranean passages where

171

unknown treasures, darkly felt, and dreamed-of, lie concealed. He is walking at the front, proud, inaccessible, but dread and despair are eating his heart – shall I be able to find her? I have promised her to the crowd: how long must I wander?

And in a second he was the cosmos which burst into a million stars, into milliards of species and it all became One in him, an eternity of feelings, an eternity of creations and planets.

He was carrying a monstrous sun within his breast, he was flying, flying into the heights. Higher and higher, and he lost the awareness of omnipotence, of will, of being: he spread white wings from one pole to the next and hovered in deep brooding over the earth.

Anger and pain collapsed: pain petrified, and longing, for the earth was slumbering in the dusk of evening.

And, below, the fields of corn were swaying in a dreaming drunkenness; in the depths the barren stubble field gleamed in the ghostly gloaming, and wandering will o' the wisps flickered across dark swamps – ah, in the depths the skies were hovering in the black abyss of the lake, and from its depths pale stars arise, and on the smooth surface dances the silent magic of sunken churches . . .

His heart was seized with a heavy, oppressive longing.

And again he was striding forwards, he, the son of earth, striding with the holy belief that he was bringing salvation, but with the deepest, saddest, most transcendent pain he realised that he would be crucified . . .

He dragged himself along the *via dolorosa* with bleeding feet; bloody sweat dripped from his brow and a Gehenna of torment seethed in his breast.

He felt that he was carrying something in his arms; he was carrying it with reverence and with infinite care, but he saw nobody . . .

And suddenly there was the rustling of a dress in his room, the gleam of a pair of hot, longing eyes.

He started in terror.

No, no, it was not a dream.

172

Not a dream!

It was *she*, incarnate!

She was standing against the wall, breathing deeply.

They looked at each other, frightened, silent, trembling.

'I have come to you,' she whispered, 'I have come to you, longing and desire were eating my soul.'

And she sank into his arms.

<center>⋆ ⋆ ⋆ ⋆</center>

Oh hour of God-intoxicated rapture, hour of wonder, when two souls flow into one!

'Are you afraid of sin?' I ask her, hot and shuddering.

'I love sin, I love hell, with you, with you . . .'

And she threw herself into my arms, without consciousness, and oblivious to all . . .

<center>⋆ ⋆ ⋆ ⋆</center>

And he said to her:

'I did not know the meaning of happiness, but now I know it. With you I can drink joy and holy, inexhaustible rapture.'

'The miraculous hour is now consummated,' she laughed, with a faint, demented smile.

'I could never previously melt into a woman,' he whispered, fervently, 'but you stream throughout my veins like a flood of golden sunbeams.'

'The miraculous hour! The miraculous hour!' she repeated quietly, in a shuddering ecstasy.

Silence.

He started up.

'Why are you weeping?'

She stroked his hair and took his face in her small hands, pressing him to her more closely; her arms embraced his throat, and her white fingers were once again tangled in his hair.

'Why are you weeping?'

'For joy!' she quietly moaned.

And he embraced her with a trembling, god-inspired love, whispering the most ardent utterances, the same words, time and time again in crazy sentences . . . He

<center>173</center>

rocked her to and fro as one rocks a child to sleep in loving arms.

She was no longer weeping.

They pressed each other close as two children embrace in fresh sweet hay when a wild storm is passing over them and the skies scatter heavy bolts of lightning upon the earth.

'Are you happy?' he asked.

'My lover, you, you, my only one . . .'

'Yours, yours!' he repeated incessantly.

And then:

'Shall we always remain together?' he asked, afraid.

She did not reply, but hot shudders rippled through her body . . .

'I shall tread the way of the cross, I shall have myself crucified. My life is now consummated in the hour of miracles . . . Do not ask . . . Take me . . . press me even closer to you . . . deeper! . . . kill me!'

A long, sultry silence.

And again he spoke unto her:

'Do you remember how I carried you in the howling storm through the forest? It seemed as though the skies were falling in on us, green sheaves of lightning were dancing around us, the palm trees were crashing down around us, blocking our path and bursting with the terrifying sound of collapsing masonry, and now and then the lightning would split the trunk of a thousand-year-old tree, and fragments of wood rained down upon us like the gigantic leaves from the chalice of a dying flower. The hurricane hurled us up and down, we were staggering, falling beating ourselves raw against the tree trunks, but I kept pulling myself up, I fell, was crawling on my knees, scrambling over the heaps of tangled branches, over the dead tree trunks, for I was carrying you in my arms, and the storm of desire within me was greater than the hurricane which was sweeping the virgin forests from the earth.'

She did not reply.

'And do you remember how we were fleeing through the prairie-fires of the steppes? The whirling fire was raging behind us, rearing upwards into the skies in fiery pillars, it rolled across the plains in monstrous streams and I was running, running and leaping madly like a wild beast with you in my arms, I flew across the hell scorched earth, and I was stronger than the fire; it could not reach us for I was carrying you in my arms and a stronger fire than the steppes was roaring in my veins.'

She did not answer.

'And do you remember when a monstrous, demented whirlpool had seized our boat? Seized it and hurled it into the depths of the fearful maw, spewed it out and flung it like a piece of flotsam on to the raging waves, and then seized it again in an insane frenzy and again the boat was hurled with the speed of a falling star into the hideous funnel, and it was hurled out again like lava from a seething volcano and I was flung three times on to the boiling waters until the boat finally came to rest on a calmer sea. And I was stronger than the maelstrom for I could feel your embrace, your head upon my breast, and a more powerful vortex was raging within me, stronger than the world. You, you in me, my love for you.'

She did not answer.

'See! I am the son of earth, I am primeval Adam. In my breast there is raging a storm more powerful than that which breaks the most powerful trees as though they were reeds: in my veins is raging a fire much hotter than that which engulfs the steppes, in me is seething a more violent maelstrom than that which seizes the greatest ship, grinding it to powder and scattering it in the depths of the ocean. Do you love me?'

'You are great, you are strong, you are all-powerful.'

'That is not what I want to hear from you. Now listen:

I can make myself a king at any time, hurling whole peoples in the dust before us, I can conquer the earth, ruling over millions of slaves, I can have you crucified and bring you back to life again, I can declare myself the sun-

god, and people will build altars to me in sacred groves and bring sacrifices. I can conjure up before your eyes all the miracles and paradises of all time, of all place. I have experienced all the pain and torment of humanity, all their sorrows, all their joys, I can hurl them into hell, and then redeem them.

Do you love me?'

'You are a god!'

'That is not what I want to hear from you. Now listen: If I should tear you to my breast with lascivious arms, if your hair were streaming like a mane, and your lips were sucking my blood, if I should whip your desires into an abyss of lust so that the world disappeared before your eyes, and eternity shrinks to one second of time, and you should sink upon me like a daffodil stem, beaten by hail, do you love me then?'

She was laughing in a strange, demented, boundless joy, she seized his body and rubbed her silken hair against his breast and gazed at him for a long time: then she poured herself into his eyes; it seemed to him that she was gliding into the very depths of his soul, beating hot about his heart, draining into every pore ... He no longer had her before him, she was in him, in his blood, dissolving into him in long, throbbing convulsions, drunk with eternity ...

'I love you, love you, love you!'

* * * *

He felt in a dream that she was quietly, gently, slipping from his arms, he felt in the dream that the blood was flowing from his heart, that something was detaching itself from his soul.

But that was only a dream ...

He heard eyes shrieking in fearful torment, twitching in the fire of febrile stars, then, suddenly, were extinguished; a distant gleaming, and then the terrifying silence of the dark ...

But that was only a dream ...

And suddenly he found himself in a fearful night, a night which was rigid, petrified in the air, and he knew

that no gleam of light could penetrate the sombre vault of darkness. He leapt out of bed and looked for her in terror, but she was not there.

For a moment he was paralysed, a hideous terror gripped his heart . . . He pulled himself together and looked for her, horror-struck.

The light of dawn poured blue streams of light into the room, he was seeking, seeking, he could see her quite plainly in front of him, he felt her arms, and gazed into her eyes, overwhelmed by bliss and happiness, he was kissing her hair . . .

She was not there!

He staggered, sat down, got up again and groped his way into the other room.

A posy of red poppies was lying on a white sheet of paper on his writing desk.

He gazed at it for a long time, at this piece of paper and the red posy, and stroked it with his fingers to reassure himself that he was not dreaming, and was now awake.

He read the following:

'I am going away, a long way away. I am entering the holy realm of torment, to my cross, the cross to which you nailed me. The wondrous hour is now fulfilled. Do not seek me out, you will not find me. Do not wait for me, it would be in vain. I am going without you, but I shall not be alone. I am with you and at your side for all eternity and my soul will be sad until the end . . .'

He read no further. He crumpled up the paper and pushed the red posy away from him. He walked endlessly up and down the room until finally he collapsed exhausted into the arm-chair.

Above him the black vault of night and within his heart the horror and the terror of ghostly hours . . .

It was already evening when he awoke.

He read her letter once more and knew that the hour of the miracle had come and would never return.

Now he knew that he would no longer find her and that he need not wait for her.

177

All in vain!

He knew this with a certainty which bored into his brain with glowing needles; he felt a senseless sadness and, at the same time, the bright, unspeakable majesty of death.

And with head held high he walked a long, long way, far beyond the city.

He was walking behind something in which his whole world lay buried, his whole happiness concealed, his past and his future incarcerated.

He was walking behind someone who was leading him, dragging him, crushing him, he was tottering, staggering and falling to the ground ... but he would get up, for somebody was dragging him by force, and whenever he fell a cruel hand gripped his hair and pulled him upwards.

And then he was walking in long, painful strides as though he were petrified with pain, his heart heavy with great, stony tears.

He could see nothing more, and could only hear his own, booming footsteps; it was a though he were clad in iron, and a heavy, bronze visor had closed over his face.

He looked round, astonished.

He must have been a powerful leader, for he could hear his booming footsteps multiplied a thousand times, for a thousand armoured knights were following him.

He was leading them all through dark forests, and behind him came the knights with their blood red torches.

He felt no more pain, no more longing; he only heard her words, incessantly, the words which she had spoken to him previously, in the miraculous hour, as he had pressed her against himself in an even greater ecstasy:

'You are holy for me, for you created me within myself, you have heard the deepest, most naked mystery of my soul, and you have interpreted the deepest, most tremendous mysteries unto me. You are radiance, light and revelation to me, you are the sun in whose radiance my heart has melted.'

He repeated these words incessantly. And these words became her small white hands, those hands in which his

face once rested, and he felt upon his skin the impression of the intricate pattern of the lines of these hands.

Her words became the silken sheen of her body, ah, with what fathomless joy did it shine in his breast, and how white did her body gleam against his dark skin!

And each word was living and trembling, he held them in his hand, they were beating, throbbing . . . He could feel the words in his veins, dissolving into his blood stream, he heard them beating around him, pouring themselves into fiery rings.

His heart grew heavy, and a dumb cry was choking him.

Mother of mercy!

But there was no pity for him.

And again the pain broke forth, and again he heard her words, the words she had uttered to him at the hour of the miracle, when her eyes had flamed in a ghostly light and flickered crazily over the mirror of his soul. She was speaking:

'A dark destiny broods over me, hell and damnation yawn at my feet. My soul is bleeding in the longing for the lost paradise.'

He was standing at the peak of a jagged rock which reared into the skies. Suddenly her small white hand touched him, and he fell from one spiked rock, gashing his body against the sharp stones . . . he slid deeper and deeper down the glacier, his whole life flashing past in the thousandth of a second, he plunged like an avalanche into the darkest pit of hell till he felt delight, a delight in plunging thus and mutilating himself on the jagged fangs.

He felt her power, her torment and her impotent beginning for it was another force, a different one, which had caused her to push him into the abyss.

And for the third time he heard her voice, but this time within his heart: a scream of hot fingers, burrowing in his hair, and the beseeching embrace of her arms, the gasping desperation of her body, rubbing itself sore against his own:

179

'I am going, see, I am going, the hour of the miracle is at hand.'

It became dark before his eyes, his knees buckled as though he had been hit in the back by a spear, and he fell to earth with a dreadful scream.

Would he wake again?

Yes, he was riding on a wild black stallion across the sun-dried steppes. The fearful heat had devoured everything, dried up streams and rivulets, and there was nothing behind him, nothing before him except the vengeful, gleaming sun and a sky consumed in a white heat. The air was a hot, boiling mist, this was what he was breathing, and the burned earth scorched the hoofs of his stallion. His helmet burned itself into his brow with burning weals; his brazen breast-plate crushed his body.

He was riding in impotent desperation, for she was dying of thirst in his arms, she to whom he had given his own blood to drink.

The stallion grew slower and weaker . . . it staggered, collapsed and pulled itself to its feet, its neck hanging like a crippled branch, it would die at the next step.

And suddenly it whinnied loud, joyfully.

For in this hell, in this scorched and searing heat, this mist of fire, there appeared a well.

And he was lifting her high, lowering her on to the earth and moistening her brow with the water, but suddenly, as though risen from the earth, a black knight was standing before him in such divine, majestic omnipotence, and his voice thundered like the trumpet of the day of judgement.

'I am the one who determines the confines of all that is joyful, all that is happy on earth.'

I am he who was before all things and who outlives the end of all.

God, Satan, Destiny!

And the ghostly apparition dissolved . . .

He gazed down into the depths, at the heaving sea of roofs, breathing gas and electric light . . . It was a town, but a strange town, not his.

No! This was not his town!

And suddenly he saw quite clearly before his eyes a city carved into strange rocks, shot through with a tangled mesh of ditches, the town of death and desolation, left to him by his ancestors, him, the last of the race.

And again he felt the great, holy sun within his breast.

He would find her here in this city of death.

There! There!

His heart swelled in an unknown power, he grew into the skies, stretched out his arms and spoke to her:

'I am going to you, but why should I seek you, you who suffuse my blood, you who are the breath of my soul, the thrust of my longing, the magic of my dreams: you are I.'

And again he looked down at the town which was strange to him.

It was there then that the miracle was fulfilled.

But the town was strange to him.

And again he spoke to her and himself:

'You are a sun which has poured itself into me. You will stand before me and be mine, as often as I will. But not here. A greater miracle will happen, there, where my city climbs the wild rocks, where the holy river rages and roars in the granite abyss and where, in subterranean caves, cascades of stalactites pour forth frozen moonlight.'

A great green star was gleaming above his head, a star that would lead him to the new Zion, to the new Jerush-Halaim, the eternal Alcazar of his ancestors – there, where, in the mysterious enchantment of a glooming death an even greater miracle should occur . . .

* * * *

He was standing at the window of the Alcazar and gazing down at that strange city which his ancestors had built for him, millennia ago.

There was a moon, and the shapes and contours of the town took on a ghostly appearance, a strangely crenellated pattern of roofs at his feet.

It was as though the earth had shuddered, as though the

181

smooth, rocky terrain had bent and split, heaving up massive slivers of rock, one above the other, or locked into each other, rearing to pyramids or grinding into the land in jagged convulsions.

It looked like a miniature mountain range, condensed into a small area with a thousand peaks, valleys, reefs, slopes, precipitous chasms and sudden elevations, and high up upon the highest peak reared the mighty castle, the ancient Alcazar.

He gazed for a long time at the town beneath him. He saw the sharp, black pattern of the streets, curiously enmeshed and stamping a strange reticulation on to the habitations beneath.

The white mass of roofs looked like a holy, arcane ornament, forming a tangle of mysterious arabesques.

It looked as though the hand of a mighty hierophant had inscribed the holy runes of his wisdom into the white surface of the massive rock.

From the height of the Alcazar the town did not look as though it had been built, but somehow created from the erosion of the rock.

The town lay spread before him, an enormous catacomb, above which reared the Alcazar, proud, remote and stern, with slim towers reaching heavenwards.

He shuddered when he thought how one day he would have to descend into these catacombs.

He knew all the lanes, all the alleys, all the secret hiding places, the labyrinths, the streets which crossed and ended in culs-de-sac; he knew that he could not get lost in this maze, this tangle of alley-ways and yet he felt a secret dread at being lost in this labyrinth and never finding his way out.

And there was no one who could show him the way out, for the town was dead.

With unspeakable misery he gazed at this city which could only inspire dread and horror.

And yet a great miracle was to come to pass here.

Here he was to form from himself that which was the

resonance of his thought, the expression of his feeling, the form of his will.

Here, for his heart had promised him this, he was to win again the lost beloved, to create her again from the precious treasure of his most secret beauty, his deepest being.

But he had waited in vain, tormented his will with sick fantasies, all in vain.

He was not able to create her out of himself.

And why, then, these splendid Alcazars, these miracles and wonders, this fearful necropolis before him?

He was suddenly seized with a terrible fear of this monstrous, midnight ghostliness at his feet, and longed with all his heart to be back home, in the town in the deep valley, breathing the precious air at night; he longed for the dark avenues in which he used to wander for days on end, seeking her; he longed for the dim-lit churches and the dark green slopes whose forests of chestnuts poured their heavy, damascene splendour into the town beneath.

And the unspeakable magic of this holy earth burst forth in majestic waves, the heavy fields of corn, rocking dreamily back and forth, the fallow fields in the fever of hot summer nights, the secret, ghostly dance of the will o' the wisp over the dark swamps, oh, and this sky which was bedded in the depths of the lake, from whose waters the magic of light conjured forth pallid stars, and over the still countenance of the dead, still waters there spread the dark memory of sunken churches.

And again he gazed down at the dead town beneath him and at the raging river which embraced it, like a holy omega.

In deep, rocky chasms it plunged from one cataract to another, crashing into eddies and whirlpools; it hurled steaming, spraying masses of water into measureless depths, flinging them upwards against the jagged spikes of rock, like Cleopatra's needles rearing from its bed; it forced the water into the crannies and fissures which lacerated the granite banks; it boiled, seethed and roared and hurled itself with hellish haste into monstrous geysers and vortices.

183

He gazed for a long time at this holy river, with a strange, tormented reverence, this river which had split the might of mountains, had hacked its way through whole pyramids of stone and excavated a myriad channels, gorges and subterranean passageways.

In the moonlight the river looked as though it were of molten moonbeams, and where it split into innumerable runnels it seemed to be frozen into cascades of frozen moon-stalactites.

With a sick joy he listened to the scoffing howl of demented cataracts, for this was the music that accompanied the Mass of desperation which was raving in his soul and he gazed at the ghostly, dark gleam of the waterfalls, for his sick, febrile fantasies were flickering in the dim grave-light of putrefaction and mildewed verdigris.

He held his breath, stood on tiptoe, stretched out his arms and greedily drew in the ghostly miracle.

Horrified, he gazed around him.

Something frightful was happening!

He was alone, totally cut off from the world in the middle of the ocean on an island, high above the sea on a monstrous block of basalt.

The whole island was, in fact, a steep rock of fused basalt pillars, a shattered, broken polygon whose sides fell abruptly into the sea like the hieratic folds in the robes of a Byzantine saint.

He saw the sea rage around the island. The mountainous waves burst upwards, hurling themselves heavenwards in wild, teeth-bearing frenzy and pouring across the top of the island. The sea was churning in the gap between the island and the jagged reefs which surrounded it, crashing and roaring with a diabolical force, seething and screaming in monstrous leaps and falls, exploding in glittering clouds of snow, and leaping upwards again as though a subterranean crater had opened and was spewing out this lava, this cascade of insane spume.

It was an unheard of joy for him to watch this monstrous battle of colliding masses of water. They poured from both

sides into the narrow straits between the island and the long adjoining reef, smashing into each other, growing into each other as they reared upwards, unable to destroy each other; they embraced each other like wrestling, fiery pillars of boiling suns; they hurled themselves backwards, leapt up again abruptly and disintegrated like planetary rings flying away from the central core, but again new hurricanes of water were flinging themselves against each other, tornadoes which seemed to tear the very sea from its bed.

On the horizon the sea was swelling in an insane fury, its womb rearing to heaven in a monstrous pregnancy – higher, higher – the whole ocean was rearing to an immeasurable cupola above its own base, the dreadful vault of water was hovering over the island, but then the power which raised the ocean from its base abruptly ceased. The aqueous curve burst, and with the crash and thunder of collapsing worlds the heavy clouds of water disintegrated, bounced back from the earth, rolled in a churning flood across the island, then all was peace.

But only for a moment.

The sea was suddenly a mass of flames.

That was no longer the sea: these were waves of molten metal, a seething whirlpool of liquid stone.

As though the whole of the earth's surface had become liquid again and was raging in primeval storms, in dreadful convulsions, spasms, choric dances.

Monstrous fountains of seething metal were shooting into the black firmament; streams of boiling ore were pouring into valleys; demented gulfs of stone writhed into each other; watery sierras raged in cosmic conflagration whilst niagaras of fire seemed to be upside down, hurling hurricanes of flame into the skies.

Slowly the seething sea solidified. Where previously the masses of water had reared into the skies he now saw an expiring range of mountains. In a light devoid of atmosphere, a light which had lost its incisive power, he saw powerful ferns spread their antediluvian violet into the

clouds; lost, black trunks of charred palms and cypresses stood rigid against the clouds like a dead forest of pillars; monstrous lilies opened their enormous calyces in a silent joy; the poisonous red tongues of orchids ate into the blueness of immense ferns, and all this was raging in an uninhibited orgy of colour: green, violet, deep purple and silky whiteness were fighting with each other, and through the groaning scream of liquid, ferrous red, were twisting dark threads of waterfalls seen from afar, and on the dark green pools of the ferns there crept brassy growths in incredible convolutions of mythical lianas, whilst curare plants spurted their secret poisons into the darkness of the dark, burned forests, lightly, sharply flickering . . . and on the dark lake of purple the water lilies rocked their heads, deep with dreams.

He closed his eyes, unable to bear the raging Tedeum of these orgiastic colours, but their impression burned itself into that secret ganglion where all senses coalesce; it over-whelmed his brain afresh, but now with the hideous, cacophonous symphony of brass instruments, with melting bassoons, howling basses, screaming violins, horns that howled like apocalyptic beasts and clarinets that whinnied like the horses of hell.

He staggered back, terrified, and ran along an avenue of pilasters to the furthest corner of an immense room and fell, exhausted, on to a carpet, where it seemed that he was sinking, eternally . . .

An inexpressible joy seized his heart.

With a rapture never before experienced he breathed in calm, stillness and a feeling of divinity.

In the gentle, dusky penumbra of a radiance exhaled by the pillars of porphyry and which streamed from the dark ceiling of cedar wood, embracing the bluish gleam of the basalt floor, he suddenly sensed the epiphany of the holy miracle . . .

<p style="text-align:center">★　★　★　★</p>

Evening slowly settled around the earth. The crimson of the porphyry pillars spread into the dark gleam of ebony;

the holy cows of the capitals became shapeless monsters and the light, forcing its way between the narrow cracks between the pillars, grew dim, became still, flickering like the light of a dying torch.

And in this holy hour he arose and strode slowly between the pillars, solemnly, with head held high, as though he were wearing the mitre of a world conqueror: he stood upon the granite terrace of his Alcazar, his soul liberated from his body, and spread across both town and ocean in a holy benediction.

And in the dead silence of the necropolis he finally knew that he was quite alone in the world, somewhere on a star, a million miles away . . . He forgot that there was anyone else apart from him in the whole of the cosmos.

He was alone, quite alone!

It grew dark. The miracles of the sky were extinguished, and night laid its mantle of mourning across the earth.

His soul fluttered and trembled in agitation like a bird before the storm, for it knew that the hour was near when the abyss would open, when the soul should penetrate all mysteries and, in the splendour, see its own nakedness.

It seemed as though the space shrank from all sides and closed ever more closely around him, as though lines and contours were detaching themselves from the town and forming new constructions: the darkness seemed to grow deeper, to assume body and shape, and suddenly the heavy curtains of night were rent asunder, and it became light, a strange light; a gleaming breath of perfumed summer nights, a cold, regular radiance of unknown worlds . . . It was light, the light of the reflections of metal mirrors – an inner light, the light of the soul and of the cosmos.

And in this lightless lustre he saw her moving slowly towards him: She – He – She!

She was coming up to him like a light wandering in dark masses of mist, as though she, with the grace of her light, were travailing and struggling to penetrate the heavy burden of mist.

She was walking as the moaning of bells miles away,

across a glittering expanse of snow on frosty winter evenings, and she was walking as gently as the dusk which stealthily surprises the mountain tops.

Sharp, extended wedges of darkness were penetrating the chasms and the jagged reefs, melting the light, longing violet into lead-grey blue; with long, pointed tongues they bit into the white of the eternal snow, and the crystal sparkling slowly darkened; the peaks and plateaux shroud themselves in darkness; the sea of darkness pours itself downwards, calm, earnest, solemn.

And she was walking like the white gleam of the silver poplars in the magic of Good Friday, dreadful, desperate. And on the rigid fields of pain the wind-sails reared, groaning, howling and moaning, and the metal, gleaming vanes clattered and beat in unison.

He started back.

Through the forest of pillars there approached ever closer the silver radiance, the silent gleaming which penetrated the curtain of night, a surge, a moaning of swinging bells, the dusky longing of twilight which streams from the heights into the valley.

He withdrew ever further into the wide expanses of his Alcazar, fell on his face, and stammered:

'Have you come at last? My soul bleeds, and my wings are torn to ribbons, I have flown over mountains and seas. The ghostly horror of this town destroys me, but here I waited for you, for my heart told me I would find you here.'

Silence and the pallor of death surrounded him. He shuddered, for perhaps he should not speak to her.

He crossed his arms, and beseeched her in a fervent whisper:

'Who are you?'

And through his soul there passed a voice like the gleam of a painful smile, like a pale shaft of light, like the exhalation of an introverted, venerable silence:

'I am the deepest depths of your soul, I am the course of all that you have experienced, I am the sound and colour

of your dreams and the goal of your longing; I am the blood that constantly feeds your lust; you were conceived through and in me; through and in me shall your being reach consummation . . .'

And through the monstrous hall echoed again that sobbing of autumnal rain; it gleamed like an unwept tear in an eye glazed with pain, and around the lofty vaults reverberated the deep lament:

'Do you remember the night that I held your face in my hands, when my hot arms held you and my head rested on your breast, my hot fingers writhing in your hair?'

He shuddered with pain. This voice, full of pain and of supernatural longing, full of trembling memories; this voice grew into his throat and blocked the blood in his veins; he rolled before something invisible in the dust, and begged: 'Oh come, come! I have waited for you so long in these terrible catacombs, for my soul bewitched me, saying that I would find you again and have you whenever I wished. How can I seize you? See, I am seeking, I am stretching out my arms, come! oh come!'

And it seemed as though someone were embracing his knees, falling about his neck, pressing herself to his breast in a joy that knew no end, and the agony of swooning rapture.

A cool silence spread about the cedar panelling of the ceiling and the green syenite of the porphyry pillars . . .

And he could feel, feel her small, small soft hand, saw her in himself, bending over him and whispering:

'I have wandered so long, seeking and waiting to see whether your hand would tear me out of the nothingness, form me, shape me and give me corporeal outline . . . Do you hear, beloved, do you feel me? I went away from you, for when you gazed on me you were looking into your own soul . . . For I am the body of your thoughts, I am the form and the shape of your longing, the expression of your feeling and the movement of your will . . . I left you because I am your damnation and your death . . . I left you, but now I implore you, I beg you, screaming: stretch

189

out your hand into the depths of my nothingness. May your hand forge the millions of tones, the shattered dissipated sounds of my soul into *one* chord ... may it pour the millions of coloured fragments into *one* sun, the sun which will warm my body. Oh thou my Saint, thou my God! I wandered so long, seeking and shrieking for you, but the tempests howled away my yearning, my imploring and you did not hear me ... But now I do not shudder that you may have perished: I know that when you gaze into me – into your own soul – you *must* perish; but you do not wish to live without me. Tear me from my nothingness, or come to me! Come! Come! Longing has made my soul crazed and obscure ... storms of torment have dishevelled my golden hair, oh, seize the golden strands, twist them around your arm! Pull me out of this abyss: with you it is paradise, without you it is hell! Do you hear me? feel me?'

And a terrible, immeasurable agony of longing twitched in wild convulsions through the hall.

'Oh you my light-born one, my genesis of light! I have called for you, writhing in fearful screams and fervent prayer, but my voice died away and did not make the metal of your heart resound. I embraced you in the trembling floods of light, my lips thirsted for yours, the mystical rose of my body opened for you, but your heart was silent. I crept into your dreams and bathed my lusting womb in their ardour, but when you woke the unearthy magic of my charms fled from you ...'

And the longing and the yearning of her voice swelled more powerfully.

'Seize my hips with your hands! Yes, like so! Tear me towards you with your powerful arms, drag me to your breast, so that my hair should swirl like a wild mane in the searing lust of your sexuality! Look, look! A fearful sweet torment ... I am become body! Do you feel the throbbing of my veins? Are you scorched by the fire of my lust? Scream, scream heavenwards, let your will, your whole being shudder, that I should become!'

He started up, grew higher, the raging storm of his will

pounded within him and three times he shrieked the fearful scream:

'Become! Become! Become!'

In vain . . .

He heard her voice like the last, dying breath of a choir of angels:

'No use . . . Come with me! This love is not of this world . . . come, follow me there . . . There we shall be one, not here, not here . . .'

<center>★ ★ ★ ★</center>

His soul fused with the body.

Down below, deep, down below the lights of the town were extinguished, the last echoes died, and only the memory of the great, the holy night spread its wings over the town.

He could no longer differentiate dream from reality, he could hear the rumbling of the waterfall like a remote echo that seemed to come from somewhere from beyond the edge of the world . . . He could see, as a dream, the golden spires of the Alcazar.

He closed his eyes.

There was something like the beating of a seagull's wings:

'Come, oh come!'

Something like the shimmer of a whispering, soundless lightning:

'Come, oh come!'

Something was embracing his heart with fine, tender hands, caressing it, kissing it:

'Come, oh come!'

A sobbing, yearning cry burst from his breast:

'I am going, I am going!'

And there in the depths of the dark avenue of chestnut trees. He thought he could see her gleaming figure between dark tree trunks.

And there in the gloom of damp churches, where the sarcophagi of kings and princes brooded. He could still feel her heart trembling, her hot breath, the pulsing of her

<center>191</center>

veins, the flush that covered her face when they once met in the dark cloisters.

Ah, in the depths, there in the town of wonders he had rocked her in his arms like a child, dragged her violently to his breast, and then he had carefully laid her to rest, whilst her golden hair streamed around her.

He threw himself on to the floor and lay there for a long time, until the pain ceased, and it became still within his heart with the calm before the Creation.

Peace, oh peace!

The seas had died, the pulse of the earth had ceased; the burned tops of dead palm trees reached the skies, and over the vast dead expanses of the sea of ice lay the fearful harvest of the scattered bones of primeval animals . . .

Stillness, dumb stillness!

With extinguished beams the moon joined with the earth and there was no hand to pluck a chord from these dead strings, the earth opened her gaping womb, but there was no light to fructify her . . . Terrified stars were hanging in the airless infinity, hanging motionless like cold brass globes, and the sun, black as coal, expired, consumed by its own conflagration.

And in this hideous silence desire was born in him again, an unspeakable longing for her whom he had once possessed, then lost, the one whom he had awakened from the earth of his soul, waking to life, pouring in her the blood of his life, giving her his will as her backbone . . .

He should have created her from his Adam's rib, but he could not do it.

With his whole strength he longed for the one whom he would never see here on earth. The night of wonder which he had spent with her spread to an eternity, he had lived with her for an eternity, an eternity of endless joy.

And he spoke unto her:

'Oh thou mine eyes. How often has my soul not poured into thy dark depths like a star which plunges into the depths of the ocean. Suck up my misery, my pain, may they sink in thy mouth like the light of invisible stars in the

empty wastes of eternity. Oh thou mine eyes! Oh thou my precious mouth! How often has its silent woe wandered on my breast, bit its despair into my flesh and its magic sated my soul with the sweet poison of unspeakable desire ... How often has it not opened in gasping moans of love, in foul ululation and wild blasphemies! Oh thou mine eyes! Oh thou my beloved head! How often have I not pressed thee to my heart, how often did thou not sink on my shoulder in my wild embraces, throw thyself back, seared by the flame of my passion, falling senselessly in wild convulsions of love upon the pillows ... Once more I bury thee in my lap, and pour the starry glory of thy hair over me! Oh thou my beloved head, oh the golden cascade of thy richness!'

The blackness of night was brooding at his feet, only a tiny light flickered like the last spark of a dying torch.

He no longer despaired. For he knew that he was going to her, would become one with her in the womb of eternity from which he and she had arisen.

No desperation, only a sick, senseless longing for these eyes which dipped their pupils into the depths of his soul in such an agony of love, for the hands which engraved the thousands of fateful lines into his face, for that sad smile which haunted her lips with a brooding heaviness ...

Let it be!

He and she should return to the primeval womb to become one holy sun.

They should become one and indivisible.

Seeing all secrets naked and free with their eyes.

In divine clarity to see all causes and goals and to direct them.

To command all worlds, all Being.

In the god-feeling: He – She!

Androgyne!

The radiance of her fine white hands flowed around him, and the scent of her body suffused him, and in his soul there rejoiced the yearning, tempting whisper:

'Come, my beloved, come!'

193

And he walked with the powerful triumph of death in his heart where the seven-armed lake was shimmering in the moonlight, he walked still and tall, saying only, time and time again, in an infinity of love:

'I am going, I am coming!'

Stanislaw Przybyszewski: *Androgyne*. In *De Profundis und andere Erzählungen*. Ed. Michael Schardt und Hartmut Vollmer. Igel Verlag, Paderborn, 1990.

Kurt Martens: *A Novel from the Age of Decadence*.

The date of Erich von Lüttwitz's Feast of Death approached without my having encountered him again. We had nothing more to say to each other and did not wish to argue about our recent differences. Yet to exclude any doubt that our relationship was now of a purely formal nature Erich wrote to me again and asked me to accept his invitation; there was also an echo of our former warmth in these lines.

When I set off the evening was wet, cold and even wintry. A biting northwesterly drove dense masses of fog before it. The streets around the Gewandhaus were even more deserted in their bleak uniformity. One scarcely saw a blurred figure groping its way along the edge of the pavement where wan circles of sulphurous yellow light formed around the lampposts.

The extensive garden, whose last autumnal leaves hid the villa from view, was also deserted, but the subdued sounds of an orchestra told me that the party was in full swing. The windows were, as usual, carefully concealed by shutters so that only a few gleaming shafts of light fell across the gravel path.

I had to ring the bell before I was admitted, but then I was standing immediately in the dazzling light of the foyer which was separated from the vestibule by lavish draperies. A flunky led me to the cloakroom where all sorts of overcoats, top-hats and mufflers were already piled on top of each other. I was, apparently, one of the last to arrive.

Then I could hear the music quite clearly coming from the first floor. They were playing Berlioz's *Symphonie fantastique* : the final notes of the last movement, the 'Songe d'une nuit du Sabbath' were just dying away. And the musicians certainly seemed up to the task: the shrill

notes of the witches' orgy raged round and round with a passionate wildness and fervour. No sooner had the symphony come to an end than another band struck up in another room: presumably a gypsy orchestra from the sound of the violins, which started to play Hungarian rhapsodies. And then, as soon as I entered the vestibule, a babble of voices and the laughter of the guests who were mostly in the upper rooms mingled with the music.

Many gentlemen were lounging upon the round sofa, strangers, all wearing dinner jackets with white waistcoats but all of them differing in various degrees. I couldn't find Erich or anyone else who was familiar to me. So I first made myself known to these gentlemen and excited their liveliest curiosity when they discovered that I was a friend of Erich Lüttwitz. They wanted to know what I thought of the whole business, whether or not Erich would in fact carry out his intention of killing himself or whether they should regard it as a prank. I could, and indeed only wanted, to give imprecise information, yet my laconic utterances, remarkably, succeeded in satisfying them. At any event, they fully intended to amuse themselves splendidly. None of them, and only very few of the remaining guests, were acquainted with Erich at all: they were simply a disparate collection of snobs from literary and artistic circles, cashiered army officers, aristocrats with various neuroses, foreigners and *bon viveurs* from abroad who had come to the party of their own accord.

I grew tired of the raucous animation of the gentlemen on the sofa and climbed the winding staircase to get hold of our host at last.

Upstairs most of the guests were crowding in high spirits around the buffet tables, the fire places and all the precious *objets d'art* which this luxurious part of the house offered in the radiance of gleaming candlelight. There must have been something like a hundred people, the female sex only sparsely represented, but certainly not without charm. Each of the girls was in some pretty fancy dress costume, and all of them belonged to the upper

classes. They were all entertaining the gallant gentlemen, in a relaxed but modest manner. I spotted Thusnelda, Elvira and Amaryllis amongst them. Amaryllis greeted me in a most tender manner and asked me to be her partner: I need, she said, not worry about Erich, who had given them all freedom to do as they liked that evening. I promised to do as she wished as long as she would show me our host. She drew my attention to a crowd of youthful nymphs from whom he was trying to extricate himself in order to greet me.

I had prepared myself for a disturbing sight, yet I was shattered to see the facial expression which had blighted those features which had once been so noble. The muscles lay, slack and bloated, beneath the greasy skin; his eyes were glazed and wide open, as if he expected a stroke at any minute; his nostrils quivered convulsively, and the brittle, pale lips were set in a petrified grin. But I saw in everything – and it was this which convinced me – an absolute determination, forced, frantic and insane. Yet the wretched man came towards me in an extraordinarily animated manner, with boisterous gestures. He was about to embrace me, but controlled himself and shook both my hands, laughing wildly.

'We are friends, Just, are we not? We've always been friends.'

I was close to forgetting myself, losing control, bursting into tears, lashing out, or rushing from the room. I stammered weakly something about, 'I hope it's all a bad joke ... keep on drinking ...!', or something similar. But he wasn't prepared to listen to me at all but started indulging in reminiscences.

'Do you remember, old chap, how we stood by the stove in Naples and how we got to know each other because we were freezing? And our journey then! I really owe you so much, the pleasures of artistic experience, the beauty of the body ... education ... so many manifold interests ... so very much!'

'No, Eric, don't say that ...' I was overwhelmed by a

feeling of genuine, of bitter regret, 'Don't say all that. On the contrary, if we had never got to know each other you would perhaps have stayed in the civil service, you might have made a successful career, the career for which you were prepared and you might never have entertained that dangerous desire for a way of life that you are not up to.'

At that the pride of his race flared up within him:

'I am as I *had to* be!' he cried, stamping. 'That is: I am ruined! But I would a thousand times rather live the life that I understand, that I have sampled and can then smash to pieces than drag a yoke through life like some ox who is driven by someone else.'

He had already started to attract the attention of the bystanders who were beginning to sense that something interesting was happening. But at that minute the nymphs arrived and pulled him into their midst.

I felt a painful sadness as, deserted, and tormented by useless apprehension, I found myself alone in the crowd which unthinkingly devoted itself to the unusual pleasures of this night.

And, indeed, they experienced something quite remarkable, and in the grand style. All the senses were satisfied simultaneously – in the manner of' Huysman's des Esseintes and his principle of accumulated gratification – with the most exquisite delicacies. Whilst the two orchestras played dances, overtures and pot pourris, and young soloists from the Conservatoire gathered small groups around them, the lovers of the fine arts feasted their eyes on the paintings, china and draperies which stood arranged beneath the electric lights, intimately and casually grouped together in the boudoir. Everything that was mediocre was now avoided: Eric had known how to gather together only the finest items, studies and collections from the most talented artists. One saw oil paintings by Liebermann and Exter, sketches by Greiner and water colours by Ludwig von Hofmann, also glass ware by Koepping and embroidery by Obrist.

The buffets had been arranged with exquisite taste and

expertise: one dined whenever one wished, with whom one wished, at small, triangular tables which stood beneath exotic, scented flowers, behind palms or tapestries: all was seductive, uninhibited. I must admit that my spirits rose as I treated myself to a glass of champagne with some pheasant which was stuffed with quail and swimming in red wine: my appetite was good. I could also not resist those pieces of toast which were spread with three delicacies – truffles, lark pâté and white caviar.

It was only then, when I was looking for somewhere to sit, that I was delighted to find Dimitri Teniakovsky who was also serving himself to the food whilst an Italian composer was serenading him with variations on a theme by Orlando di Lasso. This artist, a charming gigolo scarcely twenty years of age, got up from the piano and introduced himself. We then sat down together for a communal meal. The orchestras also took a break, and it was delightful for me to be spared the ear-shattering and nerve-destroying benediction of the instruments.

Quite naturally, our conversation soon turned to our host's intention to kill himself, an intention which the Italian held as a prank, but which Dimitri took more seriously than I had expected. 'Whatever happens', he said, 'we shall certainly have to lament his loss. It's a great pity, he was a fine man. Five years earlier we might have been able to win him over.'

'We should put him under lock and key', the Italian cried, frivolously, 'then have him admitted to a hydropathic establishment where they could douse him in cold water.'

'Fortunately nobody has the right to do that any more', I said; 'You don't cure broken lives in that way.'

'Well, then for God's sake why doesn't he take up a bohemian existence? He seems to have artistic tendencies.'

Dimitri nodded sadly in my direction. 'Because he *might* have done everything, he became nothing.'

'But only because he believed that everything was too late for him.'

'Yes, but this erroneous idea is necessarily tied in with

199

his destiny. Even if he started work *now* he would only collapse into the most lamentable mediocrity.'

Towards eleven o'clock a fanfare called us down to the vestibule where armchairs were ranged in a semicircle before a curtain. Behind this curtain the rooms had had certain walls removed to form a wide stage.

The play was Oskar Panizza's *The Council of Love*, performed in a lavish fashion. This had recently been confiscated by the public prosecutor and the author himself had been found guilty of blasphemy on ninety-nine charges and given a jail sentence. When an actor stepped forward and announced the play in a salacious prologue the audience burst forth in loud and demonstrative acclamation.

The author could not have found a more appreciative audience for his work than these overheated drones, drunk with indulgence and lubriciousness and desirous of draining the last tingling drop of this piquant distillation. As soon as the curtain rose, and the dainty cherubs had excelled themselves in blasphemy and lustfulness the hall reverberated with gusts of shrieking laughter and wild bursts of applause. When God, the Virgin Mary and Jesus appeared a tremendous cry of 'Bravo!' was heard which rose to a wild tumult when the eternal mysteries were caricatured. The second act, which represented an orgy in the papal palace to the strains of the *Missa solemnis* with puppet-show and a ballet of naked courtesans, whipped up the passions of the spectators to a paroxysm of frenzy. Roaring and screaming they imitated the actors' performance; chairs were overturned as ladies fled the room. The more devoted members of the audience objected to this interruption and feared that the performance might be terminated: the farce, however, continued unabated. The lascivious titillation remained at its peak; only towards the end, when Syphilis, with mask and make-up, was sent by the devil for the welfare of the human rabble, did a breath of foreboding and horror steal through the exquisite company.

After the curtain had closed over this divine tragedy the wildest bacchanal broke out upstairs, the actors participat-

ing. I heard that Dmitri had suddenly been called away, and would have preferred to run away myself had not the thought of Erich's demise not held me back. Fortunately I found myself amongst an elegant collection of beautifully bound books and poems by Swinburne, Mallarmé and Hugo von Hofmannsthal. The latter, I learned, was the poet of those lines which Erich had praised before me and Amaryllis some while before.

Each room was filled with diabolical uproar. Beneath the cacophony of the instruments which endlessly blared out dance music there was roaring, screaming and people dancing the can-can. Nobody knew where Erich von Lüttwitz was hiding. Some thought they had seen him during the performance; others claimed that he was lying, totally inebriated, before a picture of Venus. A search for him began, in all the corners, under all the tables, first playfully, but then with mounting horror.

Gradually the house became quieter: the musicians were ordered to stop playing. Small groups gathered, whispering and conferring. Only a few concealed the unbridled thrill they experienced at the prospect of an imminent and terrible surprise, just as the rabble in Rome had anticipated the last fight of the gladiators. Then the rumour spread: Erich Lüttwitz had shot himself at two o'clock before his mirror with two small pistols. 'Where? Where?' was the anxious question. 'Probably in his bedroom, or in the dressing-room.' 'Upstairs, then? On the second floor? Someone should go and look.'

Now they were all very sober and abashed. A few of the girls burst into tears and demanded to be taken home. Other figures made their uncertain way surreptitiously to the door. I sat alone, bathed in sweat and unable to move my limbs, watching the scene. I was listless, in the sober knowledge that the drama was now over and nothing could hinder the unknown catastrophe. Whatever the details might be did not concern me; I would rather not know. Envoys, servants and guests came back from the rooms on the second floor. Nothing extraordinary had

been found. They searched the whole house meticulously for about an hour. Erich Lüttwitz had disappeared without trace.

It was empty, silent and dark. The guests departed without a word. One of the last, I stepped over into the fog of the streets.

Extract from Kurt Martens: *Roman aus der Décadence*
Berlin, 1898, pp 247–257.

Georg Heym: *The Autopsy*

The dead man lay, alone and naked, on a white table in the large room, amid the oppressive whiteness, the cruel austerity of the operating theatre, which still seemed to tremble with the screams of unending torments.

The midday sun was spread over him like a sheet, awakening the cadaveric lividity of his forehead; it conjured a bright green from his belly, blowing it up like a huge water-bag.

His body resembled the gigantic, iridescent cup of a mysterious flower from the Indian jungle which someone had shyly laid beside the altar of Death.

Magnificent blues and reds grew along his loins, and in the heat the great wound below his navel slowly burst like a red furrow, giving off a dreadful odour.

The doctors entered. Two amiable men in white coats and gold pince-nez, with the duelling scars of the student fraternities.

They went over to the dead man and looked at him, with interest, discussing medical matters.

Out of the white cupboards they took their dissecting instruments, white boxes full of hammers, bone-saws with strong teeth, files, horrible cases full of forceps, little holders full of huge needles which looked like curved vulture's beaks, eternally screaming for flesh.

They began their horrible task. They resembled hideous torturers; the blood streamed over their hands, and they thrust them even farther into the cold corpse and took out the contents, like white cooks drawing a goose.

The intestines twisted themselves round their arms like yellowish-green snakes, and the faeces dribbled down their coats, a warm, putrid liquid. They slit open the bladder; inside, the urine shimmered like yellow wine. They poured it out into great bowls; it had a pungent, acrid smell, like ammoniac.

But the dead man slept on. Patiently he allowed himself to be tugged this way and that, to be dragged by the hair this way and that; he slept on.

And as the hammer-blows thundered against his head, a dream, one last scrap of love, awoke within him, like a torch shining out into his darkness.

Outside the window a huge, broad sky opened up, filled with little white clouds floating in the light, in the quiet of the afternoon, like little white gods. And the swallows circled high up in the blue, quivering in the warm July sun.

The black blood of death ran over the blue decay of his forehead. In the heat it evaporated to form a ghastly cloud, and the decomposition of death crept over him with its colourful claws. His skin began to disintegrate, his belly turned white, like that of an eel, under the greedy fingers of the doctors, who bathed their arms up to the elbows in the moist flesh.

Decomposition drew the dead man's mouth apart, he seemed to be smiling, he was dreaming of a happy star, of a fragrant summer's evening. His liquescent lips quivered, as if at a fleeting kiss.

'How I love you. I have loved you so much. Shall I tell you how much I love you? The way you walked through the poppy field, a fragrant poppy flame yourself, you had drunk in the whole evening. And your dress, billowing round your ankles, was a wave of fire in the setting sun. But your head was inclined in the light, and your hair was still burning, still ablaze from all my kisses.

So you walked, and kept on turning round to look back at me. And for a long time the lantern in your hand still swayed like a glowing rose in the twilight.

I will see you again tomorrow. Here, below the window of the chapel, here, where the light of the candles falls down, turning your hair into a forest of gold, here, where the narcissi rub their heads against your ankles, tenderly, like delicate kisses.

I will see you again, every evening at the hour of

twilight. We will never leave each other. How I love you! Shall I tell you how much I love you?'

And the dead man quivered gently with bliss on his white mortuary table as the metal chisels in the hands of the doctors broke open the bones of his temples.

Georg Heym: 'Die Sektion' in *Der Dieb. Ein Novellenbuch*, Rowohlt, Leipzig, 1913.

Hanns Heinz Ewers: *Alraune*

How can you deny, my dearest, that creatures exist – neither humans, nor plants – strange creatures which spring from the perverse pleasures of absurd ideas?

You know, my gentle darling, that the law is good, as is that which is strictly normal. The great God is good who created these norms, these rules and stipulations. And good is the man who respects these laws, who treads the paths of humility and patience, following faithfully the path of the God of goodness.

But the Prince who hates goodness is of another kind. He shatters the laws and the norms. He creates – and this you must understand – *against nature*.

He is evil, he is wicked. And wicked is the man who follows him, for he is a child of Satan.

It is evil – evil in the extreme – to interfere with the eternal laws, to tear them with impious hand from their everlasting foundation.

The evil one may do this, for Satan helps him, Satan, who is a powerful Lord: he creates according to his own proud destiny. He may do such things as shatter the laws, reverse the natural order and stand it on its head. But let him beware: it is deception and blind illusion that he creates. It rears up, and grows into the skies, but ultimately it collapses and buries in its fall the arrogant knave who conceived it.

<p style="text-align:center">★ ★ ★ ★</p>

His Excellency Jakob ten Briken, doctor of medicine, professor and Privy Councillor created the strange girl – *against nature*. He created her, he alone, even if the thought belonged to another. And this creature, whom they christened and called *Mandra Gora*, grew up and lived like a normal human being. What she touched, turned to gold and where she gazed, all senses laughed in exultation. But

whomsoever her poisoned breath defiled, his senses screamed in pain, and from the ground on which her dainty feet had trod there sprang the pale flowers of death. One man struck her dead, the man who first thought her into existence: Frank Braun, the man who stood apart from life.

It was not for you, my blonde little sister, that I wrote this book. Your eyes are blue and good, and know nothing of sin. Your days are like the heavy blossoms of blue wistaria, dropping gently upon a soft carpet: thus my gentle footsteps quietly pass through the sun-dappled arbour of your tender days. It was not for you, my blonde child, the lovely sister of my dream-still days, that I wrote this book.

But for you I wrote it, for the wild, sinful sister of my torrid nights. When darkness falls, when the cruel sea devours the lovely radiance of the sun, a quick, poisonous shaft twitches across the waves. This is the first, quick laughter of sin, darting at the timid day's fear of death. And sin rears up above the silent waters, ever higher, and exults in flaming, ochre, crimson, deep violet colours. And sin breathes through the depth of night, spewing her venomous breath through all the land.

You would feel happy in her hot breath. Your eyes widen, and your young breasts rise in insolence. Your nostrils tremble, your clammy hands spread wide. The decent veils of gentle mornings fall, and the serpent rears from the stygian womb of night. Then, sister, your wild soul rears, rejoicing in vileness, replete with poisons. And from torment and blood, from kisses and degradation, your soul exults and shrieks – through all the heavens and all the hells.

Sister of my sins: I wrote this book for you.

[. . .]

The Princess was asking the Professor about his latest experiments. Would she be able to come again and look at the remarkable frogs, the amphibians and the pretty monkeys? Of course she could come. She should also look at

the new breed of roses, at his villa in Mehlemer, also the new arbour of camelias which the gardener was planting.

But the Princess found the frogs and monkeys far more interesting than roses and camelias. And so he began to tell her about his experiments in transferring genes, and with artificial insemination. He told her that he had just made a pretty little frog with two heads, and another with fourteen eyes on its back. He explained how he cut the genes out of a tadpole and transferred them to another individual. And how the cells merrily developed in the new body and subsequently spawned forth heads and tails, eyes and legs. He told her about his experiments with monkeys, told her that he had two long-tailed monkeys whose virginal mother, who was now suckling them, had never seen a male.

She found this particularly interesting. She wanted to know all the details, and desired to know everything that he did; he had to translate the terms in Latin and Greek into basic German. And the Professor revelled in indecent expressions and gestures. Saliva dripped from the corners of his mouth and dribbled over his heavy, pendulous bottom lip. He enjoyed this game, this babbling coprolalia, savouring lubriciously the sound of indecent expressions. And then, when he had arrived at a particularly repulsive word he threw in 'Your Highness', and enjoyed the prurient tingle of the contrast.

But she hung upon his every work, flushed, excited, almost trembling, and drew through every pore this brothel-like atmosphere which cloaked itself in the rarefied aura of scientific discourse.

'Do you only fertilize monkeys, Professor?' she asked breathlessly. 'No', he replied, 'rats and guinea pigs as well. Would you like to be present, Your Highness, when I. . .' He lowered his voice, and almost spoke in a whisper.

'Yes!' she cried, 'Yes! This I must see! I would love to! When?' She then added – but her attempt at dignity was not convincing – 'For, you know, nothing interests me more than medical study. I think I would have been a very good doctor.'

208

He looked at her, grinning broadly. 'But of course, Your Highness!' He then entertained the idea that she would make an even better madame in a brothel. But he had her in his net. He began to talk again about the roses and the camelias in his villa on the Rhine. It was inconvenient for him, and he had only taken it on out of kindness. But the site was excellent, not to mention the view. And perhaps, if Her Highness would deign to visit him, they could –.

Princess Volkonsky decided immediately, without losing a moment. 'But of course, naturally I could take the villa!' She saw Frank Braun go by and called out to him. 'Mr Braun, Mr Braun, please come over here! Your uncle has promised to show me some of his experiments, isn't that extraordinarily charming! Have you ever seen any?'

'No', Frank Braun replied, 'I'm not interested in that kind of thing.'

He turned to go, but she had him by the sleeve. 'Give me a cigarette, and, yes, a glass of champagne.' She was unhealthily excited, and perspiration pearled across her rolls of fat. Her crude senses, whipped up by the old man's shameless descriptions, sought an outlet, and broke in a cascade over the young man.

'Tell me, young student,' she panted, her great breasts threatening to burst her bodice, 'Tell me . . . do you think . . . that your uncle . . . with all his knowledge, his scientific experiments . . . do you think he could artificially create human beings?'

She knew perfectly well that he did not do such things, but she felt compelled to carry on the conversation, at any price, and especially with this young and handsome student.

Frank Braun burst out laughing, instinctively sensing the direction her thoughts were taking. 'But of course, Your Highness', he said quietly. 'Certainly. My uncle is experimenting in this very area, and has discovered a new process that is so subtle that the poor woman in question knows nothing about it. Nothing at all: until one fine day she

finds that she is pregnant, in the fourth or fifth month. Be careful when you are with my uncle, Your Highness, who knows whether or not you –.'

'For Heavens sake!' the Princess screamed.

'Yes, that would be disagreeable' he cried, 'especially if one had none of the pleasure beforehand!'

<center>*　*　*　*</center>

CRASH!

Something fell from the wall and struck Sophie the maid on the top of her head. She let out a yell and dropped the silver tray with all the coffee cups.

'Oh the lovely Sèvres . . .,' said Frau Gontram, quite unperturbed. 'What was it, then?'

Dr Mohnen took it upon himself to look after the sobbing girl; he cut away a strand of hair, bathed the gaping wound and staunched the blood with iron chloride. He did not neglect to pat her on the cheek and quietly fondled her firm breasts. He gave her some wine to drink and whispered gently in her ear.

All sorts of extraordinary objects were hanging on the wall: an idol from the South Seas, half male, half female, striped in bold reds and yellows; two old riding boots, massive and heavy, with powerful Spanish spurs; various rusty weapons; a doctor's diploma, printed on grey silk, from the Jesuit College in Seville and inscribed with the name of an earlier Gontram; a remarkable ivory crucifix, inlaid with gold; a Buddist rosary made of large, green jade beads . . .

But the thing had been hanging at the very top, the thing that had now jumped down: you could clearly see the rip in the wallpaper which the nail had torn away from the brittle mortar. It was a brown, dusty object made of a rock-hard root, and it looked like an ancient wizened mannikin.

Well, well, it's our mandrake!' exclaimed Frau Gontram. 'Well, it certainly was a good job that our Sophie was walking underneath – she comes from the Eifel, and they're all thick-headed from there! If it had been Wolfie, now,

<center>210</center>

our lad, the nasty little mannikin would certainly have split his head open!'

And Herr Gontram continued: 'That's been in the family for the last two hundred years. It was supposed to have played a silly prank before: my grandfather remembered how it had jumped on his head one night. But he was probably inebriated: he enjoyed a drink or two.'

'What *is* it, then?' asked a lieutenant of the Hussars.

'Well, it's supposed to bring money into the house.' replied Herr Gontram. 'That's an old legend anyway; old Manasse would be able to tell us. Come on then, away you go, Mr. Polyhistoricus! What is the legend about the mandrake?'

But the little lawyer was not keen. 'Nothing, only what everyone knows.'

'Nobody knows it, nobody. You greatly over-rate our modern educational system,' the lieutenant replied.

'Come on, Manasse, don't keep us waiting,' said Mrs Gontram. 'I've always wanted to know what the ugly old thing was meant to be.'

So he began. He spoke dryly, in a scholarly fashion, as though he were reading out of a book. He did not stumble over his words, scarcely raised his voice. And he swung the root in his right hand, back and forth, like a baton.

'Mandrake, Mandragora, also called Mandragola – Mandragora officinarum. A plant of the solanaceous family, found around the Mediterranean basin, in south-east Europe and as far as Asia and the Himalayas. The leaves and blossoms are narcotic, were used in earlier times as an opiate and were used during operations in the famous medical school in Salerno. The leaves could also be smoked and the fruits were made into aphrodisiacs. They were supposed to incite lust and make men potent. Jacob used them for his little trick with Laban's flocks; the plant is called Dudaian in the Pentateuch. But it is the root which plays the most important part in the old stories. As early as Pythagoras you find a reference to its remarkable similarity to an old man or woman: in his time they believed that it

could make you invisible, that it could weave magic or, conversely, act as a talisman against witchcraft. The German legends concerning the mandrake derive from the early Middle Ages, from the time of the Crusades. The criminal, hanged stark naked at the crossroads, would ejaculate his last drop of sperm at the moment his neck was broken. The seed falls onto the earth and fertilizes it: a mandrake is born, either male or female. The local people went out at night to dig it up: the shovel had to be placed in the earth exactly on the stroke of midnight. But it was wise to block up your ears with wool and wax because when the mannikin was drawn out of the earth it would shriek in such a hideous way that you would faint in terror – you can find this referred to in Shakespeare. Then you would take it home and look after it well, give it a little of every meal to eat, and wash it in wine on holy days. It brought you luck in law-suits, and in war, was an amulet against witchcraft and brought good luck into the house. It gave grace to the one who owned it, could tell fortunes, made women lovely and eased their child-bearing. But, despite all this, it brought sorrow and torment, wherever it was. Other members of the household were dogged by ill fortune, and it drove its owner to greed, lust and manifold iniquities. It finally destroyed him, and drove him to hell. And yet mandrakes were very popular, were often sold and fetched high prices. It is said that Wallenstein carried a mandrake around with him for the whole of his life, and the same is said of England's polygamous King Henry the Eighth.' Manasse stopped, and threw the hard piece of wood on to the table.

'Most interesting, yes, most interesting,' said Count Geroldingen. 'I am most grateful to you for your little lecture, Sir.'

But Madame Marion declared that she would not for one moment tolerate such a thing in her home, and stared with eyes wide open at Mrs Gontrum's rigid, bony, mask-like face.

Frank Braun moved swiftly towards the Professor. His

212

eyes were shining, and he seized the old gentleman by the shoulder.

'Uncle Jakob . . .'

'Well, what is it, my boy?' asked the Professor. But he got up, and followed his nephew to the window.

'Uncle Jakob,' the student said again. 'This is what you need! This is far better than silly tricks with frogs, and monkeys, and small children. Come on, Uncle, go down the road that nobody has gone before!' His voice was shaking and he nervously exhaled smoke from his cigarette.

'I don't understand a word of what you're saying . . .'

'You *must* understand! Weren't you listening to what he was saying? Make a mandrake, a mandragora! Something that is alive, that has flesh and blood! You can do it, Uncle, you and no one else on earth!'

The Professor looked at him, uncertain, doubtful. But there was such conviction in the student's voice, such strength of belief, that he involuntarily hesitated.

'Speak more clearly, Frank,' he said, 'I really don't know what you mean.'

His nephew hastily shook his head. 'Not now, Uncle . . . I'll take you home, if you will allow me.'

[. . .]

They crossed the yard and entered the long low house from the right. It was basically an enormous room with a tiny antechamber and a few small offices. The massive bookshelves ran along the walls, packed with thousands of volumes. There were also low glass cabinets dotted around the room, full of Roman artefacts; many a Roman grave had been excavated and robbed of its tenaciously guarded treasures. Thick carpets covered the floors; there were also a few writing desks, arm chairs and sofas.

They entered, and the Professor threw the mandrake – a gift from the Gontrams – on to the divan. They lit the candles, drew the armchairs together, and sat down. The servant uncorked a dusty bottle.

'You may go', said his master, 'but do not go to bed yet.

The young gentleman will be leaving later, and you must lock up.' 'Now?' and he turned to his nephew.

Frank Braun drank. He picked up the mannikin and played with it. It was somewhat moist, and almost seemed to be supple.

'Yes, it's quite recognisable', he murmured. 'There are its eyes, look at them. A nose sticking out, and a mouth gaping wide. Look, Uncle, doesn't it look as though it's grinning? The arms are somewhat stunted, and the legs are joined down to the knees. It's a strange object ...' He lifted it up, and looked at it from all sides. Look round Mandrake!' he cried. 'This is your new home! This is where you belong, in the house of Jakob ten Brinken, and it is better than the Gontram's home ... You are old', he continued, 'four hundred, perhaps six hundred years old or more. They hanged your father because he was a murderer or a horse-thief or had written some scurrilous verse against a great nobleman in armour or a cardinal. It doesn't matter what he did : they called him a criminal then, and they hanged him. And then he squirted his last drop of life out into the earth and produced you, you strange creature. And mother earth received in her fruitful womb this parting gift of the criminal and laboured and brought you forth. She, the most gigantic, most powerful one, bore you, an ugly, wretched mannikin! And they dug you out at midnight, at the cross roads, shaking with dread, with howling, scream- ing incantations. And then, when you first saw the light of the moon, you saw your father's body, hanging on the gallows, all brittle bones and rotting fragments of flesh. And they took you with them, those who had strung him up, – your father. They grabbed you, and dragged you home – you were meant to make them rich! Pure gold and young love! They knew well you would also bring torment, and desperation, and finally a wretched death. They knew that but they still dug you up and took you with them : they accepted all this, for wealth and love.'

The Professor spoke. 'You have a fine way of looking on things, my boy. You are a dreamer.'

'Yes' said the student, 'I am as you are.'

'Me?' laughed the Professor, 'I feel that my life has run a fairly normal course.'

But his nephew shook his head. 'No, Uncle Jakob, it hasn't. You give normal names to things that other people would call fantastic. Just think about your experiments! For you they are trivia, paths that might some day lead to a goal. But no normal man would ever have hit upon them: only a visionary could have done that. And only a wild man, someone in whose veins blood flows which is hot as that of the ten Brinkens; only a man like this would dare to do what you must now do.'

The old man interrupted him, unwillingly, and strangely flattered. 'You're raving, Frank. And you don't know whether I've a mind to do this mysterious thing that you are talking about, something about which I haven't the faintest idea.'

But the student didn't give up; his voice was clear and confident, and every syllable expressed his strength of conviction.

'You will do it, Uncle, I know you will. And you'll do it because nobody else can, because you're the only person in the world who can do it. Of course, there are other scholars who are doing the same experiments that you began with, who have got just as far as you have, perhaps even further. But they are normal people, dry, desiccated men of science. They would mock me if I came to them with my ideas, laugh me out of court, call me a fool. Or they would throw me out on to the street because I dared come to them with such notions, notions that they would call indecent, immoral and reprehensible. Ideas that tamper with the divine laws of creation, that cock a snook at nature. But not you, Uncle, you wouldn't laugh at me or throw me out of the door. You would be intrigued, as I am intrigued and that's why you're the only man to do it.'

'But do what, for God's sake?'

The student rose, and filled both glasses to the brim. 'Let's drink a toast, old magician,' he cried, 'let's drink! Let

new life flow from old bottles! Long live your child!' He clinked glasses with his uncle, emptied his own in one draught and threw it at the ceiling. It shattered, but the splinters of glass fell silently on to the heavy carpet.

Frank brought his chair up closer. 'Now listen, Uncle, to what I mean. You're doubtless impatient with my long introduction, don't be angry with me. It only helped me get my thoughts in order, to form them and make them more tangible. What I mean is this. You are going to make a mandragora, a mandrake-creature, turning legend into reality. What does is matter whether or not it's superstition, medieval hocus-pocus or mystical obscurantism from another age? You are going to turn the old lie into something truthful : you will create it, and it will stand there in the clear light of day, tangible for all the world to see, and no stupid little professor will be able to deny it. And now pay attention to how you will make it. You will easily find a criminal, that isn't difficult. And I don't think it matters whether he died on the crossroads or was hanged. We've made progress: the prison yard and the guillotine are much more convenient. And better for your purpose : thanks to your contacts you will be able to get hold of that rare liquid which we need, and thereby wrenching new life from death. And what about the earth? Look at the symbolism, Uncle : the earth equals fertility. The earth is woman, she nourishes the seed which was given to her womb, she lets it grow, blossom and carry fruit. So take that which is as fruitful as the earth : get a woman. But the earth is an eternal whore, serving all and sundry. It is the eternal mother the ever-available whore for countless millions. Nobody is denied her lustful body, she is there for all to take. All that has life fructifies her teeming womb, and has done for millennia. So, Uncle Jakob, you must take a whore, the most brazen and shameless one you can find, one who was born to be a prostitute. Not someone who is forced into the trade by destitution, nor one who was a victim of seduction. No, nobody like that. Get someone who was a harlot before she could walk, one who exults in

her shamelessness, for whom it is life itself. That's the one you must choose, and her womb will be as the womb of the earth. You are rich, you will find her. You're no novice in these matters, you can give her a large sum of money, buy her for your experiment. And if she's the right one, why, she'll laugh her head off and press you to her greasy breasts and kiss you to death, because you'll offer her what no man has done before! What happens then, you know better than I do. You will doubtless be able to do with humans what you've been doing with monkeys or guinea pigs. To be prepared, that's the thing! Prepared for the moment when your murderer's head flies cursing into the basket!'

He had jumped to his feet and was leaning on the table, staring at the old man with a fixed, penetrating gaze. And the Professor caught his gaze and, squinting, parried it, as a dirty crooked scimitar parries an elegant foil.

'And then, my dear nephew, and then?' he asked. 'When the child is born, what happens then?'

The student trembled, and his words dropped slowly from his mouth. 'Then, we shall have, a miraculous being.' His voice was light, supple and resonant, like the tones of a stringed instrument. 'Then we shall see what was true in the old legend. We shall be able to look into the deepest corner of Nature . . .

<p style="text-align:center">*　　*　　*　　*</p>

The prostitute Alma Raune, Mandra Gora's mother, had been charged with burglary. Her case was not helped by her obstinate denials, and the fact that she had a previous conviction. But extenuating circumstances were found, probably because she was very pretty, and also because Dr Gontram was the council for the defence. She was given an eighteen month prison sentence, with her period in custody taken into account.

But Professor ten Brinken was able to have her sentence reduced, even though her behaviour in prison was hardly exemplary. But this behaviour was excused by the hysterical and febrile condition in which she found herself, which

ten Brinken stressed in his appeal for clemency: the fact that she was soon to be a mother was also taken into consideration.

She was released as soon as the first labour pain set in, and was taken early in the morning to the ten Brinken clinic. She lay there in her old, white room, no. 17, at the end of the corridor, that same room where, nine months previously, the Professor had persuaded her to undergo that strange operation ... Her contractions had begun when they had transferred her there; Dr Petersen assured her that it would all be over very quickly.

But he was wrong. The birth pangs lasted all day, the following night, and all the next day. They receded somewhat, but then set in with renewed ferocity. And the girl screamed and moaned and threw herself this way and that in fearful agony ...

In his report on her death Dr Petersen stressed the strong constitution and the splendid physical shape of the mother, both of which promised a smooth delivery. But it was the most unusual transverse presentation of the baby that caused the resulting complications which made it impossible to save both mother and child. It was further mentioned in the report that the baby, a girl, let out the most terrible scream, when it was still in its mother's womb, a scream so penetratingly shrill and loud such as neither the doctors in attendance nor the attendant midwife had ever heard from a newborn child before. This scream had almost something conscious about it as though the baby had experienced some dreadful pain on being separated from her mother : it was so awful and so penetrating that they were all horrified, and Dr Perscheide had to sit down, whilst cold sweat dripped from his brow.

Then the baby did become quiet, and did not even whimper. She was very delicate and fragile, and when she was bathing her, the midwife noticed an unusually developed *atresia vaginalis*, that is, the skin of both legs was joined down to the knees. But this remarkable phenomenon was found, after careful examination, only to be a

superficial fusion of the epidermis which could easily be severed by a prompt and simple operation.

As regards the mother, it was obvious that she had had to suffer dreadful agony. It had been impossible to give her chloroform, or an epidural injection, neither was scopolamine – morphium administered as the bleeding, which could not be staunched, had greatly weakened the heart. For hours on end she had done nothing but scream and moan; her cries had only been drowned at the moment of birth by the shrieking of the baby. Gradually her moans became quieter, and two and a half hours later she died without having regained consciousness. The cause of death was given as a ruptured womb and resultant loss of blood.

* * * *

Intermezzo

Sin, my darling, all that is sinful was brought from the deserts by the hot, southerly wind. Where the sun has been baking the earth for endless millennia a white, thin wraith hovers over the sleeping sand, and soft clouds are formed from the wraith, clouds which the whirlwind blows hither and thither, and which change into round, strange eggs, and the hot glow of the sun holds them in its breath.

And in the livid night there creeps a basilisk, spawned by the moon after its strange fashion. The moon – eternally barren – is its father, but its mother is the sand, barren likewise : this is the mystery of the desert. Many say that it is an animal, but this is not so, it is a thought, growing there where there is no earth, and no seed : a thought which sprang from that which is eternally barren, and now assumes strange forms which life does not know. This is the reason that no one can describe this being, because it is like nothingness, indescribable.

But it is true, as people say, that it is very, very poisonous. For it devours the baking eggs of the sun which the whirlwind rolls in the sandy wastes. And so it is that purple flames shoot from its eyes and that its breath smoulders in grey, hot vapours.

219

But the basilisk does not devour all the mist-eggs, this child of the pale moon. When it is sated, and bloated with the hot poisons, it spews its greenish saliva over those that are still lying in the sand, and scratches the fragile shell with a sharp talon, so that the foul slime may enter. And when the early morning wind arises it sees a strange pulsing and throbbing amongst the thin shells, as though from veils of violet and moist green.

But when in the lands of the sun the eggs burst, eggs which the sun has hatched — crocodile eggs, toads, snakes, eggs of the ugliest lizards and amphibians — then the poisonous eggs of the desert split also, with a gentle crack. There is no yolk, no lizard, no snake, only a diaphanous, strange formation. Iridescent, like the veils of the dancer whose dance is of fire, perfumed as the pale Sanga-blossoms of Lahore, resonant as the singing heart of the angel Israfel. And swollen with poison, like the basilisk's dreadful body.

And then the south wind sprang from the tropics, crept from the swamps of the hot forests, danced above the wastes of sand. It lifts the glowing veils of the sand-eggs, carries them far over the azure sea. Seizes them, like gentle clouds, like the loose robes of nocturnal priestesses.

And so the poisoned pestilence of all concupiscence flies to the golden North.

Cool, little sister, as your North, are our silent days. Your eyes are blue and good, and know nothing of hot desire. The hours of your days are like the heavy blossoms of blue wistaria, dropping gently upon the soft carpet : thus my gentle footsteps pass through your sun-dappled arbour.

But when the shadows fall, my blonde sister, a tingling spreads over your young skin. Rags of mist fly up from the south, and your greedy soul inhales them. And in a kiss of blood your lips provide the hot, hot poison of the desert places.

<p style="text-align:center">*　　*　　*　　*</p>

Yet no, my fair little sister, you sleeping child of my dream-still days! When the mistral gently curls the blue

waves, when the voices of sweet birds sing from the top of my rosy bower, then I may well browse in the heavy leather volume of Professor ten Brinken. My blood flows through my veins, slow as the sea, and with your quiet eyes, in an infinite calm, I read the story of Mandra Gora. And I pass it on, as I found it, simply, clearly as is right for one who is free of passions.

But I have drunk the blood that flowed one night from your wounds, that was mixed with my red blood, this blood that was poisoned by the sinful venom of the torrid wastes. And when my brain is feverish with your kisses, these kisses that bring pain, and with your lustful desires that bring torment, then it might happen that I shall tear myself away from your arms, wild sister.

It may be that, heavy with dreams, I sit at my window on the sea, a window open to the hot blast of the Sirocco. It may be that I shall take up the Professor's leather volume once more, where I might read Mandra Gora's story, and read with your hot, poisonous eyes. The sea shrieks on the motionless rocks; then my blood shrieks in my veins.

And that which I am reading seems very very different to me. And I pass it on as I find it, wild, hot, as is right for one so full of all the passions.

<p style="text-align:center">*　　*　　*　　*</p>

The leather volume which contained the entries relating to Mandra Gora's life began with a few episodes which seem to be of interest for our narration ... The first relates to the operation for the child's *atresia vaginalis* which Dr Petersen performed and to which we may attribute his untimely end. The Professor mentioned that he had promised his assistant a three months holiday, fully paid, because of the latter's help in the birth of the child (and also bearing in mind the savings which the mother's death had brought with it). He had also promised him an extra thousand marks on top of this. Now Dr Petersen had looked forward enormously to his holiday and to the journey that he wished to undertake, the first of any length that he had ever made in his life. He insisted,

<p style="text-align:center">221</p>

however, in performing the operation – a very simple one – before he left, although it could have been postponed without any difficulty. He did the operation a couple of days before his intended departure, and with great success as far as the baby was concerned. But unfortunately he sustained severe blood poisoning, which is all the more remarkable because Dr Petersen normally demonstrated the most scrupulous hygiene; he died some forty eight hours later after much suffering. It was not easy to determine the direct cause of this poisoning: there was a wound on the lower part of his left arm which was scarcely visible to the naked eye and may have been caused by a slight scratch from the little patient . . .

A further report tells that the baby, which had been left in the clinic under the care of the nurse, was a remarkably still and tender child. It only screamed once, and that was when it received its holy baptism, performed in the cathedral by Ignatius Schröder, the chaplain. And then it shrieked in such a terrible way that the sister who was carrying her, Princess Volkonski and Judge Sebastian Gontram, the godparents, the chaplain, the sexton and as well as the Professor did not know what to do with her. She had started screaming the moment they carried her out of the house and did not stop till they brought her back home from the church. The shrieking had risen to such an intolerable pitch in the cathedral that the Reverend Father had had to execute the holy rites as speedily as possible in order to spare himself and the assembled company the dreadful cacophony. It had been an enormous relief when the christening was at an end and the nurse had carried the baby into the carriage.

In the girl's first years of life nothing extraordinary happened; at least, we do not find anything inscribed in the leather-bound volume devoted to 'Mandra Gora', the name that the Professor, quite understandably, gave her. It was reported that the Professor had taken the decision (even before she had appeared in the world) to adopt her and, in his last will and testament, to make her his sole beneficiary,

expressly excluding all his relations. We also learn that the Princess gave her as a christening present an extremely expensive and tasteless necklace consisting of four gold chains studded with jewels and two strings of large and beautiful pearls. But in the middle, again richly adorned with pearls, was a braid of bright red hair which the Princess had had made of a lock of hair from Mandra's mother, cut from the unconscious woman at the moment of the girl's conception.

The child remained in the clinic for more than four years until the Professor relinquished it, as well as the other medical practices which he had, anyway, started to neglect. He took Mandra to his villa in Lendenich where the child was to have a companion and playmate who was, actually, nearly four years older than she – Wölfchen Gontram, the judge's youngest son.

[. . .]

During the holidays the Professor watched the little girl closely. He knew the Gontram family well, from the time of their great grandfather onwards, and knew that they had always loved animals, that this love had been instilled with their mother's milk. However much Mandra might be able to influence the boy she would – if she really *did* encourage cruelty to animals, such as sticking red hot needles into the eyes of a mole – meet a stubborn resistance and be powerless against this inmost feeling of goodness.

Yet one day he came across Wolfi one afternoon by the small pond underneath the trumpet tree. He was kneeling on the ground and a large frog was sitting on a stone in front of him. The boy had pushed a lighted cigarette into its wide mouth, deep down its throat. The frog was inhaling the smoke, deeper and deeper into its gullet, but did not breath it out : it was growing bigger and bigger. Wolfi kept staring at it, and large tears were running down his cheeks. But when the cigarette had burned away he lit another one, took the butt from the frog's mouth and, with trembling fingers, inserted the new one. And the frog swelled to a shapeless mass, its great eyes standing on stalks

from its head. It was a tough animal, and survived two and a half cigarettes before it burst. The boy yelled and wailed, his own sufferings, apparently, being worse than that of the creature he had tortured to death. He jumped back, as if to flee into the bushes, looked around and, when he saw that the fragments of frog were still twitching, he ran back and stamped in desperation on the animal to kill it and put it out of its misery. The Professor took him by his ear and first examined his pockets. There were still a few cigarettes and the boy confessed to having taken them from the writing desk in the library. But he refused point-blank to say who it was who had told him that frogs that smoke blow themselves up and finally burst. There was no persuading him, and the thrashing that the gardener administered on the Professor's behest was to no avail. Mandra also stubbornly denied everything, even when one of the maids explained that she had seen the girl stealing cigarettes. The two remained adamant : the boy insisted that it was he who had stolen the cigarettes, the girl that she had not done so.

Mandra stayed one more year in the convent school to which the Professor had sent her, when – in the middle of term – she was suddenly sent home ... The Sacré Cœur Convent had had an epidemic before – it had been measles. Fifty seven little girls lay in their beds and only a few-including Mandra – had escaped unharmed. But this time it was far worse: it was typhoid fever. Eight children and one nurse died of it; almost all the other girls were ill. But Mandra Gora was never more healthy than during this epidemic: she put on weight, flourished and happily ran through all the sick bays. And as there was nobody to look after her at this time she ran up and down stairs, sat down on all the cots and told the children that they would all die, tomorrow, and that they would all go to hell. She, Mandra Gora, would live, and would go to heaven. And she gave all the patients her holy pictures, told the sick girls that they should fervently pray to the madonna, and the holy heart of Jesus, but it would do no good in the end. For they would all burn, and be roasted evermore, it was

indeed remarkable how well she could illustrate such ago-
nies. Sometimes, when she was in a good mood, she was
tolerant: she then spoke of a hundred thousand years in
purgatory. But that was bad enough for the fragile nerves
of the pious little invalids. The doctor threw Mandra out
of the room with his own hands and the nurses, convinced
that she alone had brought the disease into the convent,
sent her packing.

[...]

When Mandra Gora finished her schooling and returned to
the villa by the Rhein, a villa dedicated to Saint Nepomuk,
Professor ten Brinken was seventy six years old. But this
was only according to the calendar: no weakness, nor the
slightest disability gave evidence of his age. He felt snug
and warm in his old village, a village soon to be swallowed
up by the creeping fingers of the town, and hung like a
bloated spider in the web of his machinations which spread
its filaments in all directions. And he felt a *frisson* at the
thought of Mandra's homecoming, and waited for her as
for a welcome plaything for his moods and also as a merry
bait to lure many a stupid fly or moth into his net.

Mandra arrived, and she did not seem any different to the
old man than she had been as a child. He studied her for a
long time as she was sitting in the library and found nothing
to remind him of her father or her mother. This young girl
was small and dainty, slim, narrow-chested and scarcely
developed. Her figure and her quick, rather jerky movements
were those of a boy. A doll, you might have thought, but the
head was certainly not that of a doll. Her cheek-bones were
prominent, and her lips, thin and pale, were pursed above her
little teeth. But her hair was thick and abundant, not red like
her mothers, but richly chestnut in colour. 'Like Mrs Josefa
Gontram's', thought the Professor, and it amused him to
think that this was a memento of the house where the idea of
creating the girl had emerged. He squinted across at her as she
sat silently before him, scrutinising her critically as though
she were a picture and seeking other reminiscences.

Yes, her eyes! They were open wide beneath the insolent,

225

thin lines of her brows which contrasted with her narrow, smooth forehead. They could be bold and scornful, yet also soft and dreamy. Grass-green, as hard as steel, like the eyes of Frank Braun, his nephew. The Professor thrust forward his thick bottom lip, this discovery did not please him particularly. But then he shrugged his shoulders, why shouldn't the boy who thought it all up not have some part of her? It was little enough, and Frank Braun was paying dearly for it, all the millions that this girl would take from him.

'You have bright eyes', he said; she simply nodded. He went on: 'You have beautiful hair. Wolfi's mother had hair like that.'

Then Mandra said: 'I shall cut it off.'

The Professor answered her in a peremptory fashion: 'You will do no such thing, do you hear?'

But when she came down to supper her long hair had gone: she looked like a page boy, her curls circling her boyish head

'What have you done to your hair?' he snapped.

She quietly answered: 'Here', and showed him a large cardboard box where the long strands were lying.

'Why did you cut if off? Because I forbade it? Out of defiance?'

Mandra smiled. 'Not at all. I would have done it anyway.'

[. . .]

He stared at her, and his old skin experienced a gentle tingling. All sorts of memories came flooding back, lascivious memories of pubescent boys and girls

She there – Mandra – was both male and female.

Damp spittle oozed from his pendulous lips and moistened the black Havana. He peered across at her, lustful, full of trembling desire. And at that moment he understood why it was that men were attracted to these slim little creatures. Like fish that swim to the bait and don't see the hook. But he saw the sharp hook very clearly, and knew how to avoid it and still enjoy the sweet morsel.

\star \star \star \star

226

On February 2nd the sleighs and automobiles drove out to the 'Vintage' Hotel for society's most splendid Carnival Ball. Royalty was present, accompanied by anyone in the town who possessed a uniform, be it military or of the student fraternities with their caps and sashes. The academic circles were represented, as was the legal profession; there were civil servants, councillors and anyone who had money – business men and industrialists.

[. . .]

Judge Gontram was sitting at the table reserved for eminent guests: he knew the wine cellar well and was able to obtain the best vintages. Princess Volkonski was there with her daughter, the Countess Figueirera y Abrantes and Frieda Gontram, Wolfi's sister, who had been visiting the Princess that winter. Then there was the lawyer Manasse, a few lecturers and scholars as well as officers. And our Professor ten Brinken, who was accompanying his little daughter to her first ball.

Mandra appeared as Mademoiselle de Maupin in the costume of a young gallant à la Beardsley. She had previously torn open all the wardrobes in the ten Brinken villa and rummaged through old chests and boxes until she finally discovered piles of Belgian lace, dating from a long time ago. The tears of poor seamstresses, crouched in dark cellars, clung without doubt to these edgings and borders, as they did to all the beautiful lace worn by society *belles*, but much fresher tears moistened Mandra Gora's cheeky costume – those of the dressmaker who had been constantly scolded for not having grasped what the dress was supposed to mean, the hairdresser who did not understand the hair-style and couldn't do chi-chis, and the little maid whom she pricked with long needles during dressing. What a torment it was, arranging Gautier's girl according to the Englishman's bizarre conception! But when it was finished, when the moody lad in his high-heeled shoes and dainty little dagger strutted through the room there was no eye that did not follow him greedily, neither young nor old, neither man nor woman.

227

The Chevalier de Maupin shared his success with Rosalind. The Rosalind (of the last scene of Shakespeare's play) was played by Wolf Gontram – and the stage never saw a more beautiful one, not in Shakespeare's time, when slender boys played the part of girls, nor later, when Margaret Hews, the mistress of Prince Rupert, was the first woman to play the pretty girl in *As You Like It*. Mandra had dressed him; she had taken great pains to teach him how to walk, how to dance, how to hold his fan and how to smile. And as she seemed to be a boy, and yet also a girl in Beardsley's costume, a creature kissed on the brow by both Hermes and Aphrodite, so Wolf Gontram no less incorporated the figure of Beardsley's great countryman who had written the *Sonnets* : in his robe of gold and scarlet brocade he was a pretty girl, yet also a boy.

[. . .]

Her Majesty sent an adjutant and summoned the two of them to present themselves. She danced the first waltz with them both, first as a gentleman with Rosalind, then as a lady with the Chevalier de Maupin. And she burst into loud applause when, in a minuet, Théophile Gautier's curly-headed dream-boy bowed in a coquettish fashion before Shakespeare's lovely dream-girl. Her Majesty was an excellent dancer, an outstanding player on the tennis court and the best ice-skater in the town, and would have preferred to dance with the two of them all night long. But the crowd also wished to stake its claim, and so Mlle de Maupin and Rosalind flew from one partner to another; now pressed by the muscular arms of young men, then held against the warm, heaving breasts of young women.

[. . .]

The orchestra was playing, soft and seductive 'Roses from the South'. Mandra seized Wolfi's hand and pulled him away. 'Come, Wolfi, let's dance!'

They moved to the centre of the floor, and presented themselves. A grey-bearded art historian noticed them, climbed on his chair and shouted: 'Silence! A waltz expressly for the Chevalier de Maupin and his Rosalind!'

Several hundred pairs of eyes rested on the pretty couple. Mandra sensed this, and every step she took was taken in the knowledge that she was being admired. But Wolf Gontram was aware of nothing; he only knew that he was in her arms, and was carried by soft strains of music. And his large, black eyebrows sunk, and shaded his deep, dreaming eyes.

The Chevalier de Maupin led, surely, confidently, like a slim page who has known the smooth dance floor since his cradle. His head was bent slightly forwards, his left hand held Rosalind with two fingers and at the same time the golden pommel of his sword, which he pushed downwards so that its point thrust upwards the lacy tail of his coat. His powdered locks swayed like little silver snakes, his lips were parted in a smile which revealed his sparkling teeth. And Rosalind obeyed the gentle pressure. Her train of red and gold swept across the floor and her figure rose above it like a lovely blossom. Her head was bent backwards and the white ostrich feathers hung heavily from her hat. She swayed beneath the garlands of roses, rapt, transported, remote from all that existed. Round and round and round the room.

The guests pushed their way to the edge of the floor, and those who could not see climbed on to tables and chairs, in breathless admiration.

'I congratulate you, your Excellency,' murmured Princess Volkonski. And the Professor answered: 'Thank you, your Highness. It appears that all our efforts were not quite in vain.'

[. . .]

The waltz ceased, and Mandra led Wolf through the cheering crowd and the deluge of roses into the corner of the room. She noticed a small door which led on to the balcony, half concealed by a heavy curtain.

'Ah, that's good!' she said. 'Come Wolfi!' She drew back the curtain, turned the key and placed her hand on the door knob. But suddenly she felt five coarse fingers on her arm. 'What are you up to?' asked a grating voice. She

turned and noticed the lawyer, Manasse, in his black costume. 'What are you going out there for?'

She shook off his ugly hand. 'What's it to do with you?' she answered. 'We're only going for a breath of fresh air.'

He nodded vigorously. 'I thought so. That's why I followed you. But you won't do it, you won't!'

Mandra Gora rose to her full height and looked at him insolently. 'And why not? Do you think you can stop us?'

He flinched involuntarily beneath her gaze, but would not give in. 'Yes, I shall stop you, me! Don't you understand that it's madness. You're both glowing hot, bathed in sweat and you want to go out on to the balcony when it's minus twelve outside?'

'We're going', insisted Mandra Gora.

'All right,'. he yelped, '*you* go. It's a matter of total indifference what *you* do, Miss. I only want to prevent the boy from going.'

Mandra looked at him from top to toe. She pulled the key from the lock, and opened the door.

'So!' she said. She stepped out on to the balcony and beckoned to Rosalind. 'Will you come out into the winter night with me?'

Wolf Gontram pushed the lawyer aside and quickly stepped through the door. Manasse grabbed him, and held his arm tightly, but Wolf silently pushed him again, so that he fell awkwardly against the heavy curtain.

'Don't go, Wolf!' the lawyer screamed. 'Don't go!' He was almost wailing, and his hoarse voice cracked.

But Mandra Gora was laughing out loud. 'Adieu, faithful retainer!' She slammed the door in his face, put the key in the lock and turned it twice.

[. . .]

The two of them walked through the snow and leaned over the balustrade, Rosalind and the Chevalier de Maupin. The full moon was shining down on to the wide street below and cast its sweet light on to the Baroque architecture of the university and the archbishop's venerable palace.

The moonlight danced over the glittering white expanse and threw fantastic shadows across the pavements.

Wolf Gontram drank in the icy air. 'How lovely', he said and pointed at the white street below, whose silence was absolute. But Mandra Gora was looking up at him, at his white shoulders gleaming in the moonlight, at his large eyes, shiny like two black opals. 'You are lovely', she said. 'You are far more beautiful than the moonlight.'

Then he loosened his grip on the stone balustrade, seized her, and embraced her. 'Mandra', he cried, 'Mandra ...' She tolerated this for one moment, then tore herself free and struck him lightly on the hand. 'No!' she laughed. 'No! You are Rosalind and I am the boy, so I shall pay court to you.' She looked round, seized a chair from the corner, dragged it forwards and beat the snow from it with her sword. 'Come, sit here, my lovely lady, you are unfortunately too tall for me. So, that's right, we're the same height now.' She bowed daintily and sat down on one knee. 'Rosalind', she fluted, 'Rosalind! May a wandering knight steal a kiss – '.

'Mandra' he began, but she jumped up and put her hand across his mouth. 'You must say 'Sir'!' she cried. 'So, may I steal a kiss, Rosalind?' 'Yes, Sir', he stammered. Then she stepped behind him and took his head in both hands. And she began, trembling, one after another ... 'First your ears,' she laughed, 'the right, and the left ... and both cheeks ... and the silly nose, I've kissed that often enough ... And, finally, take care Rosalind, your beautiful mouth.' She bent forwards and thrust her curly head across his shoulder, under the wide hat. But then she started back. 'No, pretty maiden, put your hands modestly in your lap.'
He laid his trembling hands upon his knees, and closed his eyes. And so she kissed him, long and passionately. But her little teeth finally sought his lips, and quickly bit him, so that heavy drops of blood fell into the snow. Then she tore herself away and stood before him, gazing wide-eyed at the moon. She shivered, and her slender limbs were trembling. 'I'm freezing', she whispered, and lifted first one

foot, then the other. 'The stupid snow has got everywhere into my lacy slippers!' She took off a shoe and beat the snow out of it.

'Put on my shoes', he cried 'they are bigger and warmer.' He quickly pulled them off and let her slip into them. 'Is that better?' 'Yes!' she laughed, 'much better! I shall give you another kiss for this, Rosalind.'

And she kissed him again, and bit him again. And both of them laughed as the moon shone on the red drops on the white snow.

'Do you love me, Wolf Gontram?' she asked.

And he replied: 'I think of you always, constantly.'

She paused for a moment, and then continued: 'If I wanted you to, would you throw yourself from this balcony?'

'Yes!' he replied

'And from the roof?' He nodded.

'And from the cathedral spire?' He nodded again.

'Would you do anything for me, Wolfi?' she asked. And he said: 'Yes, Mandra, if you loved me. '

She pursed her lips mockingly and gently swung her hips. 'I don't know whether I do love you,' she said slowly. 'Would you do it if I didn't love you?'

Then those splendid eyes – his mother's eyes – gleamed with a darker radiance than ever. And the moon above was jealous of these human eyes, crept away and concealed itself behind the cathedral tower.

'Yes', the boy said, 'yes, even then.'

She sat upon his lap and put her arms around his neck. 'For that, Rosalind, for that I shall kiss you a third time!'

And she kissed him, longer, more passionately. But they could no longer see the dark drops in the glittering snow as the disgruntled moon had hidden its silver torch.

'Come', she whispered, 'come, we must be going.'

They changed their shoes, beat the snow from their clothes and unlocked the door, slipping quietly back into the room from behind the curtain. The lamps threw their harsh light upon them, and the air, hot and stuffy, enveloped them.

Wolf Gontram staggered when he let go of the curtain and quickly pressed both hands to his breast.

She noticed it. 'Wolfi?' she asked.

He said: 'It's all right, only a stitch. It's passed.'

Hand in hand they walked through the room.

<div align="center">★　　★　　★　　★</div>

Wolf Gontram was not in the office next morning. He did not get out of bed, was feverish, with a high temperature. Nine days he lay there, calling out her name in his delirium: he never regained consciousness during this time.

Then he died. Inflammation of the lungs. And they buried him in the new cemetery.

Miss Mandra Gora ten Brinken sent a large wreath of dark roses.

<div align="center">★　　★　　★　　★</div>

The Privy Councillor, His Excellency Professor ten Brinken, was walking up and down in his room, slowly, with heavy dragging steps. 'Is it really so bad? How long do you think I need to go away?'

Manasse, the little lawyer, turned and looked at him. 'For how long?' he gasped. 'What kind of a question is that? For as long as you live! You should count yourself lucky that this possibility remains open to you – it's certainly pleasanter to squander your millions in a villa on the Riviera than ending your days in prison! And it *would* be prison, I can assure you! And it's the authorities that have left this escape route for you, the prosecution could just as well have signed the warrant for your arrest this morning, and everything would have been over by now! Damned decent of them, but they would take it very badly if you didn't use this little exit. And when they decide to act, then they'll get you . . . and then, your Excellency, this would be your last night as a free man.'

The judge said, 'Flee, make your escape. It seems to me the best thing you could do.'

'Yes', yelped Manasse 'certainly the best and, indeed, the only solution for a crook and an embezzler. Disappear into thin air and take that daughter with you. Lendenich, and the whole town, would be grateful.'

The Professor pricked up his ears. For the first time that evening some sign of life entered his features, and the rigid mask of apathy slipped, that mask upon which a nervous restlessness had flickered.

'Mandra,' he whispered, 'Mandra, if she came too.' He passed his plump hand two or three times across his powerful forehead. He sat down, took a glass of wine, emptied it.

'Gentlemen, I think you're right', he said. 'I thank you for this. Would you please go through everything once more.' He seized the bundle of documents, shares, policies – the papers which were his undoing.

The lawyer began, and quietly, precisely, explained the legal technicalities. He worked through the stocks and shares, summed up each possibility of getting out, or self-defence. And Professor ten Brinken threw in the occasional word and, as in the old days, fought and manipulated. He grew increasingly clearer in his mind, and with each new danger there was also a new suppleness in his thinking.

Some papers he kept to one side, these posed no danger. But there were still sufficient number to bring about his undoing. He dictated a few letters, gave out instructions, took down notes and suggested appeals, complaints . . . Then he studied the train timetable, made his plans and gave instructions for what to do next. And when he left his office he could claim that he had ordered his affairs to his satisfaction. He hired a taxi and was driven to Lendenich, confident and assured. And it was only when the servant opened the gate and he was walking across the courtyard and up the stairs to the mansion that his confidence left him.

He looked for Mandra and felt it was a good omen that there were no guests in the house. The maid informed him that she had dined alone and was in her room. So he climbed the stairs, knocked on her door, and went in at her 'Enter'.

'I must talk to you' he said.

She was sitting at her writing desk and briefly looked up at him. 'No,' she said, 'it's not convenient'.

'It's most important, it can't be delayed.'

She looked at him, and lightly crossed one foot over the other. 'Not now. Go downstairs. Give me half an hour.'

He left, took off his fur coat and sat on the sofa. He waited and mulled over what he would say, every sentence, every word.

After a good hour had passed he heard her footsteps. He rose and went to the door and there she stood, dressed as a liftboy in a bright, strawberry-coloured uniform.

'Ah . . .' he sighed. 'That's nice of you.'

'To reward you', she laughed. 'Because you are such an obedient daddy . . . Now, what's it all about?'

The Professor concealed nothing of his affairs, the malpractice, neglect, the dubious transactions. He spoke precisely, embellishing nothing. She did not interrupt him, and let him speak and confess.

'It's basically you who are to blame,' he said. 'I could have dealt with everything, without any trouble. But I let it all slide, and devoted myself to you, and then the many-headed hydra – '

'The naughty Hydra!' she mocked. 'And now poor Hercules has his difficulties? [. . .] Now, little daddy, tell me what you are going to do.'

He explained that they would have to flee, now, immediately. They could do a bit of travelling, see the world – London first, then Paris. They could stop there for a bit and get whatever they wanted. And then overseas, travel through America, to Japan or India, just as she wished. Or both: they had time after all. And then Palestine, Greece, Italy, Spain. Just as she wanted: they could stop for a bit, then move on. And finally they would buy a beautiful villa somewhere, on Lake Garda, or on the Riviera. She could have horses, her cars, also her own yacht. She could entertain, if she wished, and live in grand style. He was not abstemious with his promises: he painted the scene in bright colours, all the splendours, and his febrile brain devised new, even more enticing blandishments. And then he stopped, and put his question to her. 'So, little one,

what do you say? Would you like to see all of this? Would you like to live like this?'

She was sitting on the table, and swung her slim legs back and forth. 'O yes,' she nodded, 'I'd like to very much. Only – '

'What?' he asked quickly. 'If you have another wish, just let me know. I know I can grant it.'

She laughed at him. 'Well, grant it then! I'd love to travel, but not with you!'

The Professor staggered backwards and almost fell; he grasped the arm of a chair. He gasped for words, but found none.

She continued: 'It would be boring with you. I find you tiresome. I shall travel, but without you!'

He laughed, too, trying to convince himself that this was a joke. 'But it's *me* who's got to travel!' he said. 'I've got to escape this very night.'

'So go then,' she said quietly.

He tried to seize her hands, but she put them behind her back. 'And you Mandra?'

'Me? I'm staying.'

He started again, begging, imploring. He told her that he needed her, needed her like the air that he breathed. She should take pity on him, he would soon be eighty and he wouldn't be a burden for much longer. Then he threatened her, yelling that he would disinherit her, cut her off without a penny . . .

'Just you try it,' she interposed.

He kept on talking, describing the radiance that would surround her. She would be free as no girl before her, do whatever she wished. There would be no wish, no thought that he would not grant her. But she should just come with him, and not leave him alone.

She shook her head. 'I like it here. *I've* done nothing wrong. I'm staying.'

She said this quietly, calmly. She didn't interrupt him, but let him do all the speaking, all the promising. But she shook her head every time he put the question.

Finally she jumped from the table and walked past him, quietly, to the door.

'It's late', she said, 'and I'm tired. Goodnight, daddy, and *bon voyage* '.

He stood in her way and made his last attempt. He insisted that he was her father, and spoke of filial duty, like a vicar. She burst out laughing: 'That I might enter the Kingdom of Heaven!' She was standing next to the sofa and sat astride the armrest. 'How do you like my leg?' she asked suddenly. And she thrust a slim leg upwards, towards him, and swung it back and forth. He gazed at it, and forgot everything, the flight, the danger. He saw nothing, experienced nothing, except this slim, boyish leg, strawberry red, that was swinging up and down before his eyes.

'I'm a good girl', she fluted, 'a very good girl who gives her silly daddy so much pleasure. Kiss my leg, daddy, stroke my pretty leg, daddy!'

He fell heavily to his knees, seized the red leg and grasped with trembling fingers the thigh and the plump calf . . . He pressed his moist lips against the red cloth, and licked it for a long time with a quivering tongue.

Then, quickly and lightly, she jumped from the sofa, tweaked him by the ear and tapped him lightly on the cheek. 'Well, daddy',she cooed, 'haven't I done my filial duty nicely? Good night, have a good trip, and don't let them catch you, it's supposed to be rather nasty in prison. And don't forget to send a pretty postcard!'

She reached the door before he could rise. She made a bow, correct and stiff as a boy, and saluted with her right hand to her cap. 'A great honour, your Excellency!' she called. 'And don't make too much noise with your packing, it might disturb my sleep!'

He staggered after her and saw her run quickly up the stairs. He heard her open the door, then it snapped shut and the key was turned twice in the lock. He wanted to reach her, and laid his hand on the banister, but he sensed that she would not open, despite his pleading. This door would remain shut in his face, even if he stood all night in

front of it, till dawn, till, till the police arrived to take him away.

He stood stock still. He listened, and could hear her footsteps above him, going back and forth across the floor. Then all was silent.

He crept out of the house and walked bare-headed through the heavy rain, across the courtyard to the library. He entered, looked for matches and lit a couple of candles on his writing desk; he collapsed heavily into an armchair.

'Who is she?' he whispered. 'What is she? What a creature!'

He opened the old mahogany desk, drew open a drawer and took out the leather volume, staring at her initials on the cover.

The game was finished, he knew this well enough. And he had lost, he had no more cards left. It had been *his* game: he had dealt the cards. He had held all the trumps, but he had lost the game. He smiled grimly. Now he would have to pay the bill. Pay? Oh yes, and in which currency?

He looked at the clock, it was past midnight. They would come with a warrant for his arrest, no later than seven. He had six hours left. They would be very polite, very considerate: they would take him to prison in his own car. And then, the trial would begin. That would not be so bad, he could defend himself for months and make difficulties for his opponents every inch of the way. But finally, in the main hearing, he would collapse – Manasse was correct. And finally, prison.

Or: flight. But alone? All on his own? Without her? He felt hatred for her now, but he also knew that he could think about nothing but her. He would rush about the world endlessly, aimlessly, hearing nothing, seeing nothing but her warbling voice, her red, swinging leg. He would die of hunger, either out there, or in prison, whichever. This leg! This sweet, slim boyish leg! How could he live without it?

The game was lost, and he had to pay the cost. So he

would pay it, now, tonight, and be in nobody's debt. He would pay it with what remained: his life. And then he felt that it was a worthless tribute, and that he would be cheating his partners at the end. The thought cheered him, and he brooded on the chance of giving one final kick. That would finally give some satisfaction.

He took his will from the writing desk, the will which had made Mandra his sole beneficiary. He read it through, then tore it carefully into tiny pieces. 'I must make a new one,' he whispered, 'but for whom?'

He took out a sheet of paper, and dipped his pen in the ink. There was his sister, and there was her son, his nephew, Frank Braun.

He paused. Him? him? Had he not brought this gift into his house, this strange creature who was now destroying him? He, like the others? He should strike *him*, him more than Mandra Gora.

'You will be tempting God,' the young man had said. 'You will ask him a question, one so insolent that He must reply.' Oh yes, and now he had his answer!

But if he were inexorably lost, perished, so the boy must share his fate also, he, Frank Braun, who gave him the idea in the first place! He had a very sharp weapon, his little daughter Mandra! And she would bring Frank Braun to the place that *he* was in now . . .

He pondered, shook his head slowly and grinned in the certain knowledge of having gained his last triumph. And he wrote his will without a pause in quick, ugly writing.

Mandra remained his legal heir, she alone. But he left a legacy to his sister and one to his nephew. The latter was also to be his executor and guardian to the girl until she came of age. So Frank Braun would have to come, to be close to her and breathe the sultry perfume of her lips. And he would go the same way as all the others, as *he* had done!

He laughed out loud. He then added a codicil making the University a beneficiary if Mandra should die without issue, thus excluding his nephew. He signed the document, then dated it. And then he took up the leather volume,

read it, added the details and scrupulously brought it up to date. He finished with a final address to his nephew, dripping with venom. 'Try your luck . . .' he wrote. 'Pity I won't be there when it's your turn! I would like to have seen it!'

He carefully blotted the wet ink, closed the volume and carefully placed it in the drawer, alongside other mementoes [. . .] He went across to the curtain and loosened the silk braid. With a long pair of scissors he cut a piece off and threw it into the drawer. 'Mascotte!' he laughed. 'ça porte bonheur pour la maison!'

He moved along the walls, climbed on to a chair and, with considerable effort, removed a massive iron crucifix from its heavy hook. He laid it carefully on the divan. 'Sorry to have to move you,' he grimaced, 'but it's only for a short time, for a couple of hours . . . You shall have a worthy deputy!'

He knotted the silk braid and threw it over the hook. He tugged at it to make sure it was firmly attached, and then he climbed back on the chair again . . .

The police found him early next morning. The chair had fallen over, but the dead man was still touching it with the tip of one of his feet. It seemed as if he had regretted his deed and had tried to save himself at the very last minute. His right eye was wide open, staring at the door. And his thick, blue tongue was hanging out of his mouth. He looked very ugly.

<p style="text-align:center;">* * * *</p>

Intermezzo.

And perhaps my blonde little sister, perhaps the silver bells of your quiet days now send forth the gentle tones of sleeping sins.

Now the golden laburnum casts its poisonous yellow where the pale snow of the acacias is lying, and the hot clematis shows its deep blue where the pious bunches of wistaria sound peace to all . . .

Sweet is the gentle play of lustful desires, sweeter, to me it seems, the cruel battle of the nocturnal passions. But sweeter than all, I think, is the sleeping sinfulness of hot summer days.

Lightly she slumbers, my gentle friend, and one may not wake her. For she is never so lovely than in such a sleep.

My dear sinfulness rests in a mirror, quite near, resting in a thin silk shift upon white linen. Your hand, my sister, hangs over the edge of the bed, the narrow fingers lightly clenched, fingers that wear my golden rings; your pink nails gleam like the first blush of day. Fanny, your black maid, has manicured them, created this small miracle. And in the mirror I kiss the transparent wonder of your rosy nails.

Only in the mirror, in the mirror alone. Only with caressing glances and the gentle breath of my lips. For when sin awakes they grow, grow and become the sharp claws of a tigress. And tear my flesh.

Your head rises from the lacy pillow, and your blonde curls fall profusely. They fall gently, like a flickering golden fire, like the gentle rustling of the first winds at the young day's awakening. But your small teeth smile between your narrow lips like the milky opals in the gleaming bracelet of the moon-goddess. I kiss your golden hair, little sister, and your gleaming teeth.

Only in the mirror, in the mirror alone. With the gentle breath of my lips and with caressing glances. For this I know: when hot sin awakes, then the little milky opals become tusks, and your golden locks become fiery vipers. Then the tiger's claws tear my flesh, and the sharp fangs gouge bloody wounds. The flaming vipers hiss about my head, creep into my ears, squirt their poison into my brain, and whisper and utter the wild legends of monstrous lusts . . .

Your silken shift slips from your shoulder, and your childish breasts laugh. They rest like two white kittens, young as the day, and their sweet, pink lips pout upwards. They gaze at your gentle eyes, blue eyes of stone which refract the light: they dazzle as the starry sapphire which gleams in the silent head of my golden Buddha.

Do you see, little sister, how I kiss them back in the mirror? For I know well: when it wakes, when the eternal sin awakes, blue lightning will flash from your eyes and strike deep into my poor heart. Make my blood boil and seethe, and their heat will melt the powerful chains which keep madness in thrall, and madness will roar into the world.

And then the wild beast, free of its chains, will be unleashed, and it will hurl itself upon you, sister, in raging torment. And it will hack its claws into your sweet little breasts, breasts that now – because sin is wakened – become the monstrous breasts of a lustful harlot, and the beast's wild maw will sink its fangs into you . . . And pain exults in torrents of blood.

But my glances are still gentle, quieter than the tread of nuns at the holy sepulchre. And still more gentle is the breath of my lips. Like the spirit's kiss on the Host in the minster, the kiss that transforms the bread into the body of our Lord.

It should not wake, this beautiful sin, it should rest and have peace.

For nothing, my dear friend, seems to me sweeter than chaste sinfulness in its tender sleep.

<p style="text-align:center">* * * *</p>

Frank Braun had returned to his native land, to his home, from somewhere or other, from one of his fruitless journeys, from Kashmir, or the Bolivian chaco, from the West Indies perhaps, where he had played at being a revolutionary in preposterous republics, or from the south seas, where he had dreamed strange dreams with the slender daughters of dying people.

He returned, from somewhere or other. [. . .] He returned to Lendenich, through the fragrance of Spring, to his ward. [. . .]

Frank Braun crossed the courtyard and noticed that a light was burning in the library. He entered and Mandra was sitting on the couch.

'Are you here, dearest coz?' he greeted her flippantly. 'Up so late?'

242

She said nothing, but beckoned him to sit down. He sat opposite her, and waited, but she was silent, and he did not press her.

At last she spoke. 'I wanted to speak to you.' He nodded, but still she was silent. So it was he who made the first move. 'You've been reading the leather volume?' 'Yes,' she said, and breathed deeply. 'So I'm just a joke, that you made once, Frank Braun.'

'A joke?' he asked. 'More of an idea if you wish.'

'So, an idea,' she said. 'What difference does a word make? What's the difference between a joke and an amusing idea? And it's certainly amusing, I would have thought.' She burst out laughing. 'But I'm not waiting for you for that reason. I want to know something else. Tell me, do you think it's true?'

'What am I supposed to believe?' he answered. 'You mean, whether I believe what Uncle wrote in his book? Yes, I believe it.'

She shook her head impatiently. 'No, I don't mean that. It is true, naturally, why should he lie? I want to know if you believe, as my, well, your uncle did, that I am different from other people, that I'm, well, a mandrake, a mandragora, as my name suggests.'

'How can I answer such a question? Ask a physiologist, he will doubtless tell you that you are human being like everyone else in the world, even if your entrance was rather unusual. He will say that all the subsequent events were accidents, trivia which – '

'I'm not interested in all that,' she interrupted. 'It's a matter of indifference to me. I only want to know: are you of the opinion that I am an unusual being?'

He was silent, looking for an answer, and did not know what to say. He believed it, and yet, at the same time, did not.

'Look,' he started.

'Go on,' she urged him. 'Do you think that I'm some sort of joke which took on shape and form, your idea, which the old Professor threw into his retort, which he

boiled and distilled until that creature emerged who is sitting before you now?'

And this time he did not hesitate. 'If you put it like that, yes, I do believe it.'

She laughed lightly. 'I thought so. And that was why I was waiting for you this evening, so that you would be cured as quickly as possible of this arrogance. No, cousin, it wasn't you who put this thought into the world, no more than your dear uncle did.'

He did not understand her. 'Well, who was it then?'

She put her hand under the cushions: 'This did!' she cried. She drew out the mannikin, threw it into the air and caught it again, gently caressing it with her nervous fingers. [. . .] She laid it down on a silken cushion and looked at it with an almost tender gaze. And she spoke to it thus: 'You are my father and my mother: you are that which created me.'

He looked at her. 'Perhaps it is true,' he thought to himself. 'Thoughts drift through the air, like pollen, swirl about and then settle in a human brain. They often sicken, dry out, and die, only a very few find a good, fertile soil. She may be right, my brain was always a richly fertilized nursery for all sorts of craziness!' And it seemed to him to be a matter of indifference whether it was he who had thrown this seed into the world, or had been the fruitful earth which had received it.

She slowly rose, still holding the ugly mannikin in her hand.

'I wanted to say something else to you, to thank you for showing me the leather volume, and for not having burned it.'

'What is it?' he asked.

'Shall I kiss you? I know how to kiss [. . .] I want to kiss you.'

'Be careful!' he said, 'I'll kiss you too.'

She did not avert her gaze. 'Yes,' she said. Then she smiled. 'Sit down, you're rather too tall for me.'

'No!' he cried gaily. 'Not like that!' He walked across to

244

the broad divan, stretched himself out on it and laid his head on the cushions, closing his eyes.

'Now come, Mandra!' he called.

She came closer and knelt down before him. She paused, looked at him, then threw herself upon him, seized his head and pressed her lips on his.

He did not embrace her, did not move his arms, but clenched his fingers into a fist. He felt her tongue, and the gentle bites of her teeth.

'More,' he whispered, 'more.'

Red mists swirled before his eyes. He heard the hideous laughter of Professor ten Brinken, the large, startled eyes of Mrs Gontram when she asked the lawyer Manasse to explain what a mandrake was, saw them wiping it with a large napkin.

'More . . .,' he murmured.

And she, Mandra Gora, saw her mother, with hair red as fire, with large, snow-white breasts shot through with small, blue veins. And the execution of her father as the Professor had described it in his book . . . And the hour in which the old man had created her, and the moment when the doctor brought her into the world.

'Kiss me,' he gasped, 'kiss me.'

He drank in her kisses, drank the hot blood of his lips which her teeth had torn. And he knowingly, wilfully, intoxicated himself, as though he were drinking foaming wine, or the drugs of the Orient . . .

Then: 'Stop!' he cried suddenly. 'Stop! you don't know what you're doing . . .'

Then she pushed her curls ever closer across his brow and her kisses grew wilder and more violent.

The thoughts, the clear thoughts of day lay shattered, and now dreams were born, and a red sea of blood rose and burst. Wild Maenads waved the thyrsus rod, and the holy ecstasy of Dionysus foamed and churned.

'Kiss me!' he screamed.

But she let go, and her arms dropped to her sides. He opened his eyes and stared at her.

'Kiss me,' he repeated softly. Her eyes were dulled, and she was panting. She slowly shook her head.

Then he jumped up. 'So, I shall kiss you,' he cried. He lifted her in his arms and threw the struggling girl on to the divan. He knelt where she had been kneeling.

'Close your eyes,' he whispered, and he bent over her.

His kisses were good, tender and cosseting as the play of harps in a summer night. Wild, too, rough and harsh as a tempest over Northern seas. Glowing as the fiery breath of Etna's mouth, tearing and devouring as the maelstrom's vortex.

'It's going under . . .,' she felt, 'everything is going under . . .'

Then the fires roared forth and the hot flames shot upwards into the skies. The torches blazed, the altars ignited, and with bloody jaws the wolf burst through the sanctuary.

She held him tight and pressed herself hard against his breast.

'I'm burning,' she shrieked, 'I'm burning . . .'

Then he tore the clothes from her body.

. . . .

* * * *

The sun was already high when she awoke. She saw that she was naked but did not cover herself. She turned her head and saw him sitting upright next to her, as naked as she was.

'Are you leaving today?' she asked.

'Do you want me to go?' he retorted.

'Stay!' she whispered, 'stay!'

* * * *

Early, when the young sun arose, he left the room in his dressing gown. He went into the garden and walked along the path past the trellis-work, entering the rose garden, where he cut Boule de Neige, Empress Victoria Augusta, Madame Carl Drusky and Merveille de Lyon. He turned left where the larches were standing and the noble firs.

Mandra was sitting on the edge of the pond. She was

246

wearing her black silk gown and was throwing bread-crumbs to the goldfish. As he approached she plaited a wreath of pale roses and quickly, skilfully, crowned her curls with it. She cast aside her gown and sat there in her lacy shift, her bare feet paddling in the cool water.

They scarcely spoke. But she was trembling when his fingers lightly touched her neck and his breath caressed her cheeks. She slowly removed her shift and placed it upon the bronze water nymph at her side. On the marble edges of the pool six naiads were sitting, pouring water from the urn and the amphora, squirting it in a thin jet from their breasts. All sorts of creatures were crawling around them, lobsters and crayfish, tortoises, fish, water snakes and reptiles. And in the middle Triton was blowing his horn, and around him the denizens of the deep were snorting water from bloated lips in to the air.

'Come, my friend!' she said.

They climbed into the water. It was very cool, and he shivered, his lips became blue, and goose pimples crept up his arms. He had to swim briskly, to kick and beat the water in order to warm his blood and adapt himself to the unfamiliar temperature. But she noticed nothing, she was in her element and laughing at him, swimming around like a little frog.

'Turn on the taps!' she called.

He turned them on and then, from four places close to the edge of the pool, near the picture of Galathea, light waves began to foam. They swelled for a while, broke, and grew higher and higher. They rose strong and power-ful, rising and falling, higher than the rays of Triton's creatures. Four gleaming, sparkling silver cascades.

There she stood, in the middle of the four, surrounded by the shimmering rain. Like a lovely boy, slim and tender, and his gaze kissed her slowly. There was no blemish in the elegant proportions of these limbs, no defect in this sweet apparition. Her skin was of an even colour, white Paros marble with a light hint of yellow. Only the inside of her upper thighs were pink and showed a strange mark or line.

'That was how Dr. Petersen died,' he thought to himself. He bent down, knelt, and kissed the rosy softness.

'What are you thinking?' she asked.

He said: 'I think you're a Melusine! Look at the mermaids round us, they've got no legs, only a long, scaly fish's tail. They have no soul, these nixies, but it is said that they can still love a human being sometimes. A poor fisherman, or a knight errant. They can love him so much that they leave the cool waters and step onto the land. Then they go to an old witch, or a wizard, and he brews up an evil mixture which they must drink. And he takes a sharp knife and begins to cut, right in the middle of the fish tail. It is agonising, agonising, but Melusine swallows her suffering for the sake of her great love. Doesn't lament, doesn't weep, till almost unconscious with pain. But when she wakes up, her fish tail has gone and she can walk on two lovely legs, just like a human being. But you can still see the marks that the old wizard made.'

'But she still remains a nymph?' she asked. 'Even with her human legs? And can the wizard give her a soul?'

'No,' he said. 'He can't do that. But there's something else that people said about nixies.'

'What?' she asked.

And he continued: 'Melusine only has her magic powers as long as she's untouched. But when she drowns in love's kisses, when she loses her maidenhood in the knight's embrace, then she loses her powers. She can't find treasure any more, and can't bring the gold from the depths of the Rhine, but that black sorrow which haunts her also avoids her threshold . . . She is like a human being from now on.'

'I wish it were so!' she whispered. She tore the white wreath from her hair and swam to the sea gods and tritons, the mermaids and naiads. She threw the blossoming roses into their lap

'Take them, sisters, take them!' she laughed. 'I'm a human being!'

* * * *

A massive four poster bed stood in Mandra's bedroom, on

248

low, ornate supports. At the foot end there were two columns holding bowls with golden flames. The sides of the bed were decorated with carvings: Hercules spinning for Omphalos, Perseus kissing Andromeda, Vulcan catching Mars and Venus in his net. There were also carvings of branches and tendrils, doves, and winged boys [. . .]

He saw Mandra standing on a chair at the head of the bed with a heavy pair of pincers in her hand.

'What are you doing?' he asked.

She laughed. 'Just wait, I'll soon be finished.' She knocked and carefully pulled the golden cupid who hovered over her head with bow and arrow. She pulled out one nail, then another, and twisted and turned the little god until he was free. She seized him, jumped down, and placed him on the cupboard. She took out the mandrake root, climbed back with him on to the chair and fastened him with wire to the head of the bed. She descended and looked critically at her work.

'How do you like him?' she asked.

'What's he supposed to be doing there?'

'He belongs there!' she answered, 'I didn't like that golden cupid, that's too common. I want to have Galeotto, my mannikin.'

'What did you call it?'

'Galeotto!' she replied. 'Was it not he who brought us together? Now let him hang there, and keep watch through the nights.'

[. . .]

They lay naked under the scarlet Pyrrhus: their bodies, which had been fused during hot midday hours, fell apart.

Their caresses lay broken and trampled, their embraces, their tender words. Like the flowers and the gentle grasses across which the storm of their passion had passed. Dead lay the fiery brand, consumed by its own tearing teeth, and from the ashes there grew a cruel, steely hatred.

They looked at each other, and saw that they were deadly enemies.

The long, red line on her thighs repulsed him, and the

saliva ran in his mouth as though he had drunk the bitter poison of her lips. And the small wounds which her teeth and her nails had inflicted burned, throbbed, swelled.

'She will poison me,' he thought, 'just as she killed Dr Petersen.'

Her green eyes laughed at him, mocking, spiteful, insolent. He closed his eyes, drew his lips together and clenched his fingers tightly. But she stood up, turned and kicked him with her foot, casually, scornfully.

He jumped to his feet and stood before her, and their glances crossed. Not a word was uttered, but she curled her lip and raised her arm; she spat at him, and struck him in the face.

And he threw himself upon her, shook her, seized her hair and whirled her round. He hurled her to the ground, beat her, kicked her, seized her by the throat.

She defended herself bravely, her nails flayed his face, her teeth bit into his arm, his breast. And in blood and saliva their lips sought each other, and found, and took in an agony of lust. He then seized her and hurled her yards from him, so that she sank to the ground, unconscious. He staggered for a few paces, then fell and stared into the blue sky with neither wish nor will, and listened to the pounding in his temples. Until his eyelids dropped.

When he awoke she was kneeling at his feet, drying his blood with her hair. She had torn her shift into long strips and was skilfully bandaging him.

'Let us go, beloved.' she said. 'The dusk is falling.'

* * * *

The midday sun was blazing down, and they were sitting on the edge of the pool, paddling their feet in the water.

'Go to my room,' she said, 'and on my bedside table you will find a hook, on the left hand side.'

'No,' he replied, 'you shouldn't go fishing. What have the goldfish done to you?'

'Do it!' she commanded.

He rose and walked towards the villa. He entered her room, found the hook and looked at it critically. Then he

smiled, satisfied. 'Well, she won't catch a great deal with *that*!' he thought. But then he stopped, and deep furrows wrinkled his brow. 'Not a great deal? *She'd* catch goldfish if she threw a meat-hook in!'

His gaze fell on the bed, with the mannikin fixed on top. He threw the hook into the corner and in a moment of decision seized the chair and placed it by the bed. He climbed up and, with a quick jerk, he wrenched the mandrake free. He gathered some paper together, put it in the grate, lit it and placed the mandrake on it.

He sat down and gazed at the flames. But they only consumed the paper and scarcely scorched the mannikin. It seemed to be laughing at him, as if its ugly face were becoming a mask – the grinning countenance of uncle Jakob! And now he could hear, all around him, this greasy laughter . . .

He leapt to his feet, took his knife from the table, and opened its sharp blade, pulling the mandrake from the fire. The wood of the root was hard, and immensely tough – he could only cut small chips off it. But he persevered, and hacked, and hacked, one piece after another. The sweat stood out on his brow, and his fingers were aching with the unaccustomed effort. He rested, got some more paper, some bundles of un-read newspapers. He threw the wood chippings on to it and poured eau de Cologne and attar of roses on top.

Ah, now it was burning merrily. The flame gave him strength again, and he hacked the chips from the wood, feeding the fire as he went. The mannikin grew smaller, without his arms and legs, but still continued to resist, driving deep splinters into Frank Braun's fingers. But he laughed, and grimly anointed the hateful head with his blood, and pared new segments from the body.

Then he heard her voice, hoarse, almost broken.

'What are you doing?' she cried.

He jumped to his feet and flung the last fragment into the hungry flames. He turned, and his green eyes gleamed madly. 'I've killed it!' he yelled.

'It's me, it's me!' she groaned, pressing her hands to her heart. 'It hurts,' she whispered, 'it hurts . . .'

He strode passed her, slamming the door. But an hour later he was lying in her arms again, sucking her poisonous kisses once more.

<p style="text-align:center">★ ★ ★ ★</p>

It was true, he was her teacher. They walked hand in hand through the park of love, on secluded paths, away from the crowded avenues. But where the paths ended, in the wild undergrowth, where he stopped and turned away from steep precipices, there she strode laughingly forward, nonchalant, without fear or shame, lightly, as though it were a dance. In the park of love there was no red, poisoned fruit that she did not pluck and which her smiling lips did not taste.

She knew from him how sweet it was to be drunk when the tongue sipped the little drops of blood which sprang from beloved flesh. But her lust seemed insatiable, and her burning thirst could not be slaked.

In this night he was exhausted by her kisses, and slowly freed himself from her limbs. He closed his eyes and lay like a dead man, rigid and immovable. But he was not sleeping, his senses wide awake despite his tiredness.

He lay like this for many hours. The full moon shone brightly through the open window, on to the white bed. And he heard her move at his side, gently moaning and whispering wild words, as she always did in such moonlit nights. He heard her get up, go singing to the window, then slowly return. He felt her bend over him, staring for a long time.

He did not move. She got up again, ran to the desk and then returned. And she blew, quicker and quicker on his left breast, and then waited, listening to his breathing.

Then he felt something cold and hard scratch his skin, and knew that it was the knife. 'Now she will drive it in,' he thought, but the thought was not terrible, sweet rather, and good. He did not move, and waited for the quick incision which would cut his heart open. She cut, slowly,

gently. Not very deep, but deep enough for his hot blood to spurt forth. He heard her quick breathing, and opened his eyes a little. Her lips were half open, and the tip of her tongue was thrust greedily between her shining teeth. Her small white breasts were heaving, and a demented fire sparkled in her green, staring eyes.

She suddenly threw herself over him, pressing her mouth to the open wound, and drank, drank. He lay immovable and felt his blood flowing to his heart: it seemed as though she would drain him dry, drink all his blood, leave not one single drop in him. And she drank, drank through all eternity . . .

She finally lifted her head. He saw how flushed she was, her cheeks gleaming red in the moonlight, and pearls of sweat upon her brow. With caressing fingers she stroked the drying source of her red intoxication, and pressed a few light kisses on the wound. She turned and gazed at the moon with staring eyes.

Something was drawing her. She rose, and moved heavily to the window; she climbed on to a chair and placed one foot upon the window ledge, transfigured by a silvery effulgence.

Then, quickly and decisively, she climbed down again. Looking neither to right not left she glided through the centre of the room.

'I am coming,' she whispered, 'I am coming!'

And she opened the door, and slipped into the night.

<p style="text-align:center">★ ★ ★ ★</p>

Extracts from Hanns Heinz Ewers: *Alraune.
Geschichte eines lebenden Wesens*. Sieben Stäbe Verlag, Berlin, 1928.

Thomas Mann: *The Blood of the Wälsungs*

It was seven minutes to twelve. Wendelin came into the first-floor entrance-hall and sounded the gong. Dressed in violet knee-breeches and with his feet firmly planted on a prayer-rug pale with age, he belaboured the metal disc with his drumstick. The brazen din, savage and primitive out of all proportion to its purport, resounded through the drawing-rooms to left and right, the billiard-room, the library, the winter-garden, up and down through the house; it vibrated through the warm and even atmosphere, heavy with exotic perfume. At last the sound ceased, and for another seven minutes Wendelin went about his business while Florian in the dining-room gave the last touches to the table. But on the stroke of twelve the cannibalistic summons sounded a second time. And the family appeared.

Herr Aarenhold came toddling out of the library where he had been busy with his old editions. He was continually acquiring old books, first editions, in many languages, costly and crumbling trifles. Gently rubbing his hand he asked in his slightly plaintive way:

'Beckerath not here yet?'

'No, but he will be. Why shouldn't he? He will be saving a meal in a restaurant,' answered Frau Aarenhold, coming noiselessly up the thick-carpeted stairs, on the landing of which stood a small, very ancient church organ.

Herr Aarenhold blinked. His wife was impossible. She was small, ugly, prematurely aged, and shrivelled as though by tropical suns. A necklace of brilliants rested upon her shrunken breast. She wore her hair in complicated twists and knots to form a lofty pile, in which, somewhere on one side, sat a great jewelled brooch, adorned in its turn

with a bunch of white aigrettes. Herr Aarenhold and the children had more than once, as diplomatically as possible, advised against this style of coiffure. But Frau Aarenhold clung stoutly to her own taste.

The children came: Kunz and Märit, Siegmund and Sieglinde. Kunz was in a braided uniform, a stunning tanned creature with curling lips and a duelling scar. He was doing six weeks' service with his regiment of hussars. Märit made her appearance in an uncorseted garment. She was an ashen, austere blonde of twenty-eight, with a hooked nose, grey eyes like a falcon's, and a bitter contemptuous mouth. She was studying law and went entirely her own way in life.

Siegmund and Sieglinde came last, hand in hand, from the second floor. They were twins, the youngest of the children, slender as willow wands, and with immature figures despite their nineteen years. She was wearing a Florentine cinquecento frock of claret-coloured velvet, too heavy for her slight body. Siegmund had on a grey jacket suit with a tie of raspberry shantung, patent-leather shoes on his narrow feet, and cuff-links set with small diamonds. He had a strong growth of black beard but kept it so close-shaven that his sallow face with the heavy gathered brows looked no less boyish than his figure. His head was covered with thick black locks parted far down on one side and growing low on his temples. Her dark brown hair was waved in long, smooth undulations over her ears, confined by a gold circlet. A large pearl − his gift − hung down upon her brow. Round one of his boyish wrists was a heavy gold chain − a gift from her. They were very like each other, with the same slightly drooping nose, the same full lips lying softly together, the same prominent cheek-bones and black, bright eyes. But the closest resemblance lay in their long slim hands, his no more masculine than hers, save that they were slightly redder. And they went always hand in hand, untroubled by the fact that the hands of both tended to become sweaty.

The family stood about awhile in the lobby, scarcely

speaking. Then von Beckerath appeared. He was engaged to Sieglinde. Wendelin opened the door to him and as he entered in his black frock-coat he excused himself on all sides for his tardiness. He was a senior civil servant and came of a good family. He was short of stature, with a pointed beard and a very yellow complexion, like a canary. His manners were punctilious. He began every sentence by drawing his breath in quickly through his mouth and pressing his chin on his chest.

He kissed Sieglinde's hand and said:

'And you must excuse me too, Fräulein Sieglinde – it is so far from the Ministry to the Tiergarten –'

He was not allowed to say the familiar *du* to her – she did not like it. She answered briskly:

'Very far. Supposing that, in consideration of the distance, you left your office a bit earlier?'

Kunz seconded her, his black eyes narrowing to glittering slits:

'It would no doubt have a most beneficial effect upon the tempo of our domestic arrangements.'

'Oh, well – business, you know what it is,' von Beckerath said dully. He was thirty-five years old.

The brother and sister had spoken glibly and with point. They may have attacked out of a habitual inward posture of self-defence; perhaps they deliberately meant to wound – perhaps again their words were due to the sheer pleasure of turning a phrase. It would have been pedantic to hold it against them. They let his feeble answer pass, as though they found it in character; as though cleverness in him would have been out of place. They went in to lunch; Herr Aarenhold led the way, eager to let von Beckerath see that he was hungry.

They sat down; they unfolded their stiff table-napkins. The immense room was carpeted, the walls were covered with eighteenth-century panelling, and three electric chandeliers hung from the ceiling. The family table, with its seven places, was lost in the void. It was drawn up close to the large French window, beneath which a dainty little

fountain spread its silver spray behind a low lattice. Outside was an extended view of the still wintry garden. Tapestries with pastoral scenes covered the upper part of the walls; they, like the panelling, had been part of the furnishings of a French château. The dining-chairs were low and soft and cushioned with tapestry. A tapering glass vase holding two orchids stood at each place, on the glistening, spotless, faultlessly ironed damask cloth. With careful, skinny hands Herr Aarenhold settled the pince-nez half-way down his nose and with a mistrustful air read the menu, three copies of which lay on the table. He suffered from a weakness of the solar plexus, that nerve centre which lies at the pit of the stomach and may give rise to serious distress. He was obliged to be very careful what he ate.

There was bouillon with beef marrow, sole *au vin blanc*, pheasant, and pineapple.

Nothing else. It was a simple family lunch. But it satisfied Herr Aarenhold. It was good, light, nourishing food. The soup was served: a dumb-waiter above the sideboard brought it noiselessly down from the kitchen and the servants handed it round, leaning forward, concentration written all over their faces in a kind of passionate service. The tiny cups were of translucent porcelain, whitish morsels of marrow floated in the hot golden liquid.

The warmth of the soup caused Herr Aarenhold to bring up a little wind. He carried his napkin cautiously to his mouth and cast after a means of expressing what was on his mind.

'Have another cup, Beckerath,' he said. 'A working-man has a right to his comforts and his pleasures. Do you really like to eat – really enjoy it, I mean? If not, so much the worse for you. To me every meal is a little celebration. Somebody said that life is beautiful, in that it is arranged so that we can eat four times a day. He's my man! But to do justice to the arrangement one has to preserve one's youthful receptivity and not everybody can do that. We get old – well, we can't help it. But the thing is to keep things

fresh and not get used to them. For instance,' he went on, putting a bit of marrow on a piece of roll and sprinkling salt on it, 'your situation is about to change, the plane on which you live is going to be a good deal elevated' (von Beckerath smiled), 'and if you want to enjoy your new life, really enjoy it, consciously and artistically, you must take care never to get used to your new situation. Habit means death. It is ennui. Don't become settled, don't let anything become a matter of course, preserve a childlike taste for the sweets of life. You see . . . for some years now I have been able to command some of the amenities of life' (von Beckerath smiled), 'and yet I assure you, every morning that God lets me wake up I have a little thrill because my bed-cover is made of silk. That is what it is to be young. I know perfectly well how I did it; and yet I can look round me and feel like an enchanted prince.'

The children exchanged looks, so openly that Herr Aarenhold could not help seeing it; he became visibly embarrassed. He knew that they were united against him, that they despised him: for his origins, for the blood which flowed in his veins and through him in theirs; for the way he had earned his money; for his fads, which in their eyes were unbecoming; for his valetudinarianism, which they found equally annoying; for his weak and whimsical loquacity, which in their eyes traversed the bounds of good taste. He knew all this – and in a way conceded that they were right. But after all he had to assert his personality, he had to lead his own life; and above all he had to be able to talk about it. That was only fair – he had proved that it was worth talking about. He had been a worm, a louse if you like. But just his capacity to realize it so fully, with such vivid self-contempt, had become the ground of that persistent, painful, never-satisfied striving which had made him great. Herr Aarenhold had been born in an out of the way place in the east, had married the daughter of a well-to-do tradesman, and by means of a bold and shrewd enterprise, of sharp practice on a grand scale which had as its object a new and productive coal-bed, he had diverted a large and inexhaustible stream of gold into his coffers.

The fish course descended. The servants hurried with it from the sideboard through the length of the room. They handed round with it a creamy sauce and poured out a Rhine wine that prickled on the tongue. The conversation turned to the approaching wedding between Sieglinde and von Beckerath.

It was close at hand, it was to take place in the following week. They talked about the trousseau, about plans for the wedding journey to Spain. Actually it was only Herr Aarenhold who talked about them, supported by von Beckerath's polite acquiescence. Frau Aarenhold ate greedily, and as usual contributed nothing to the conversation save some rather pointless questions. Her speech was interlarded with guttural words and phrases from the dialect of her childhood days. Märit was full of silent opposition to the church ceremony which they planned to have; it affronted her highly enlightened convictions. Herr Aarenhold also was privately unenthusiastic about the wedding ceremony. Von Beckerath was a Protestant and in Herr Aarenhold's view Protestant ceremonial was without any æsthetic value. If von Becklerath had belonged to the Catholic faith, now that would have been a different matter altogether. Kunz said nothing, because when von Beckerath was present he always felt annoyed with his mother. And neither Siegmund nor Sieglinde displayed any interest. They held each other's narrow hands between their chairs. Sometimes their gaze sought each other's, melting together in an understanding from which everybody else was shut out. Von Beckerath sat next to Sieglinde on the other side.

'Fifty hours,' said Herr Aarenhold, 'and you are in Madrid if you like. That is progress. It took me sixty by the shortest way. I assume that you prefer the train to the sea route via Rotterdam?'

Von Beckerath hastily expressed his preference for the overland route.

'But you won't leave Paris out. Of course, you could go direct to Lyons. And Sieglinde knows Paris. But you

should not neglect the opportunity ... I leave it to you whether or not to stop before that. The choice of the place where the honeymoon begins should certainly be left to you.'

Sieglinde turned her head, turned it for the first time towards her betrothed, quite openly and unembarrassed, careless of the lookers-on. For quite three seconds she bent upon the courteous face beside her the wide-eyed, questioning, expectant gaze of her sparkling black eyes – a gaze as vacant of thought as any animal's. Between their chairs she was holding the slender hand of her twin; and Siegmund drew his brows together till they formed two black furrows at the bridge of his nose.

The conversation veered and tacked to and fro. They talked of a consignment of cigars which had just come by Herr Aarenhold's order from Havana, packed in zinc. Then it circled round a point of purely abstract interest, brought up by Kunz: namely whether, if *a* were the necessary and sufficient condition for *b*, *b* must also be the necessary and sufficient condition for *a*. They argued the matter, they analysed it with great ingenuity, they gave examples; they lost the thread more and more, attacked each other with steely and abstract dialectic, until feelings began to run just a little high. Märit had introduced a philosophical distinction, that between the actual and the causal principle. Kunz told her, with his nose in the air, that 'causal principle' was a pleonasm. Märit, in some annoyance, insisted upon her terminology. Herr Aarenhold straightened himself, with a bit of bread between thumb and forefinger, and prepared to elucidate the whole matter. He suffered a complete rout, the children joined forces to laugh him down. Even his wife jeered at him. 'What are you talking about?' she said. 'Where did you learn that – you didn't learn much!' Von Beckerath pressed his chin on his breast, opened his mouth, and drew in breath to speak – but they had already passed on, leaving him hanging.

Siegmund began, in a tone of ironic amusement, to speak of an acquaintance of his, a child of nature whose

simplicity was such that he had managed to remain in ignorance of the difference between an ordinary jacket and a dinner jacket. This Parsifal actually talked about a checked dinner jacket. Kunz knew an even more pathetic case – a man who went out to tea in a dinner jacket.

'Wearing a dinner jacket in the afternoon!' Sieglinde said, making a face. 'Only animals do that.'

Von Beckerath laughed assiduously. But inwardly he was remembering that once he himself had worn a dinner jacket before six o'clock. And with the game course they passed on to matters of more general cultural interest: to the plastic arts, of which von Beckerath was an amateur, to literature and the theatre, which in the Aarenhold house had the preference – though Siegmund did devote some of his leisure to painting.

The conversation was lively and general, the young people taking a dominant part in it. They talked well, their gestures were highly strung and self-assured. They marched in the van of taste, and demanded the ultimate. For the vision, the intention, the labouring will, they had no use at all; they ruthlessly insisted upon power, achievement, success in the cruel trial of strength. The triumphant work of art they recognized – but they paid it no homage. Herr Aarenhold himself said to von Beckerath;

'You are very indulgent, my dear fellow; you speak up for intentions – but results, *results* are what we are after! You say: 'Of course his work is not much good – but he was only a peasant before he took it up, so his performance is after all astonishing.' Nothing doing. Accomplishment is absolute, not relative. There are no mitigating circumstances. Let a man do first-class work or let him shovel coals. How far should I have got with a good-natured attitude like that? I might have said to myself: 'You were nothing but scum originally – wouldn't it be wonderful if you manage to set up your own business.' Well, I'd not be sitting here! I've had to force the world to recognize me, so now I won't recognize anything unless I am forced to! This is Rhodes, why then, so dance!'

The children laughed. At that moment they did not look down on him. They sat there at table in their low, luxuriously cushioned chairs, with their spoilt, dissatisfied faces. They sat in splendour and security, but their words rang as sharp as though sharpness, hardness, alertness, and pitiless clarity were demanded of them as survival values. Their highest praise was a grudging acceptance, their criticism deft and ruthless; it snatched the weapons from one's hand, it paralysed enthusiasm, made it a laughing-stock. 'Very good,' they would say of some masterpiece whose lofty intellectual plane would seem to have put it beyond the reach of criticism. Passion was a blunder – it made them laugh. Von Beckerath, who tended to be disarmed by his enthusiasms, had a hard time of it – also his age put him in the wrong. He got smaller and smaller in his chair, pressed his chin on his breast, and in his excitement breathed through his mouth – beset on all sides by the brisk arrogance of youth. They contradicted everything – as though they found it impossible, discreditable, lamentable, not to contradict. They contradicted most efficiently, their eyes narrowing to gleaming slits. They pounced on some word, one single word that he had used, they worried at it, they tore it to pieces and replaced it by another so telling and deadly that it went straight to the mark and sat in the wound with quivering shaft. Towards the end of luncheon von Beckerath's eyes were red and he looked somewhat ruffled.

Suddenly – they were sprinkling sugar on their slices of pineapple – Siegmund said, wrinkling up his face in the way he had, as though the sun were making him blink:

'Oh, by the bye, von Beckerath, something else, before we forget it. Sieglinde and I approach you with a request – metaphorically speaking, you see us on our knees. They are giving the *Walküre* tonight. We should like, Sieglinde and I, to hear it once more together – may we? We are of course aware that everything depends upon your gracious favour –'

'How thoughtful!' said Herr Aarenhold.

Kunz drummed the Hunding motif on the cloth.

Von Beckerath was overcome at anybody asking his permission about anything. He answered eagerly, 'But by all means, Siegmund – and you too, Sieglinde; I find your request very reasonable – do go, of course; in fact, I shall be able to go with you. There is an excellent cast tonight.'

All the Aarenholds doubled up over their plates to hide their laughter. Von Beckerath, shut out and blinking in his desperate attempt to find his bearings, joined in their amusement as best he could..

Siegmund hastened to say:

'Oh, well, actually, it's a rather poor cast, you know. For the rest, be assured of our gratitude, but I am afraid there is a slight misunderstanding. Sieglinde and I were asking you to permit us to hear the *Walküre* once more *alone* together before the wedding. I don't know if you feel now that –'

'Oh, certainly. I quite understand. How charming! Of course you *must* go!'

'Thanks, we are most grateful indeed. Then I will have Percy and Leiermann put in for us . . .'

'Perhaps I may venture to remark,' said Herr Aarenhold, 'that your mother and I are driving to dinner with the Erlangers and using Percy and Leiermann. You will have to condescend to the brown coupé and Baal and Zampa.'

'What about seats?' asked Kunz.

'Bought them long ago,' said Siegmund, tossing back his head.

They all laughed, all staring at the bridegroom.

Herr Aarenhold unfolded with his finger-tips the paper of a belladonna powder and shook it carefully into his mouth. Then he lighted a fat cigarette, which presently spread abroad a priceless fragrance. The servants sprang forward to draw back the chairs as he and Frau Aarenhold rose. The order was given to serve coffee in the winter-garden. Kunz in a sharp voice ordered his dog-cart brought round; he would drive to the barracks.

* * * *

Siegmund was dressing for the opera; he had been dressing for a hour. He had an abnormal and constant a need for cleansing, to such an extent that he spent a considerable part of his time at the wash-basin. He stood now in front of his large Empire mirror with the white enamelled frame; dipped a powder-puff in its embossed box and powdered his freshly shaven chin and cheeks. His beard was so strong that when he went out in the evening he was obliged to shave a second time.

He presented a colourful picture as he stood there, in rose-tinted silk drawers and socks, red morocco slippers, and a quilted smoking-jacket in a dark pattern with lapels of grey fur. For background he had his large bedroom, full of all sorts of elegant and practical white-enamelled devices. Beyond the windows was a misty view over the tree-tops of the Tiergarten.

It was growing dark. He turned on the circular arrangement of electric bulbs in the white ceiling – they filled the room with soft milky light. Then he drew the velvet curtains across the darkening panes. The light was reflected from the liquid depths of the mirrors in wardrobe, washstand, and dressing-table, it flashed from the polished bottles on the tile-inlaid shelves. And Siegmund continued to work on himself. Now and then some thought in his mind would draw his brows together till they formed two black furrows over the bridge of the nose.

His day had passed as his days usually did, vacantly and swiftly. The opera began at half past six and he had begun to change at half past four, so there had not been much afternoon. He had rested on his chaise-longue from two to three, then drunk tea and employed the remaining hour sprawled in a deep leather armchair in the study which he shared with Kunz, reading a few pages in each of several new novels. He had found them pitiably weak on the whole; but he had sent a few of them to the binder's to be artistically bound in choice bindings, for his library.

He had, though, done some work in the morning. He had spent the hour from ten to eleven in the atelier of his

264

professor, an artist of European repute, who was developing Siegmund's talent for drawing and painting, and receiving from Herr Aarenhold two thousand marks a month for his services. But what Siegmund painted raised nothing more than an indulgent smile. He knew it himself; he was far from having any glowing expectations in his talent as an artist. He was too shrewd not to know that the conditions of his existence were not the most favourable in the world for the development of a creative gift. The accoutrements of life were so rich and varied, so elaborated, that almost no place at all was left for life itself. Each and every single accessory was so costly and beautiful that it had an existence above and beyond the purpose it was meant to serve – confusing the observer and absorbing attention. Siegmund had been born into superfluity, he was perfectly adjusted to it. And yet it was a fact that this superfluity never ceased to thrill and occupy him, to give him constant pleasure. Whether consciously or not, it was with him as with his father, who practised the art of never getting used to anything.

Siegmund loved to read, he strove after the word and the spirit as after a tool which a profound instinct urged him to grasp. But never had he lost himself in a book as one does when that single work seems the most important in the world; unique, a little, all-embracing universe, into which one immerses and immures oneself in order to draw nourishment out of every syllable. The books and magazines streamed in, he could buy them all, they piled up around him and even while he read, the number of those still to be read disturbed him. But he had the books bound in stamped leather and labelled with Siegmund Aarenhold's beautiful book-plate; they stood in rows, weighing down his life like a possession which he did not succeed in subordinating to his personality.

The day was his, it was given to him as a gift with all its hours from sunrise to sunset; and yet Siegmund found in his heart that he had no time for a resolve, much less for a deed. He was no hero, he commanded no enormous

strength. The preparation, the lavish preliminaries for what should have been the serious business of life used up all his energy. How much mental effort had to be expended simply in making a proper toilette! How much time and attention went to his supplies of cigarettes, soaps, and perfumes; how much occasion for making up his mind lay in that moment, recurring two or three times daily, when he had to select his cravat! And it was worth the effort. It was important. The blond-haired citizenry of the land might go about in elastic-sided boots and turn-over collars, heedless of the effect. But he – he of all people – had to be unassailable and without reproach in his appearance from head to toe.

And in the end no one expected more of him. Sometimes there came moments when he had a feeble misgiving about the nature of the 'real'; sometimes he felt that this lack of expectation lamed and dislodged his sense of it ... The household arrangements were all made to the end that the day might pass quickly and no empty hour be perceived. The next mealtime always came promptly. They dined before seven; the evening, when one can idle with a good conscience, was long. The days disappeared, swiftly the seasons came and went. The family spent two summer months at their little castle on the lake, with its large and splendid grounds, and many tennis courts, its cool paths through the parks, and shaven lawns adorned by bronze statuettes. A third month was spent in the mountains, in hotels where life was even more luxurious than at home. Of late, during the winter, he had had himself driven to the University to listen to a course of lectures on the history of art which came at a convenient time. But he had had to leave off because his sense of smell indicated that the rest of the class did not wash often enough.

He spent the hour walking with Sieglinde instead. Always she had been at his side since the very first; she had clung to him since they lisped their first syllables, taken their first steps. He had no friends, never had had one but this, his exquisitely groomed, darkly beautiful counterpart,

whose moist and slender hand he held while the richly gilded, empty-eyed hours slipped past. They took fresh flowers with them on their walks, a bunch of violets or lilies of the valley, smelling them in turn or sometimes both together, with languid yet voluptuous abandon. They were like self-centred invalids who absorb themselves in trifles, as narcotics to console them for the loss of hope. With an inward gesture of renunciation they cast aside the evil-smelling world and loved each other alone, for the priceless sake of their own rare uselessness. But everything that they uttered was honed to a glittering sharpness, striking the people they met, the things they saw, everything done by somebody else, to the end that it might be exposed to the unerring eye, the sharp tongue, the witty condemnation.

Then von Beckerath had appeared. He had a post in the government and came of a good family. He had proposed to Sieglinde. Frau Aarenhold had supported him, Herr Aarenhold had displayed a benevolent neutrality, Kunz the hussar was his zealous partisan. He had been patient, assiduous, endlessly good-mannered and tactful. And in the end, after she had told him often enough that she did not love him, Sieglinde had begun to look at him searchingly, expectantly, mutely, with an earnestness in her glistening black eyes, which spoke without words, like an animal's – and had said yes. And Siegmund, whose will was her law, had taken up a position too; slightly to his own disgust he had not opposed the match; was not von Beckerath in the government and a man of good family too? Sometimes he wrinkled his brows over his toilette until they made two heavy black furrows at the bridge of his nose.

He stood on the white bearskin which stretched out its claws beside the bed; his feet were lost in the long soft hair. He sprinkled himself lavishly with toilet water and took up his dress shirt. The starched and shining linen glided over his yellowish torso, which was as lean as a young boy's and yet shaggy with black hair. He arrayed himself further in

black silk drawers, black silk socks, and heavy black silk suspenders with silver buckles, put on the well-pressed trousers of silky black cloth, fastened the white silk braces over his narrow shoulders, and with one foot on a stool began to button his shoes. There was a knock on the door.

'May I come in, Gigi?' asked Sieglinde.

'Yes, come in,' he answered.

She was already dressed, in a frock of shimmering sea-green silk, with a square neck outlined by a wide band of ecru embroidery. Two embroidered peacocks facing each other above the girdle held a garland in their beaks. Her dark brown hair was unadorned; but a large egg-shaped precious stone hung on a thin pearl chain against her bare skin, the colour of smoked meerschaum. Over her arm she carried a scarf heavily worked with silver.

'I am unable to conceal from you,' she said, 'that the carriage is waiting.' He parried at once:

'And I have no hesitation in replying that it will have to wait patiently two minutes more.' It was at least ten. She sat down on the white velvet chaise-longue and watched him at his labours.

Out of a rich chaos of ties he selected a white piqué band and began to tie it before the glass.

'Beckerath,' she said, 'wears coloured cravats, crossed over the way they wore them last year.'

'Beckerath,' he said, 'is the most banal being into whose existence it has been my misfortune to gain some insight.' Turning to her quickly he added: 'Moreover, you will do me the favour of not mentioning that Teuton's name to me again this evening.'

She gave a short laugh and replied: 'You may be sure it will not be a hardship.'

He put on the low-cut piqué waistcoat and drew his tail coat over it, the soft silk lining caressing his hands as they passed through the sleeves.

'Let me see which buttons you have chosen,' said Sieglinde. They were the amethyst ones; shirt-studs, cuff-links, and waistcoat buttons, a complete set.

She looked at him admiringly, proudly, adoringly, with a world of tenderness in her dark, shining eyes. He kissed the lips lying so softly on each other. They spent another minute on the chaise-longue in mutual caresses.

'Quite, quite soft you are again,' she said, stroking his shaven cheeks.

'Your little arms feel like satin,' he said, running his hand down her tender forearm. He breathed in the violet odour of her hair.

She kissed him on his closed eyelids; he kissed her on the throat where the pendant hung. They kissed one another's hands. They loved one another sweetly, sensually, for sheer mutual delight in their own well-groomed, pampered, expensive smell. They played together like puppies, biting each other with their lips. Then he got up.

'We mustn't be too late today,' he said. He turned the top of the perfume bottle upside down on his handkerchief one last time, rubbed a drop into his narrow red hands, took his gloves, and declared himself ready to go.

He put out the light and they went along the red-carpeted corridor hung with dark old oil paintings and down the steps past the little organ. In the vestibule on the ground floor Wendelin was waiting with their coats, gigantic in his long yellow ulster. They yielded their shoulders to his ministrations; Sieglinde's dark head was half lost in her collar of silver fox. Followed by the servant they passed through the stone-paved vestibule into the outer air. It was mild, and there were great ragged flakes of snow in the pearly air. The coupé awaited them. The coachman bent down with his hand to his cockaded hat while Wendelin ushered the brother and sister to their seats; then the door banged shut, he swung himself up to the box, and the carriage was at once in swift motion. It crackled over the gravel, glided through the high, wide gate, curved smoothly to the right, and rolled away.

The luxurious little space in which they sat was pervaded by a gentle warmth. 'Shall I shut us in?' Siegmund asked. She nodded and he drew the brown silk curtains across the polished panes.

They were in the city's heart. Lights flew past behind the curtains. Their horses' hoofs rhythmically beat the ground, the carriage swayed noiselessly over the uneven ground, and round them roared and shrieked and thundered the machinery of urban life. Quite safe and shut away they sat among the quilted brown silk cushions, hand in hand. The carriage drew up and stopped. Wendelin was at the door to help them out. A little group of grey-faced shivering people stood in the brilliance of the arc-lights and followed them with hostile glances as they passed through the lobby. It was already late, they were the last. They mounted the staircase, threw their cloaks over Wendelin's arms, paused a second before a high mirror, then went through the little door into their box. They were greeted by the last sounds before the hush — voices and the slamming of seats. The lackey pushed their plush-upholstered chairs beneath them; at that moment the lights went down and below their box the orchestra broke into the wild pulsating notes of the prelude.

Night, and tempest . . . And they, who had been wafted hither on the wings of ease, with no petty annoyances on the way, were in exactly the right mood and could give all their attention at once. Storm, a raging tempest, the wailing of the winds in the woods. The angry god's command resounded, once, twice repeated in its wrath, obediently the thunder crashed. The curtain flew up as though blown by the storm. There was the rude hall, dark save for a glow on the pagan hearth. In the centre towered up the trunk of the ash tree. Siegmund appeared in the doorway and leaned against the wooden post, beaten and harried by the storm. Wearily he moved forwards on his sturdy legs wrapped round with hide and thongs. He was rosy-skinned, with a straw-coloured beard; beneath his blond brows and the blond forelock of his wig his blue eyes were directed upon the conductor, with an imploring gaze. At last the orchestra gave way to his voice, which rang clear and metallic, though he tried to make it sound like a gasp. He sang a few bars, to the effect that no matter to whom the

hearth belonged he must rest upon it; and at the last word he let himself drop heavily on the bearskin rug and lay there with his head cushioned on his plump arms. His breast heaved in slumber.

A minute passed, filled with the singing, speaking flow of the music, rolling its waves at the feet of the events on the stage . . . Sieglinde entered from the left. She had an alabaster bosom which heaved magnificently against the neckline of her fur-trimmed muslin dress. She displayed surprise at the sight of the stranger; pressed her chin upon her breast until furrows appeared round the lips as they formed the words, words giving expression to her surprise in tones which swelled, soft and warm, from her white throat and were given shape by her tongue and her mobile lips.

She tended the stranger. Bending over him so that her bosom strained towards him from the wilderness of fur like ripe buds, she proffered him the drinking-horn with both hands. He drank. The music spoke movingly to him of cool refreshment and cherishing care. They looked at each other with the beginning of enchantment, a first dim recognition, silently abandoning themselves while the orchestra sang in a melody of profound enchantment.

She gave him mead, first touching the horn with her lips, then watching while he took a long draught. Again their glances met and mingled, while below, the melody voiced their yearning. Then he rose, in deep dejection, turning away painfully, his arms hanging at his sides, to the door, that he might remove from her sight his affliction, his loneliness, his persecuted, hated existence and bear it back into the wild. She called upon him but he did not hear; heedless of self she lifted up her arms and confessed her intolerable anguish. He stopped. Her eyes fell. Below them the music spoke darkly of the bond of suffering that united them. He stayed. He folded his arms and remained by the hearth, awaiting his destiny.

Announced by his pugnacious motif, Hunding entered, paunchy and knock-kneed, like a cow. His beard was black

271

with brown tufts. He stood there frowning, leaning heavily on his spear, and staring ox-eyed at the stranger guest. But as the primitive custom would have it he bade him welcome, in an enormous, rusty bass.

Sieglinde laid the evening meal; Hunding's slow, suspicious gaze moved to and fro between her and the stranger. Dull lout though he was, he could well see that they resembled one another, were of one and the same breed, that odd, untrammelled rebellious stock, which he hated, to which he felt inferior. They sat down, and Hunding, in a few words, introduced himself and accounted for his simple, regular, and orthodox existence. Thus he forced Siegmund to speak of himself –, and that was incomparably more difficult. Yet Siegmund spoke, he sang clearly and with wonderful beauty of his life and misfortunes. He told how he had been born with a twin sister – and as people do who dare not speak out, he called himself by a false name. He gave a moving account of the hatred and envy which had been the bane of his life and his strange father's life, how their hall had been burnt, his sister carried off, how they had led in the forest a harried, persecuted, outlawed life; and how finally he had mysteriously lost his father as well ... And then Siegmund sang the most painful thing of all: he told of his yearning for human beings, his longing and ceaseless loneliness. He sang of men and women, of friendship and love he had sometimes won, only to be thrust back again into the dark. A curse had lain upon him forever, he was marked by the brand of his strange origins. His speech had not been that of the others, nor theirs his. What he found good was vexation to them, he was galled by the ancient laws to which they paid honour. Always and everywhere he had lived amid anger and strife, he had borne the yoke of scorn and hatred and contempt – all because he was strange, of a breed and kind hopelessly different from them.

The way Hunding reacted to all this was entirely characteristic. His reply showed no sympathy and no understanding, but only a sour disgust and suspicion of all

272

Siegmund's story. And finally understanding that the stranger standing here on his own hearth was the very outlaw he had, following a summons, been hunting that day, he behaved just as one would have expected of the brawny pedant he was. With a grim sort of courtesy he declared that his house was sacred and would protect the fugitive for that night, but that on the morrow he would have the honour of slaying him in battle. Gruffly he commanded Sieglinde to the inner chamber, to spice his night-drink for him and to wait for him in bed; then after a few more threats he followed her, taking all his weapons with him and leaving Siegmund alone and despairing by the hearth.

Up in the box Siegmund bent over the velvet ledge and leaned his dark boyish head on his narrow red hand. His brows made two black furrows, and one foot, resting on the heel of his patent-leather shoe, was in constant nervous motion. But it stopped as he heard a whisper close to him.

'Gigi!'

His mouth, as he turned, had an insolent twist.

Sieglinde was holding out to him a mother-of-pearl box with maraschino cherries.

'The brandy chocolates are underneath,' she whispered. But he accepted only a cherry, and as he took it out of the tissue paper wrapping she said in his ear:

'She will come back to him again at once.'

'I am not entirely unaware of the fact,' he said, so loud that several heads were jerked angrily in his direction . . . Down in the darkness the great Siegmund was singing alone. From the depths of his heart he cried out for the sword – for a shining blade to swing on that day when there burst forth at last the bright flame of his anger and rage, which so long had smouldered deep in his heart. He saw the hilt glitter in the tree, saw the embers fade on the hearth, sank back in gloomy slumber – and started up, leaning on his hands in horrified delight when Sieglinde glided back to him in the darkness.

Hunding, drugged and intoxicated, was sleeping like a

273

log. Together they rejoiced at the outwitting of the dolt; they laughed, and their eyes had the same way of narrowing as they laughed. Then Sieglinde stole a look at the conductor, received her cue, and putting her lips in position sang a long recitative: related the heart-breaking tale of how they had forced her, forsaken, strange and wild as she was, to give herself to the crude and savage Hunding and to count herself lucky in an honourable marriage which might bury her dark origins in oblivion. She sang too, sweetly and soothingly, of the strange old man in the hat and how he had driven the sword-blade into the trunk of the ash tree, to await the coming of the one who alone was able to draw it out. Passionately she prayed in song that it might be he whom she had in mind, whom she knew and grievously longed for, the consoler of her sorrows, the friend who should be more than friend, the avenger of her shame, whom once she had lost, whom in her abasement she wept for, her brother in suffering, her saviour, her rescuer . . .

But at this point Siegmund flung about her his two rosy arms. He pressed her cheek against the pelt that covered his breast and holding her so, sang above her head – sang out his exultation to the four winds, in a silver trumpeting of sound. Hot in his breast burned the oath that bound him to her, his fair companion. All the yearning of his hunted life found assuagement in her, and in her he found everything that had been so scornfully refused him when he had sought the company of men and women, when he had sought friendship and love with that arrogance which came from shyness and the consciousness of his stigma. Shame was her lot, as his was suffering, dishonoured was she as he was outcast, and revenge – their revenge – was to be this love between brother and sister.

The storm whistled, a gust of wind burst open the door, a flood of white electric light poured into the hall. Divested of darkness they stood and sang their song of spring and spring's sister, love!

Crouching on the bearskin they looked at each other in

the white light, as they sang their duet of love. Their bare arms touched each other as they held each other by the temples and gazed into each other's eyes, and as they sang their mouths were very near. They compared their eyes, their foreheads, their voices – they were the same. The growing, urging recognition wrung from his breast his father's name; she called him by his: Siegmund! Siegmund! He freed the sword, he swung it above his head, and ecstatically she sang to him, revealing who she was: his twin sister, Sieglinde. In rapture he stretched out his arms to her, his bride, she sank upon his breast – the curtain fell as the music swelled into a roaring, rushing, foaming whirlpool of passion – swirled and swirled and with one mighty throb stood still.

Rapturous applause. The lights went on. A thousand people got up, stretched unobtrusively as they clapped, then made ready to leave the hall, with heads still turned towards the stage, where the singers appeared before the curtain, like masks hung out in a row at a fair. Hunding too came out and smiled politely, despite all that had just been happening.

Siegmund pushed back his chair and stood up. He was hot; little red patches showed on his cheek-bones, above the lean, sallow, shaven cheeks.

'For my part,' he said, 'what I want now is a breath of fresh air. Siegmund was pretty feeble, wasn't he?'

'Yes,' answered Sieglinde, 'and the orchestra felt the need to drag during the the Spring Song.'

'Frightfully sentimental,' said Siegmund, shrugging his narrow shoulders in his dress coat. 'Are you coming out?' She lingered a moment, with her elbow on the ledge, still gazing at the stage. He looked at her as she rose and took up her silver scarf. Her soft, full lips were quivering.

They went into the foyer and mingled with the slow-moving throng, greeting acquaintances, downstairs and up again, sometimes hand in hand.

'I should enjoy an ice,' she said, 'if it were not almost certain to be of inferior quality.'

'Impossible,' he said. So they ate bonbons out of their box – maraschino cherries and chocolate beans filled with cognac.

The bell rang and they looked on contemptuously as the crowds rushed back to their seats, blocking the corridors. They waited until all was quiet, regaining their places just as the lights went down again and silence and darkness fell soothingly upon the hall. A bell rang quietly, the conductor raised his arms and summoned up anew the wave of splendid sound.

Siegmund looked down into the orchestra. The sunken space stood out bright against the darkness of the listening house; hands fingered, arms drew the bows, cheeks puffed out – all these simple folk laboured zealously to bring to utterance the work of a master who suffered and created; created the noble and simple visions enacted above on the stage. Creation? How did one create? Siegmund felt a pain in his breast, a burning or gnawing, something like an exquisite urgency. To do what? For what? It was all so dark, so shamefully unclear! Two thoughts, two words he sensed: creation, passion. His temples glowed and throbbed, and it came to him as in a yearning vision that creation was born of passion and was reshaped anew as passion. He saw the pale, spent woman hanging on the breast of the fugitive to whom she had given herself, he saw her love and her destiny, and felt that life, in order to be creative, must be like that. He saw his own life, and knew its contradictions, its clear understanding and spoilt voluptuousness, its splendid security and idle spite, its weakness and wittiness, its languid contempt; his life, so full of words, so void of acts, so full of cleverness, so empty of emotion and he felt again the burning, the searing anguish which yet was sweet – whither, and to what end? Creation? Experience? Passion?

The finale of the act came, the curtain fell. Light, applause, general exit. Sieglinde and Siegmund spent the interval as before. They scarcely spoke, as they walked hand-in-hand through the corridors and up and down the steps. She offered him the liqueur chocolates, but he did

not take any. She looked at him, but withdrew her gaze as his rested upon her, walking rather constrained at his side and enduring his eye. Her childish shoulders under the silver web of her scarf looked like those of an Egyptian statue, a little too high and too square. Upon her cheeks burned the same fire he felt in his own.

Again they waited until the crowd had gone in and took their seats at the last possible moment. Storms and wind and driving cloud; wild, heathenish cries of exultation. Eight females, not exactly beauties, eight untrammelled, laughing maidens of the wild, were disporting themselves amid a rocky scene. Brünnhilde broke in upon their merriment with her fears. They fled in terror before the approaching wrath of Wotan, leaving her alone to face him. The angry god nearly annihilated his daughter – but his wrath roared itself out, by degrees grew gentle and dispersed into a mild melancholy, on which note it ended. A noble prospect opened out, the scene was pervaded with epic and religious splendour. Brünnhilde slept. The god mounted the rocks. Great, full-bodied flames, rising, falling, and flickering glowed all over the boards. The Valkyrie lay with her coat of mail and her shield on her mossy couch ringed round with fire and smoke, with leaping, dancing tongues, with the magic sleep-compelling fire-music. But she had saved Sieglinde, in whose womb there grew and waxed the seed of that hated unprized race, chosen of the gods, from which the twins had sprung, who had mingled their misfortunes and their afflictions in free and mutual bliss.

Siegmund and Sieglinde left their box; Wendelin was outside, towering in his yellow ulster and holding their cloaks for them to put on. Like a gigantic slave he followed the two dark, slender, fur-mantled, exotic creatures down the stairs to where the carriage waited and the pair of large finely matched glossy thoroughbreds tossed their proud heads in the winter night. Wendelin ushered the twins into their warm little silk-lined retreat, closed the door, and the coupé stood poised for yet a second, quivering slightly

from the swing with which Wendelin agilely mounted the box. Then it glided swiftly away and left the theatre behind. Again they rolled noiselessly, easily over the uneven ground to the brisk rhythm of the horses' hooves, sheltered from the shrill harshness of the bustling life through which they passed. They sat as silent and remote as they had sat in their opera-box facing the stage – almost, one might say, in the same atmosphere. Nothing was there which could alienate them from that extravagant and stormily passionate world which worked upon them with its magic power to draw them to itself.

The carriage stopped; they did not at once realize where they were, or that they had arrived before the door of their parents' house. Then Wendelin appeared at the window, and the porter came out of his lodge to open the door.

'Are my father and mother at home?' Siegmund asked, looking over the porter's head and blinking as though he were staring into the sun.

No, they had not returned from dinner at the Erlangers'. Nor was Kunz at home; Märit too was out, no one knew where, for she went entirely her own way.

They left their overcoats in the vestibule on the ground floor and went up the stairs and through the first-floor hall into the dining-room. It stretched out before them, immense in its murky splendour. Only one chandelier was lit, over the table at the farther end which had been laid and where Florian was waiting to serve them. They moved noiselessly across the thick carpet, and Florian seated them in their softly upholstered chairs. Then a gesture from Siegmund dismissed him, they would dispense with his services.

The table was laid with a dish of fruit, a plate of sandwiches, a jug of red wine. An electric tea-kettle hummed upon a great silver tray, with all the accoutrements about it.

Siegmund ate a caviar sandwich and poured out wine into a slender glass where it glowed a dark ruby red. He drank in quick gulps, and grumblingly stated his opinion

that red wine and caviar were a combination offensive to good taste. He drew out his case, jerkily selected a cigarette, and began to smoke, leaning back with his hands in his pockets, wrinkling up his face and twitching his cigarette from one corner of his mouth to the other. His strong growth of beard was already beginning to show again under the high cheek-bones; the two black furrows stood out on the bridge of his nose.

Sieglinde had made herself some tea and added a drop of burgundy. She touched the fragile porcelain cup delicately with her full, soft lips and as she drank she looked across at Siegmund with her great humid black eyes.

She set down her cup and leaned her dark, sweet little head upon her slender hand. Her eyes rested full upon him, with such liquid, speechless eloquence that, in comparison, what she actually said seemed less than nothing.

'Won't you have any more to eat, Gigi?'

'One would not draw,' he said, 'from the fact that I am smoking, the conclusion that I intend to eat more.'

'But you have had nothing but bonbons since tea. Take a peach, at least.'

He shrugged his shoulders – or rather he wriggled them like a naughty child, in his tail coat.

'This is boring. I am going upstairs. Good night.'

He finished his wine, tossed away his table-napkin, and slouched away, with his hands in his pockets, into the darkness at the other end of the room.

He went upstairs to his room, where he turned on the light – not much, only two or three bulbs, which made a wide white circle on the ceiling. Then he stood considering what to do next. The good-night had not been final; this was not how they were used to take leave of each other at the close of the day. She was sure to come to his room. He flung off his coat, put on his fur-trimmed smoking-jacket, and lighted another cigarette. He lay down on the chaise-longue; sat up again, tried another posture, with his cheek in the pillow; threw himself on his back again and so remained awhile, with his hands under his head.

The subtle, bitter scent of the tobacco mingled with that of the cosmetics, the soaps, and the toilet waters; their combined perfume hung in the tepid air of the room and Siegmund breathed it in with conscious pleasure, finding it sweeter than ever. Closing his eyes he surrendered to this atmosphere, as a man will console himself with some delicate pleasure of the senses for the extraordinary harshness of his lot.

Then suddenly he started up again, tossed away his cigarette and stood in front of the white wardrobe, which had long mirrors let into each of its three divisions. He moved very close to the middle one and, eye to eye, he studied himself. His curiosity subjected each feature to a meticulous examination; he opened the two side wings and studied both profiles as well. For a long time he stood there, scrutinising the signs of his race, the slightly drooping nose, the full lips that rested so softly on each other; the high cheek-bones, the thick black, curling hair that grew far down on the temples and parted so decidedly on one side; finally the eyes under the knit brows, those large black eyes that flowed like fire and had an expression of weary sufferance.

In the mirror he saw the bearskin lying behind him, spreading out its claws beside the bed. He turned round, and went over to it with tragic, stumbling steps; after a moment of hesitation he sank down and stretched out on the skin, his head pillowed on his arm.

For a while he lay motionless, then propped his head on his elbows, with his cheeks resting on his slim reddish hands, and fell again into contemplation of his image opposite him in the mirror. There was a knock on the door. He started, reddened, and moved as though to get up – but sank back again, his head against his outstretched arm, and stopped there, silent.

Sieglinde entered. Her eyes searched the room, without finding him at once. Then with a start she saw him lying on the rug.

'Gigi, what ever are you doing there? Are you ill?' She

ran to him, bent over him and, stroking his hair and forehead, repeated, 'You're not ill, are you?'

He shook his head, looking up at her from below as she continued to caress him.

She was half ready for bed, having come over in slippers from her dressing-room, which was opposite his. Her loosened hair flowed down over her open white peignoir; beneath the lace of her chemise Siegmund saw her small breasts, the colour of smoked meerschaum.

'You were so cross,' she said. 'It was beastly of you to go away like that. I wasn't going to come at all. But then I did, because that was not a proper good-night at all . . .'

'I was waiting for you,' he said.

Still bending over him, she gave a grimace of pain, which made the facial characteristics of her kind stand out to an extraordinary degree.

'Which does not prevent my present posture,' she said in their habitual tone, 'from causing me a not unappreciable amount of discomfort in the back.'

He threw himself from side to side to stop her.

'Don't, don't . . . Not like that, not like that . . . It doesn't have to be like that, Sieglind, you see . . .' His voice was strange, he himself noticed it. He felt parched with fever, his hands and feet were cold and clammy. She knelt beside him on the skin, her hand in his hair. He lifted himself a little to fling one arm round her neck and so looked at her, looked as he had just been looking at himself – at eyes and temples, brow and cheeks.

'You are just like me,' he said, haltingly, and swallowed to moisten his dry throat. 'Everything is . . . as it is with me . . . and the way . . . nothing touches me is just like . . . Beckerath for you . . . it balances out . . . Sieglind . . . and on the whole it is . . . the same, especially as far as . . . taking revenge is concerned, Sieglind . . .'

He was seeking to clothe in reason what he was trying to say – yet his words sounded as though he uttered them out of some strange, rash, bewildered dream.

But to her it had no quality of strangeness. She was not

281

ashamed to hear him say such unpolished, such clouded, confused things; his words enveloped her senses like a mist, they drew her down whence they had come, to the borders of a kingdom she had never entered, though sometimes, since her betrothal, she had been carried thither in expectant dreams.

She kissed him on his closed eyelids; he kissed her on her throat, beneath the lace she wore. They kissed each other's hands. They loved each other with all the sweetness of the senses, each for the other's spoilt and costly well-being and delicious fragrance. They breathed it in, this fragrance, with languid and voluptuous abandon, like self-centred invalids, consoling themselves for the loss of hope. They forgot themselves in caresses, which took the upper hand and turned into an urgent thrashing and then just sobbing —

She sat there on the bearskin, with parted lips, supporting herself with one hand, and brushed the hair out of her eyes. He leaned back on his hands against the white chest of drawers, rocked to and fro on his hips, and gazed into the air.

'But Beckerath,' she said, seeking to find some order in her thoughts, 'Beckerath, Gigi ... what do we do about him, now?'

'Oh,' he said and for a second the characteristics of his kind stood out sharply in his face 'he ought to be grateful to us. His existence will be a little less banal, from now on.'

From: *Stories of Three Decades*.
Thomas Mann. Secker and Warburg,
London, 1946.

About the Authors

Bahr, Hermann (Linz 1863 – Munich 1934)
Hermann Bahr's fame rests primarily on his work as a critic and essayist: his essay on 'Die Décadence' is probing and perceptive. He was at the centre of the latest literary developments or, indeed, one step ahead. He was often lampooned (by Karl Kraus particularly) for his awareness and championship of the latest trends. His novel *Die gute Schule* (*The School of Love*), appearing in 1890, is the first German novel to deserve the predicate 'fin de siècle': it portrays the sexual adventures and entanglements of a nameless painter from Lower Austria with Fifi in Paris. The school of love is, apparently, the only source of wisdom.

Ewers, Hanns Heinz (Düsseldorf 1871 – Berlin 1943)
Ewers began writing poetry heavily indebted to neoromantic and decadent modes; he appeared in cabaret in Munich where his grotesquely satirical humour was exploited to the full. His second novel, *Die Alraune: The Story of a Living Creature* (1911) was immensely popular, reaching sales of over a quarter of a million in ten years. Ewers considered himself the herald of a fantastic, Satanist movement that looked back to Poe and de Sade; later he willingly served the Nazi cause but was soon rejected as degenerate, his work being incompatible with visions of rude Nordic health. His work is of interest in the link it provides between decadence and proto-Nazi attitudes.

Heym, Georg (Hirschberg, Silesia 1887 – Berlin 1912)
Son of a lawyer, Georg Heym embarked on legal studies in Würzburg but soon took up writing: a longing for violent catastrophe characterized his work from its beginnings. Attempts at historical drama were unsuccessful and

Heym's literary breakthrough came with an introduction to the avant-garde *Neuer Club* in Berlin. Heym excelled at highly structured portrayals of apocalyptic horror; there are traces of Baudelaire in his poetry and word paintings akin to Van Gogh. *The Autopsy* demonstrates Heym's brilliant (and morbid) imagination, with echoes of Edgar Allan Poe. He was drowned in a skating accident on the Wannsee.

Hille, Peter (Erwitzen/Höxter 1854 – Berlin 1904)
Peter Hille is known primarily as an arch-Bohemian and vagabond (the poetess Else Lasker-Schüler propagated the legend). He studied briefly in Leipzig, then attempted journalism and finally turned to writing; he lived in the slums of Whitechapel, worked sporadically in the British Museum and visited Swinburne (with an introduction from Victor Hugo). Hille attempted novels and plays but was not successful in sustaining a narrative thread and was not at ease with conventional drama, preferring sketch, impression and aphorism. Impoverished, he often slept in the open, frequently in the Tiergarten, Berlin. His *Heriodias* is an example of the German contribution to portrayals of that fascinating figure which haunted the imagination of the decadents.

Holitscher, Arthur (Budapest 1869 – Geneva 1941)
Holitscher was born in Budapest as the son of a Jewish businessman. He turned from banking to literature and published his first book in 1893 (the influence of Knut Hamsun is apparent). In 1896 he settled in Munich and worked as a publisher's reader: *Der vergiftete Brunnen* (*The Poisoned Well*), his most famous novel, appeared in 1900 (Thomas Mann had recommended it). After World War One Holitscher became increasingly disenchanted with Bohemian attitudes and became active in left-wing politics; sympathy for the Soviet Union became manifest in many of his writings. He was in Paris in January 1933 and moved to Ascona, later Geneva, where he died. Robert Musil spoke at his grave.

Leppin, Paul (Prague 1878 – Prague 1945)
Born into an impoverished lower middle-class background, Paul Leppin worked until 1928 as a clerk in the Post and Telegram service in Prague. His writing is very much of its time in the morbid (and frequently lascivious) atmosphere evoked; he became part of the literary bohême of the city and achieved notoriety with *Severins Gang in die Finsternis* (*Severin's Journey into Darkness*) of 1914, where a sultry sexuality prevails. Greatly influenced by Meyrink, he became a spokesman of the mysterious and the erotic atmosphere of old Prague, of which he became the 'Troubadour'. He was arrested by the Gestapo in 1939 and suffered two strokes after his release: he died as a result of syphilis. The novel *Blaugast. Ein Roman aus dem alten Prag* (*Blaugast. A novel from Old Prague*) was written in 1932 and published posthumously in 1948.

Mann, Thomas (Lübeck 1875 – Kilchberg/Zürich 1955)
Thomas Mann is one of the greatest twentieth century German novelists; his magisterial stance, immense erudition, psychological finesse and ironic subtlety have little equal in world literature. As a young man he was fascinated by the phenomenon of decadence and observed the literary scene in Munich most keenly, claiming that his own work derived much from the awareness of degeneration. *Wälsungenblut* was originally meant to appear in 1906 but was withheld from publication for many years because of certain objections and reservations on the part of Thomas Mann's father-in-law. It appeared in 1921 as a bibliophile edition with lithographs by Th. Th. Heine. It has been included in this anthology as it is one of the stories of Thomas Mann which most blatantly portrays the dubious influence of Wagner, one of Thomas Mann's 'trinity of eternally united spirits' (the others being Schopenhauer and Nietzsche).

Martens, Kurt (Leipzig 1870 – Dresden 1945)
Martens was the son of an eminent civil servant in Leipzig,

and studied law there, also in Heidelberg and Berlin. He turned to writing and made his name with the novel *Roman aus der Décadence* (*A Novel from the Age of Decadence*) in 1898. He lived from 1899 to 1922 in Munich where he contributed to the literary journal *Die Jugend*. He was a friend of Thomas Mann who wished to use the title of Marten's novel as a subtitle for his own *Buddenbrooks*. Martens wrote other novels and plays which met with little success. His autobiography (1921–1924) gives a memorable account of the literary vie de bohême in Munich. He witnessed the air raid on Dresden in February 1945 and committed suicide afterwards.

Przybyszewski, Stanislaus (Lojewno, Prussian Poland 1868 – Jaronty/Hohensalza 1927)
Przybyszewski studied medicine and architecture in Berlin before publishing pseudo-psychological studies on Chopin and Ola Hansson. He became the centre of Berlin's bohême, an habitué of the wine cellar 'Zum schwarzen Ferkel' where he consorted with Edvard Munch and Richard Dehmel. As a 'satanist' and 'androgynist' he is the most *outré* of the German writers of decadence, an intensely subjective individual whose writing probed sub-rational darkness and exulted in wild, chaotic descriptions of hyperbole and uproar. He made an indelible impression on his German contemporaries and is frequently portrayed in the literary works of the day. He lived in Munich from 1906–1919 before moving to independent Poland. His works in Polish are less significant: he became a member of the Young Polish Movement and edited the literary journal *Zycie* . He was married to Dagne Juel whom Edvard Munch frequently painted; she was later murdered in Tiflis.

Sacher-Masoch, Leopold von (Lemberg 1836 – Lindheim/Hessen 1895)
Born in Ruthenia, i.e. Western Galizia, as the son of a senior police official, Sacher-Masoch studied law in Prague

and Graz before devoting himself entirely to literature. He edited the 'Gartenlaube für Österreich' and later, in Leipzig, the literary journal 'Auf der Höhe'. His earlier novels extol the Carpathian landscape and the rich confusion of races in the Bukovina; the later work, including *Venus im Pelz* (*Venus in Furs*) (originally part of a series of novellas called *Das Vermächtnis Kains* (*The Legacy of Cain*)) explores the world of sexual fantasy and perversion. It was Krafft-Ebing's *Psychopathia Sexualis* (1886) which coined the term 'masochism' and made the author notorious; his wife Wanda sought later to cash in on this notoriety by her own anthology *Damen im Pelz* (*Ladies in Furs*).

Trakl, Georg (Salzburg 1887 – Cracow 1914)
Georg Trakl is the poet of decay par excellence; his slender *œuvre* is suffused with an awareness of transience and putrefaction. Addicted to drugs at an early age (he studied pharmacy in Salzburg) he adopted the pose of the *poète maudit* and was drawn into an incestuous relationship with his sister. Like many others of his generation he was fascinated by the poetry of Baudelaire and may have known Baudelaire's (and Mallarmé's) translations of Edgar Allan Poe. *Verlassenheit* (*Desolation*) is very reminiscent of *The Fall of the House of Usher*. Trakl wrote many poems of haunting euphony but was also keenly aware of sin and damnation. He committed suicide in the psychiatric wing of the military hospital in Cracow.

Decadence from Dedalus

Titles in the Decadence from Dedalus series include:

Senso (and other stories) – Boito £6.99
The Child of Pleasure – D'Annunzio £7.99
The Triumph of Death – D'Annunzio £7.99
The Victim (L'Innocente) – D'Annunzio £7.99
Angels of Perversity – de Gourmont £6.99
The Dedalus Book of Medieval Decadence – editor Brian Murdoch (June 1995) £7.99
The Dedalus Book of Roman Decadence – editor G. Farrington £7.99
The Dedalus Book of German Decadence – editor R. Furness £8.99
La-Bas – J. K. Huysmans £7.99
Monsieur de Phocas – Lorrain £8.99
The Green Face – Meyrink £7.99
The Diary of a Chambermaid – Mirbeau £7.99
Torture Garden – Mirbeau £7.99
Le Calvaire – Mirbeau £7.99 (February 1995)
Monsieur Venus – Rachilde £6.99
La Marquise de Sade – Rachilde £8.99
The Dedalus Book of Decadence – editor B. Stableford £7.99
The Second Dedalus Book of Decadence – editor B. Stableford £8.99

Decadent titles in the Dedalus European Classics series include:

Little Angel – Andreyev £4.95
The Red Laugh – Andreyev £4.95
Les Diaboliques – Barbey D'Aurevilly £6.99
The Cathedral – J. K. Huysmans £6.95
En Route – J. K. Huysmans £6.95

All these titles can be obtained from your local bookshop, or by post from Dedalus by writing to:
Dedalus Cash Sales, Langford Lodge, St Judith's Lane, Sawtry, Cambs, PE17 5XE
Please enclose a cheque to the value of the books ordered + £1 pp for the first book and 75p thereafter up to a maximum of £4.75